READING ROCK ART

READING ROCK ART

Interpreting The Indian Rock Paintings Of The Canadian Shield

GRACE RAJNOVICH

NATURAL HERITAGE/NATURAL HISTORY INC.

Reading Rock Art
Published by Natural Heritage/Natural History Inc.
P.O. Box 95, Station O
Toronto, Ontario M4A 2M8

Design: Derek Chung Tiam Fook
Editor: Rosemary Tanner
Printed and bound in Canada by Hignell Printing Limited, Winnipeg, Manitoba.
First Printing June 1994
Second Printing February 2002

Canadian Cataloguing in Publication Data
Rajnovich, Grace
 Reading rock art: Indian rock paintings of the Canadian Shield

ISBN 0-920474-72-1
1. Rock paintings – Canadian Shield. 2. Indians
of North America – Canada – Painting. 3. Indians
of North America – Canada – Antiquities. I. Title.

E78.C2R3 1994 709'.01'1308997 C94-930436-0

*This publication has been assisted by an Ontario Heritage Book Award from the Ontario Heritage Foundation,
an agency of the Ministry of Tourism, Culture & Recreation.*

Natural Heritage/Natural History Inc. gratefully acknowledges the assistance of the Canada Council, the
Ontario Arts Council, and the Government of Ontario through the Ministry of Culture, Tourism and
Recreation.

CONTENTS

FOREWORD

I was a field archaeologist for the Ontario government for 14 years in Kenora, Ontario, the heart of pictograph country and the hometown of Selwyn Dewdney, Canada's foremost rock art researcher. With Kenneth Kidd, Selwyn wrote *Indian Rock Paintings of the Great Lakes*. This book is intended to complement that classic work. Hundreds of people asked me about the rock paintings surrounding us. What do they mean, how old are they, who put them there? This book is written for those hundreds of people: the general public. Footnotes are provided at the back for professional researchers to do what they love best, check on my sources.

I met Selwyn late in his life at an archaeological conference in Winnipeg. He read the name-tag on my lapel and exclaimed, "Kenora! My hometown! I miss it so much!" I miss that beautiful part of Canada, too, and I am indebted to the people in the towns and reserves of northwestern Ontario; their unfailing interest in the rock art gave me the idea for this book.

I thank the Canada Council and the Ontario Heritage Foundation for giving me grants for the research and production of this book. "Migwetch" also to Chief Willie Wilson of the Rainy River First Nation and William A. Ross of the Ontario Ministry of Culture, Tourism and Recreation for recommending my grant applications.

I also thank Peter Storck and his staff at the Royal Ontario Museum, Department of New World Archaeology, for giving me access to the Dewdney Collection, one of Canada's greatest treasures. I am grateful to the Ontario Ministry of Culture, Tourism and Recreation and its staff, William A. Ross and C. S. Paddy Reid, for providing reproductions of rock art from ministry collections in Kenora, Thunder Bay and Sault Ste. Marie. James R. Glenn and his staff of the Smithsonian Institution, National Anthropological Archives, provided material by Frances Densmore and Garrick Mallery, two early and excellent researchers of Indian picture writing. The U. S. National Archives provided material by W. H. Hoffman, another superb observer of 19th century Indian ways.

Parts of this book are from a research paper I published in 1989 in the Midcontinental Journal of Archaeology and are quoted here with permission of the Kent State University Press, Kent, Ohio.

Archaeology is teamwork; it is never done alone. I am grateful to the following people for giving me ideas, help and encouragement: David Arthurs, Carl Blackhawk, Len Blyth, Tom, Ann and Stacey Bruyere, Peter Carruthers, Peter Engelbert, Colleen Halverson, Larry Hoffman, M. T. Kelly, Ian

Kenyon, Herb and Peggy Lash, Robert McNally, Karen Nachtigall, Michael O'Connor, Georgine Pastershank, Gordon Peters, Nan, James and Michael Rajnovich, Walter Red Sky, Jacqueline Rusak, Dennis Smyk, James Swauger, Elizabeth Tooker and Allen Tyyska.

I especially thank Maria Seymour, Director of the Lake of the Woods Ojibway Cultural Centre in Kenora, for creating my interest in interpreting the rock paintings and for reviewing the research paper that forms the basis of this book.

I am also grateful to a number of people who read and commented on portions of the manuscript: Dr. Robert Bothwell, Dr. Charles E. Cleland, William A. Fox, Nan Rajnovich, Dr. Robert J. Salzer and Beverley Sawchuk.

Illustrations in ink of the rock paintings, presented in this book by artist Wayne Yerxa of Couchiching Reserve near Fort Frances, Ontario, were taken from field work by David Arthurs, Marieange Beaudry, Thor and Julie Conway, Selwyn Dewdney, David Hems, Gordon Hill, Joan Holmes, Peter Lambert, Victor Pelshea and the author. I thank Charles E. Cleland, William A. Fox, Tim Jones, James Molnar, Robert J. Salzer and Gilles Tassé for the use of reproductions from their works.

My biggest round of applause is in memory of the late Selwyn Dewdney whose lifelong work in rock art research has given us the Dewdney Collection, and it helps us get to know the Indian people a little better. Some of the rock paintings here are from Dewdney's field tracings and the water-colours are his.

The mistakes are mine.

Grace Rajnovich
Sault Ste. Marie, Ontario

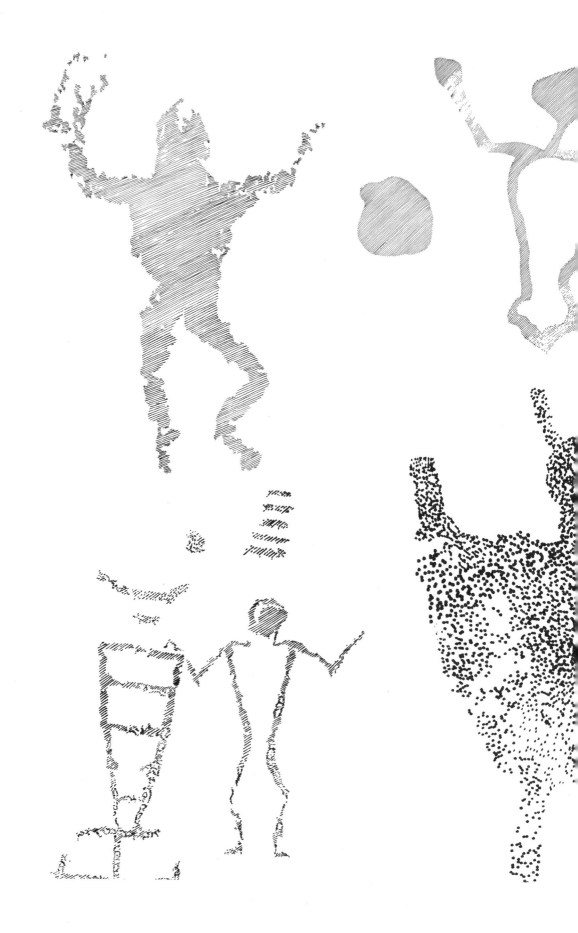

CHAPTER 1

VISIONS IN THE QUEST FOR MEDICINE

More than 400 rock paintings adorn the cliff faces of the Canadian Shield (Figure 1): they are stories in picture writing put on the cliffs as far back as 2,000 years ago. Some people, in attempting to explain how the picture writing got there, have speculated that it originated with mythical visitors to our continent, Egyptians or even Phoenicians. However, the Canadian Shield is the home of the Algonkian-speaking Indians who traditionally put picture writing on their birchbark, copper, stone and wood objects. The 19th-century treaties between the Algonkian nations and the Canadian Crown, that set out the Indian reserves and annual payments, were signed by the chiefs using pictures of their totems, or clans (Figure 2): the Beaver, Otter, Sturgeon, Caribou, Moose and others. We need not go far, as Canadians, nor dream up exotic visitors, to understand and respect the use of picture writing. It is a living part of our own nation.

The rock paintings – bright red figures of people, animals, canoes, and bows-and-arrows common to the traditional boreal forest life – also abound with the signs of medicine – drums, rattles, medicine bags and other items precious to the Indian healer (Figure 3). They are an astonishing legacy of the first nations of the Shield, astonishing both in their antiquity and their ability to elicit a sense of wonder. J. W. Powell of the

Smithsonian Institution wrote about rock paintings back in 1881 using the phrase "awe-inspiring" to describe his impressions. We still do.

Rock paintings are often called "rock art", a term generally accepted among researchers. However, their other name, "pictographs", is more accurate; it means picture writing. Powell, in emphasizing the fact that the tradition of Indian rock painting is picture writing not art, said, "From it can be written one of the most interesting chapters in the early history of mankind."[1]

The majority of researchers and the native people themselves attribute the Shield paintings to Algonkian-speaking peoples[2] whose long history in a harsh northern world produced a reliance on "medicine", a concept of curing bound up with a deep spiritual connection with the manitous (pronounced muni-doe), the spirits who inhabited every special place on the landscape. For the Algonkian Indians, every place where rock paintings occur was special. They were the homes of the medicine manitous. "Medicine" had a great depth of meaning in traditional Indian usage; it meant something like "mystery" and "power" and included not only the activities of curing with tonics from plants and minerals, but also the receipt of powers from the manitous for healing, hunting and battle. The most important step in the practice of

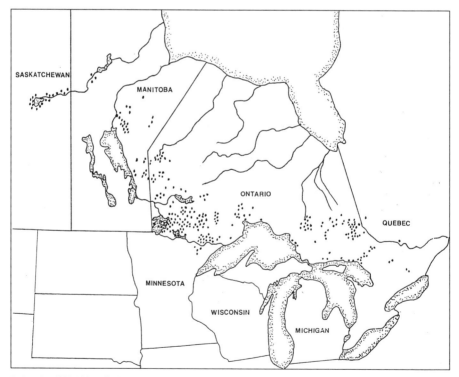

FIGURE 1. INDIAN ROCK PAINTINGS OF THE CANADIAN SHIELD

medicine was communication between the practitioners and the manitous, for without their powers the medicine wouldn't work. The rock paintings tell of the Indians' struggles for the powerful medicine, but especially, they are a spectacular record of achievement; they were painted by the seekers of medicine who were successful.

The paintings are on vertical rock walls immediately beside the water (Figure 4), some situated at the base of the cliffs, easily reached by a person sitting in a canoe. Others are in spectacular settings 20 metres up the steep cliff faces with no visible perches for the painter to stand on. They hang in the air. Many are on rock faces that have crevices or small caverns, giving the effect of entrances to the cliff (Figure 5).

The paintings were done with red ochre, a chalky mineral that outcrops in veins in many places all across the Shield. In northeastern Ontario, two archaeologists located a red ochre mine where Indians carved the mineral out of a deep cave in a cliff face and climbed to the mountain top to cut it into useable chunks. The archaeologists were quite excited about their discovery; at least they thought they found a red ochre mine. They weren't sure because they were both colour blind and had to get some one else to verify their find![3]

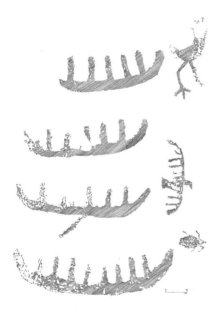

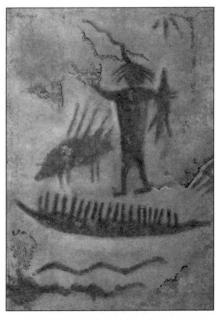

FIGURE 2. PEOPLE IN CANOES AT AGAWA ROCK ON LAKE SUPERIOR. THE ANIMALS LEADING THE BOATS ARE THE TOTEMS OF THE PEOPLE, CRANE, THUNDERBIRD AND POSSIBLY BEAVER.

FIGURE 3. A MEDICINE MAN HOLDING AN OTTER MEDICINE BAG, ON THE BLOODVEIN RIVER IN NORTHWESTERN ONTARIO. POWER LINES RADIATE FROM HIS HEAD. COURTESY OF THE ROYAL ONTARIO MUSEUM, TORONTO, CANADA.

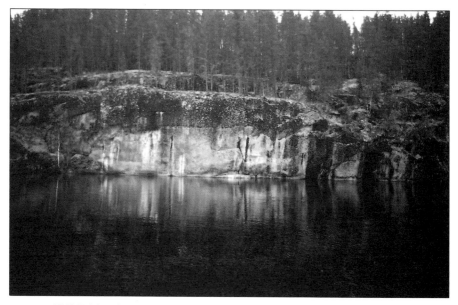

FIGURE 4. THE BLOODVEIN RIVER PICTOGRAPH SITE, NORTHWESTERN ONTARIO, ONE OF THE LARGEST SITES IN THE SHIELD. THE PAINTINGS ARE ALONG THE ROCK FACE NEAR THE WATERLINE. COURTESY OF THE ONTARIO MINISTRY OF CULTURE, TOURISM AND RECREATION.

FIGURE 5. PINENEEDLE LAKE, NORTHWESTERN ONTARIO. COURTESY OF THE ONTARIO MINISTRY OF CULTURE, TOURISM AND RECREATION.

Archaeological sites in the Canadian Shield date back about 10,000 years, beginning with the Palaeo Indian Period (10,000 to about 7,500 years ago), followed by the Archaic Period (7,500 to about 2,000 years ago) and the Woodland Period (2,000 years ago to the Historic Fur Trade). Chapter 2 presents evidence for dating Shield rock art to the Woodland and Historic Periods. Debate exists as to the cultural identification of the Woodland peoples of the Shield of the first half of the period, from 2,000 to 1,000 years ago. Some archaeologists claim there was a cultural continuity throughout the period, linking modern Algonkian speakers with the earliest Woodland cultures while others say the evidence is inconclusive. Whatever the case, archaeology can place the Algonkian people in the Shield for at least a thousand years.[4]

Archaeologists commonly find red ochre chunks in their excavations of prehistoric Indian encampments in the Shield. Maria Seymour, director of the Lake of the Woods Ojibway Cultural Centre in Kenora, Ontario, took samples from an excavation of a 2,000-year-old Indian site near Kenora and made a durable paint by powdering the ochre, known to the Ojibway as

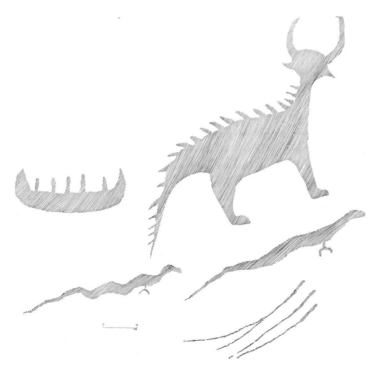

FIGURE 6. THE MISHIPIZHEU (GREAT LYNX) AT AGAWA ROCK ON LAKE SUPERIOR.

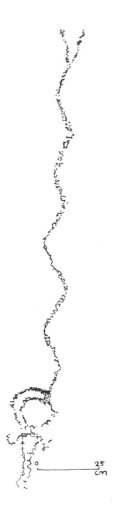

FIGURE 7. ANNIE ISLAND, LAKE OF THE WOODS, DEPICTING A LONG AND DIFFICULT JOURNEY.

onamin or wunnamin, and mixing it with glue and oil from sturgeon fish.[5] The Indian paint on the cliffs has proven to be better than modern house paint. In the 1930s, some one defaced the Agawa Rock painting on Lake Superior by writing initials with store-bought paint on top of one of the figures, a Mishipizheu, the Great Lynx (Figure 6). The modern paint has now weathered away and the Great Lynx is still there, looking out toward the lake, challenging the next vandal.

Powerful healers said they entered the mountain homes of the medicine manitous in search of their blessings, and they drew the stories of their journeys in picture writing on the cliff faces. Figure 7 is the Annie Island pictograph on Lake of the Woods, telling of a long and difficult journey, depicted as a long, snaky line. We shouldn't think of these events as supernatural because nothing was supernatural in the traditional Algonkian world.[6] In European thought, the god resides in Heaven beyond our world and communicates to us directly only in extraordinary circumstances that we call miracles. The Algonkian manitous belonged to the same family as the people who called them "grandfathers",[7] and the people and manitous shared the same landscape. They could enter each other's worlds and talk to each other directly.

A person of Judaeo-Christian background can easily understand the concept of calling upon a spirit for help, but the Indian idea is different. The native person believed there was an in-dwelling spirit not only in man but also in every living creature, and even in some objects we normally think of as inanimate, including some rocks and minerals. A person needing more than human power to heal, hunt or go to war would seek to supplement his own power by the addition of the power of another creature. So nothing was supernatural as all created things shared the mysterious spirit. The animals were his brothers and the manitous his grandparents. The Land is still alive today for the Indian people and is a relative – Mishakamigokwe (Earth Woman), their great grandmother – so it is easy to see how wrenching the loss

of land is to the native people and why they are persistent in urging that She must not be exploited, but loved and listened to as an Elder.

Humans could gain powers from the manitous, and the most powerful humans, those with the most ability to communicate with the manitous, had the ability to transform themselves into the form of a manitou. Figure 8, a pictograph from Sassaginnigak Lake, Manitoba, shows two medicine men transformed into birds, woodpeckers or kingfishers, playing the medicine drum.

The rock paintings are in danger. Some have graced the rocks for hundreds of years but many are fading away with time, and archaeologists have found no way to conserve them. A painting near Dryden, Ontario, disappeared completely when part of the cliff face fell into the lake. Others are the victims of vandalism; they were shot at and spray-painted. A painting on the Bloodvein River in northwestern Ontario was partially defaced by someone who scratched his name into one of the figures. Somebody else tried to chisel an entire painting from a rock face near Vermilion Bay, Ontario.

There are many friends of the rock paintings. Both Manitoba and Ontario have rock art conservation associations made up of more than 200 caring people, both native and non-native. But there are not enough people to monitor every rock face, and our only hope to save the paintings is through our own understanding that the sites are a sacred heritage of the Algonkian

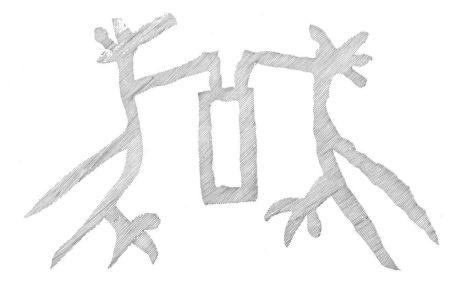

FIGURE 8. SASSAGINNIGAK LAKE, MANITOBA, DEPICTING TWO HEALERS AS BIRDS PLAYING THE MEDICINE DRUM.

people and are among North America's most spectacular archaeological treasures. They are the dreams of the healers who appealed for aid, and their memories of the manitous who reached out to help so long ago.

THE PEOPLE

Algonkian is the principal family of languages of northeastern North America south of the Arctic. The Algonkian peoples traditionally inhabited the region from the Atlantic seaboard through the Canadian Shield to the prairie's edge, and as far south as the Ohio River. The word "Algonkian" is a common term; the people call themselves the Anishinaubeg, a word possibly derived from "anishaw" – spontaneous – and "inaubawese" – human body – hence "spontaneous or original people".[8]

The Algonkian family has several branches, or languages. Among the groups mentioned in 1852 by Ojibway historian William Warren were the Ojibway, forming the most numerous branch, living across northeastern Ontario to Lake Superior. The Cree lived north and west of them on the Shield and into the Hudson Bay Lowlands. The Odawa, ("traders", accent on the second syllable) traditionally inhabited Manitoulin Island and the Bruce Peninsula of Ontario and acted as middle men in trade between the Algonkians of the north and the Iroquoians and Europeans to the south.

Other groups include Odishkwagumig ("last water people"), also known as Algonquins, along the Quebec-Ontario border; Waubunukig ("eastern earth dwellers"), known also as the Delaware, on the Atlantic shoreline; Shawnee ("southerners") in the Ohio River area; Illini ("the people") in the state named after them; the Pottawotami ("those who keep the fire") in Michigan; Maumee or Miami ("people who live on the peninsula") of southern Michigan; Menomini ("wild rice people") at Green Bay in Western Lake Michigan; Sauk ("those who live at the entry") also at Green Bay; and Fox or Otagamig ("those who live on the opposite side") south of Green Bay. The last two may have been named from their former locations in Michigan, the Sauk at the mouth of the Saginaw River and the Fox across the water on the southeast shore of Saginaw Bay. Out on the plains were the Blackfeet, Cheyenne and Arapaho.

In the midst of the Algonkian world, in upper New York, southern Ontario and southern Quebec, was a small human island of Iroquoian speakers including the Five Nations and Huron, Petun and Neutral confederacies, surrounded by Algonkians. Relations between the two language groups was both friendly and hostile: for instance, the Huron carried out lively trade with

the Algonkians but the western Neutral carried on longterm war with the Algonkian groups of Michigan and Ohio. The Five Nations of upper New York waged war in the 17th century with nearly everybody else in efforts to secure a foothold on the fur trade. The Iroquois wars caused ripples of fear throughout the Great Lakes, sending many Ojibways southwestward beyond Lake Superior and into the hands of the equally hostile Dakota, or Sioux, in Minnesota. Wars lasted until the mid-1800s in these western lands but the Ojibways prevailed and remain today in northern Wisconsin and Minnesota. In Canada, they also spread west of Lake Superior as far as the prairies.

The locations of these groups constantly shifted, especially after the onslaught by the Iroquois in the 17th century, but it is generally agreed that the people who painted the rocks were mainly Cree and Ojibway speakers.[9].

Authorities debated the origin of the word Ojibway for centuries. American Indian agent Henry Schoolcraft thought it was related to "ojib" – puckered or drawn up – and "bwa" – voice – and denoted a peculiarity in their way of speaking, but Warren disagreed, pointing out that there isn't the slightest puckering up to be done when speaking Ojibway. Elders told him that the word refers to the old style of moccasin that had a puckered seam running over the top of the foot. However, Warren disagreed again, offering the notion that the word is made of "ojib" – puckered up – and "ubway" – to roast, referring to the treatment their captives received, roasting until puckered up.[10] In the 1660s, an Ojibway war party captured a Shawnee near Carolina and transported him all the way to Sault Ste. Marie to burn him but they eventually released him and the Shawnee made it back home, a close call.[11]

Warren said the traditional Indian view is that the tribes enumerated above were not the original groupings of the Algonkian family. Lack of constant communication for generations produced the different but related languages. The real divisions were not by language but by clan, or do-dem – whence the English language received the word totem – each clan represented by an animal, fish or reptile. Marriages never took place between people of the same clan even if they belonged to different tribes because they considered themselves related by blood and called each other brother and sister. Some of the clan signs may appear on rock paintings (see Figure 2).

There were five original Ojibway clans: Fish, Crane, Loon, Moose and Marten. By the 19th century, the clans had grown to about 20, including Bear, Caribou, Otter, Beaver, Lynx, Rattlesnake, Hawk, Gull and Sturgeon.[12] Cranes considered themselves the orators of the tribe while Bear clan members were the war chiefs and warriors, keepers of the war pipe and club.

The Algonkian tribes, though separated by hundreds of miles of water

and bush, continued to communicate and shared both traditions and cere-
monies. They told similar legends, with local variations, about similar mani-
tous. The Midewiwin, usually translated as the Grand Medicine Society, was
conducted by the Ojibway, Shawnee, Miami, Menominee, Odawa and oth-
ers, and songs of the society were traded among them widely. A Shawnee
medicine song was known among the Odawa. Other songs about Walpole
Island in Lake St. Clair and the rapids of Sault Ste. Marie were sung in
Minnesota. Other traditions connected with medicine, including the Shaking
Tent, dog sacrifice and picture writing, were also widespread, and character-
ize a general Algonkian culture flourishing across a vast rocky, watery space
from Quebec to Saskatchewan and Ontario to Ohio, enhanced by local def-
initions and variations.

Exchange of ideas among the native groups is ancient in the northeast.
For instance, the concept of burial mound-building which arose a little over
2,500 years ago in the southern Great Lakes-Ohio River area reached north-
western Ontario by 2,000 years ago. Goods from the Ohio valley, including
a medicine man's sucking tube made of Ohio pipestone[13] (Figure 9), are
found along the shores of the Rainy River. Not only the tube but also the con-
cepts of medicine must have been shared among those people. Some archae-
ologists suggest that aspects of the Midewiwin were practised by the Ohio
mound builders that long ago, and we also must admit the possibility that
those aspects were also shared with the people of the north who were then
engaged in a lively trade of their Lake Superior copper southward.

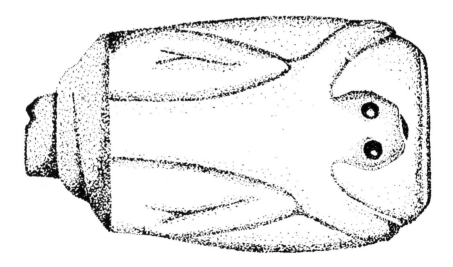

FIGURE 9. HEALER'S SUCKING TUBE FROM THE RAINY RIVER WITH A FROG OR TOAD IN RELIEF.
COURTESY OF THE ROYAL ONTARIO MUSEUM, TORONTO, CANADA.

The Ohio mound builders (archaeologists call their cultures "Adena" and "Hopewell") used stone plaques as palettes for red ochre paint applied to the deceased before burial, probably as signs on the skin.[14] The concept of applying red paint to the deceased goes back to the first people to arrive in North America, the Palaeo Indians, who sometimes covered their deceased with paint, but evidence for the use of painted signs is found first in the mound builders' cultures of about 2,000 years ago in Ohio. The idea may have reached northerners at that early date, and the possibility that the Algonkians of the Canadian Shield so long ago added their own touch to the tradition by painting signs on the rocks will be discussed in Chapter 2.

In 1669, Jesuit Claude Dablon visited Sault Ste. Marie where he found a major trading centre of the Algonkian people. At least 16 nations gathered there from north, south, east and west to fish, hunt and trade. He noted that the people at the Sault had a custom of making signs on their skin in connection with dreams. When a child reached the age of 10 or 12, he (or she) received instructions from the parent of the same gender on how to discover a personal manitou. The child then fasted for several days and when the manitou revealed itself the child marked his body with the vision.

One way to begin to comprehend the concepts of Indian picture writing, including the rock paintings, is to understand the character of the languages spoken by the painters. Recent rock art studies have focused on semiotics, an approach that deals in part with the meanings of words as conveyed in signs, symbols and metaphors,[15] and rock art researchers are transferring the linguistic approach to the signs, symbols and metaphors of pictography. In this book, I use the concept of signs to mean a representation of an object – a boat means a boat. By symbols I mean a picture that stands for something else – a boat could stand for the concept of a journey. By metaphor, I mean a picture of something can stand for many related things in a poetic linkage – a boat could mean a journey and a vision quest at the same time. The approach attempts to reconstruct the painters' own world view, and apply that reconstruction to the rock art. Another approach, rejected here, is to assume that hunter-gatherer communities everywhere shared a similar world view so that cross-cultural studies – for instance the use of boat imagery in North America, Europe and Asia – would elucidate a world-wide world view.[16] However, Algonkian languages have a distinctive use of imagery expressing their beliefs that may be very different from hunter-gatherer communities elsewhere. We turn, then, to their languages. Kohl noted in his book about the Ojibways of Lake Superior, "All the thinking and experience of a people are reflected in their language. Language accompanies the entire life and conduct of the Indian; it is like a great collection of commemorative medals."[17]

The Algonkian languages are metaphorical. The words form signs in sound. Ojibway historian George Copway, in describing his mother tongue said it "has music in its words and poetry in their meaning."[18]

The language gives clues to the interpretation of signs on the rock paintings. They don't mean one thing but several, and the observer must, like the poetry critic, have all the possibilities in mind when drawing conclusions about their meanings. Selwyn Dewdney, Canada's foremost rock art researcher, recognized this fact when he said, "The bird form [on a rock painting at Dryberry Lake near Kenora] which I have guessed to be an eagle looks rather more like a loon … However, unlike Gertrude Stein who wrote, 'A rose is a rose is a rose,' the Indian would be more likely to say, 'A bird is a loon is an eagle is a man is a manitou'!"[19]

Copway noted, "After reading the English language, I have found words in the Indian combining more expressiveness. There are many Indian words which when translated into English lose their force and do not convey so much meaning in one sentence as the original does in one word. It would require an almost infinitude of English words to describe a thunder storm, and after all you would have but a feeble idea of it. In the Ojibway language, we say, 'be-wah-sam-moog'. In this we convey the idea of a continual glare of lightening, noise, confusion – an awful whirl of clouds and much more."[20]

Other examples of poetry wrapped in single words include "dodem" meaning family and "odena" meaning town, both of which include "ode" meaning heart. The word for old man is "akiwenzii", containing the word for earth, "aki", indicating he is getting closer to the earth, bent over. A rainbow is "nimkunabkwagan", containing "nimkii", thunder, and "nabkawagan", scarf.

The Ojibways emphasize the shape-changing capacity of both manitous and powerful medicine men and women through the generous use of metaphor, the poetic figure of speech whereby one object becomes another. The metaphor is a common device in their sacred songs, recorded on strips of birchbark and rolled into scrolls. The singers used picture writing, each song signified by one sign. They are often not the exact picture of the subject of the song, a fact that makes interpretation often difficult – it was deliberately meant to exclude the uninitiated but also to add power to the song by providing several levels of meaning, much in the way we think of a poem as being better the more meanings it conveys. For instance, the memory device for a medicine song from Minnesota depicts the Thunderbird but the singer said the song actually refers to Bear![21] This constant use of metaphor causes much trouble when we seek interpretations for the rock paintings, but it constantly reminds us that

Indian thought is poetic and complex, and Indian initiates spent years learning the wisdom of the medicine songs and scrolls.

Another song has the picture device of a bear (see Figure 86), but the words to the song are, "I have tried it. My body is of fire."[22] The singer said that he likens himself to the Bear Manitou, a powerful medicine manitou, and has power by virtue of the megis, the shell symbol of the Midewiwin, shown below the lines running from the Bear's mouth. Bear stands in the medicine lodge where the ceremonies of the Midewiwin take place. In this song, the singer equals Bear equals fire equals powerful medicine, a fourfold metaphor with great power.

The Mide masters sat long into the night discussing their scrolls and comparing interpretations.[23] More meanings brought more power to the scroll. The scrolls could be read in several ways; for instance, a long line on a scroll could depict the steps of the ceremonies, showing the path of the processions and dances. It could also stand for the history of the people, showing the path they took to arrive at their present homes. It could also depict the history of the religion, showing the path the manitous took to bring medicine to the people. But it also could display memory devices for the teaching of Ojibway ethics, showing the right Path of Life. And it could stand for all four at once.[24]

Ojibway writer Basil Johnston says that the stories too are not to be read literally; there are four degrees in the operation of the mind, and "listeners are expected to draw their own inferences, conclusions and meanings according to their capacities." [25] The same must be true for the rock paintings, and a master of the Midewiwin would coach us, "Go ahead. Try to understand the paintings. But once you've found one meaning, go back and find more." Thus the paintings, like the scrolls, are living things that continue to challenge us.

The use of metaphor makes the sacred signs difficult for the uninitiatied to interpret. The Mide candidate copied his master's song scrolls, but he was allowed to change the arrangement and compose new songs. W. H. Hoffman, who recorded the ceremonies and songs of the Minnesota Ojibway in the late 19th century, noted, "It is for this reason that a Mide is seldom, if ever, able to recite any songs but his own, although he may be fully aware of the character of the record and the particular class of service in which it may be employed."[26]

Hoffman observed the above in the 1880s in Minnesota. George Nelson, a fur trader with the North West Company in the first two decades of the 19th century found a singer in northern Wisconsin who could interpret a scroll written by a stranger. When Nelson asked him how he did it, he replied,

"The same as you do reckon your papers. See, this one is meant for Thunder, that, the Earth, etc. but I only know a few of these songs; the possessor of this bag knew a great deal – he was a great medicine man."[27]

In the early 20th century the scroll symbols gradually became common to many practitioners and several were decipherable by Mides over a wide geographical area in Wisconsin, Minnesota and Ontario.[28]

The close similarities between the symbols on the scrolls and the rock art figures, and the translations of the Mides' songs should lead us in the right direction toward an interpretation of the paintings, perhaps not to the exact word-for-word meaning but at least to "the character of the record and the particular class of service" in which the paintings were employed.

But a person speaking the English language misses out on the poetry in even discussing the figures. Copway noted that Ojibway is a natural language derived from the land on which it is spoken. The pronunciation of the names of animals are the very sounds they produce: great horned owl is "o-omis-eh", owl is "koo-koo-ko-ooh". Rapids are "saah-see-je-won". "See" is the sound of the waters on the rocks and "sah-see" the commotion of waters. He concludes, "Our orators have filled the forest with the music of their voices, loud as the roar of a water-fall, yet soft and wooing as the gentle murmur of a mountain stream."[29]

The language also has the cutting edge of humour, the Ojibway's constant companion in hard times. It is obvious that wherever the Indians are, no matter how far they have to go or how far they are pushed, they are never far from a good joke. This explains their favourite manitou, Nanabojou, who is both the giver of medicine – the gift of life – and a bumbler at the same time. He once slipped and fell on the shore of Lake Superior, leaving a deep impression of his rear end in the rock. Nanabojou, of course, was not injured; he got up and laughed. He left his impression there to give passers-by in future generations a good laugh too. After all, laughter is the best medicine.

A case in point of the use of humour to heal a painful situation: two chiefs went on business to Washington in about 1850 and they were invited to dinner. Being seated for the first time "at table" they began to eat the things set before them. One, seeing some interesting yellow sauce in a bowl, took a spoonful of the hot mustard and swallowed it. Tears began running down his cheeks and his companion asked, "Brother, why do you weep?"

Not wishing to show weakness, the first replied, "I am thinking about my son who was killed in battle."

The second chief then took a spoonful of mustard and he also began to cry. The first asked him, "Why do you weep?"

Came the reply, "Because you were not killed in battle along with your son!"[30]

THE MEDICINE

Dreams were the vehicles for the journey to the manitous' homes. Thus, one observer noted that the Ojibways "go to school in their dreams."[31] In the traditional Indian world, the dream world was more real than the waking one. In that state, the Indian first met his guardian manitou when, at about 12 years of age, he or she fasted. The medicine men travelled in dreams to the cliffs[32] where the manitous gave them songs to use when collecting the medicines, mixing them into prescriptions and administering them to the patients. The people also received dream songs for hunting and war medicine. In 1637, Jesuit missionary Paul Le Jeune met an Algonquin medicine man named Pigarouich who sang one of his hunting medicine songs for him which he learned in a dream. He asked Le Jeune for his songs in return.[33] Figure 10 is a hunting medicine pictograph from Deer Lake in northwestern Ontario depicting the animal with a lifeline to the heart, so that the hunter may gain control of it, and a circle-within-a-circle, a sign for medicine and a feast.

The songs were absolutely necessary because they gave the medicine its power to act: music was the link to the spirit world, so the songs, drums, rattles and tinkling cones of the medicine men and women were sacred items, considered animate in the Ojibway language and treated with the utmost respect.[34] Figure 11 depicts two healers with a drum and rattle and Figure 12 is a panel from Agawa Rock on Lake Superior portraying two healers with their rattles.

The dreamers did not reveal to the general public the knowledge and songs received in dreams except in exceptional circumstances. Often they would draw signs of their dreams on their clothing and their bodies, but the

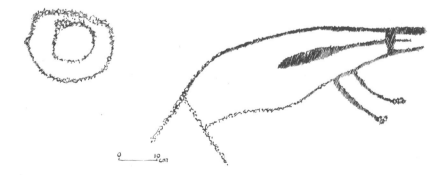

FIGURE 10. HUNTING MEDICINE PAINTING FROM DEER LAKE, NORTHWESTERN ONTARIO.

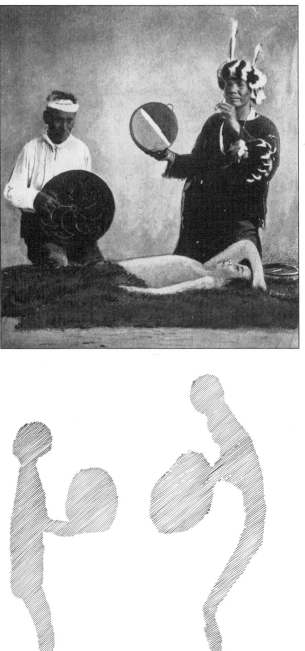

FIGURE 11. HEALERS WITH A DRUM ON THE LEFT AND A RATTLE AND SUCKING TUBE ON THE RIGHT. SMITHSONIAN INSTITUTION, NATIONAL ANTHROPOLOGICAL ARCHIVES.

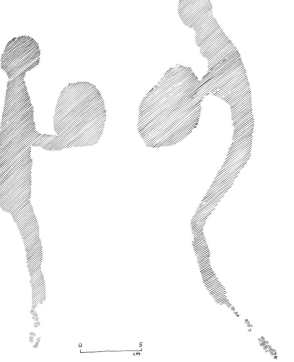

FIGURE 12. TWO HEALERS WITH RATTLES AT AGAWA ROCK.

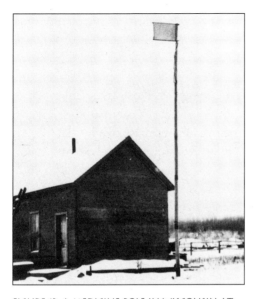

FIGURE 13. A MEDICINE POLE IN WISCONSIN AT THE TURN OF THE 20TH CENTURY. SMITHSONIAN INSTITUTION, NATIONAL ANTHROPOLOGICAL ARCHIVES.

meaning of the dream signs remained a secret until such time as the dreamer wished to disclose the vision and use its power. They also raised banners on medicine poles, resembling flags (Figure 13), to act as charms and to let others know, in pride, that the owner received powers. An old man in northern Wisconsin in the last century named Kitchi-odjanimwewe-gizhig (Sky in Terrible Commotion) said that, when he was a boy, he fasted and dreamed of a bird. It was a warrior's dream but, as he never went to war and didn't have need for the power of the song imparted by the dream, he erected a medicine pole near his home and drew on the cloth banner a picture of his dream (Figure 14) so it would be known to the white people far away, impressing upon them the power of "the song that was never sung".[35]

The rock paintings are dream signs too, and no doubt had accompanying medicine songs. If we could hear a rock painting as well as see it, we would hear music. We are expected to know enough about the signs to appreciate them, to understand the general context and the purpose for which they were done, and to recognize many of the figures proudly painted for all to see in such brilliant red paint. But the painters' songs, like that of Sky in Terrible Commotion, will never be sung again.

Although nearly everybody in Algonkian society received power in their dreams, some acquired more than others. Some received superior skill in hunting or gaming, but the ability to cure was most prized.[36]

FIGURE 14. A DREAM SIGN ON A MEDICINE POLE. SMITHSONIAN INSTITUTION, NATIONAL ANTHROPOLOGICAL ARCHIVES.

Copway met a woman in 1842 in northern Michigan who told him that she fasted and dreamed when she was young. Shahwonoequa (Southern Woman) went to a cave near the Pictured Rocks on the Lake Superior shoreline of northern Michigan, a place where the cliffs of the Upper Peninsula are naturally sculpted into fantastic shapes by the great lake's waves. She made a soft seat of cedar boughs in the cave and pulled her fur robes around her for warmth. Then she sang until sleep came on. She repeated this for days.

As she fell asleep one time, a young warrior approached and said: "Woman, I have watched you for three days and now I come to speak to you. What do you want? The furs from the woods, the plumes of rare birds, the animals of the forest, or knowledge of the properties of the wild flowers?"

"Young man," she replied, "I know your fathers are the manitous of the earth. I don't want the furs, the plumes, or the animals. I want knowledge of the roots so I can relieve the suffering of my people.

"I loved to gather the flowers until I learned there is life in them and the power to impart it. Then I hurried here to learn the secrets of the herbs and flowers. I fasted here in seclusion, waiting for your fathers to teach them to me."

After ten days fast, Shahwonoequa returned home, and when Copway met her in 1842, she was a famous medicine woman.[37]

The medicine consisted of both the knowledge of the plants and minerals and the songs to accompany the gathering, mixing and administering. Maingans (Little wolf), a medicine man from northern Minnesota in the early 20th century, told a researcher that a medicine called Bizhikiwuk (Cattle or Bison), used partly to stem the flow of blood from a wound, had its origin in a dream.

A healer dreamed he saw horned animals resembling cattle under the water. They came up and talked to him, telling him how to prepare the medicine. The medicine man composed a song to persuade the manitous to return to him whenever he needed their power, and he sang it whenever he dug the roots or prepared the medicine. He taught it to others who also always sang the song when preparing the medicine.[38] A rock painting at Cow Narrows, Saskatchewan, (Figure 15) depicts a bison conversing with a man, as shown by the lines running from the eyes and mouth, a reference probably to Bizhikiwuk medicine. This medicine, apparently widely used, was mentioned in ethnographic reports among the Algonkian peoples of northern Michigan and Wisconsin as well.[39]

There are hundreds of Indian medicines. A researcher recently compiled a list of the known medicines of the North American Indians, and they constitute two thick volumes. Healers travelled great distances to obtain knowl-

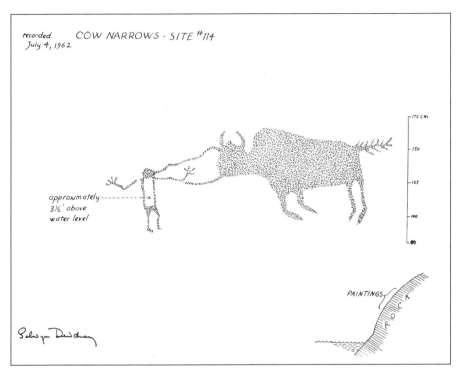

recorded July 4, 1962 COW NARROWS - SITE #114

approximately 3½' above water level

PAINTINGS ROCK

FIGURE 15. MEDICINE MAN AND BISON AT COW NARROWS, SASKATCHEWAN. THE PAINTING PROBABLY REFERS TO THE BISON MANITOU GIVING BIZHIKIWUK MEDICINE TO A HEALER. COURTESY OF THE ROYAL ONTARIO MUSEUM, TORONTO, CANADA.

edge of the plants and minerals and spent years in apprenticeship. The work of the healers has often been described. Claude Allouez, a Jesuit priest, travelled from Quebec to Georgian Bay in 1665 with the Odawa. At Lake Huron, he saw Odawa healers treat eight young men burned when a powder keg accidently exploded. They sang, conducted ceremonies, then administered the medicines and healed all the young men except one who later died.[40]

As late as 1974, Indian medicines were still at work. Gilles Tassé, a Quebec rock art researcher, was doing field work when the following happened:

> One of our students was given a small dog (called Maskwashish, Little Bear, because it was all black). The poor animal was very lean and always hungry. Intestinal worms were suspected. Jeremie [a cook at their camp] burned some poplar bark on the kitchen range, reduced it to powder between a hammer and the flat of an axe, and mixed it into the dog's food. After a few minutes, the worms were energetically expelled from both ends!

Maskawashish had a habit of sleeping on a black bear skin carpet. Being so black, he was walked on two times by tall men, and went crawling like a toy with half-broken wheels. Jeremie boiled the leaves of a plant growing nearby and bathed the little one's legs in it. The next day he was in perfect shape and running around.[41]

Traditional medicine also included the use of a "sucking tube" to draw evil from the body of a patient, as the healers believed that some diseases were caused by foreign objects or spirits invading the sick person. The concept is ancient; sucking tubes are found on Algonkian archaeological sites at least 2,000 years old. Figure 9 is a sucking tube, found on the Rainy River that flows between Minnesota and Ontario, in a context dating to about 2,000 years ago. The tube portrays a frog or toad in relief. Toad Woman was a form of Nokomis (accent on the first syllable), meaning Grandmother, and she was the healer of the manitous when they were injured.[42]

Three types of medical practitioners worked among the Algonkians. The oldest religious society and most respected among the Ojibway, Odawa and others is the Midewiwin (pronounced Mee-day-wi-win, accent on the "day"), often known as the Grand Medicine Society, but more correctly translated as the "Society of Good Hearted Ones" and "The Resonance" in reference to the drums and songs associated with it.[43] It had eight degrees and a candidate often spent years learning traditional lore, Indian philosophy and ethics, plus the use of medicines. A man of the society was called a Midewinini ("Mide man"), or Mide (pronounced Mee-day) for short, and a woman was called a Midekwe ("Mide woman"). Their long training in ethics showed in their demeanour. One researcher said she could recognize a member without being told because they invariably were kind, calm, dignified and respectful people, hence the "society of good hearted ones". The society's aims were to bring health and long life to the Ojibways and to preserve traditional knowledge.[44] The Mides used picture writing on birchbark scrolls (Figure 16) to provide themselves with memory devices to use when remembering the intricate rituals and hundreds of songs of the society. One Mide possessed more than 200 songs.[45]

The Jiissakid or Jiisakii anini,[46] another type of medical practitioner, was proficient in communicating with the manitous and therefore he conducted the Shaking Tent ceremony (Jiissakiiwin) in which the Jiissakid entered a small, tubular, bark lodge and summoned the manitous. They often revealed curing methods.[47] This type of practitioner was known among many Algonkian groups including Cree, Ojibway, Odawa and others.

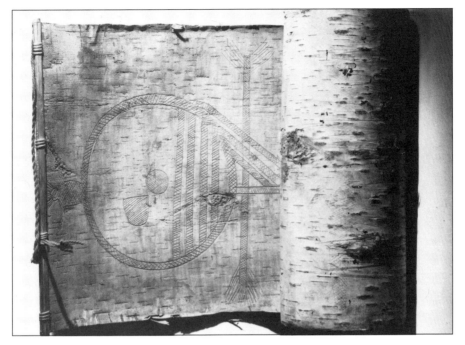

FIGURE 16. A BIRCHBARK SCROLL OF THE MIDEWIWIN. COURTESY OF THE ROYAL ONTARIO MUSEUM, TORONTO, CANADA.

The third type of healer was a Wabeno. The Wabeno was believed to be the most recent form among the Ojibway and may have come from members of the third degree of the Midewiwin who were dissatisified with that organization. Many people feared the Wabeno whom they believed conducted "bad medicine" to inflict harm or death on their enemies, using their powers learned in the Midewiwin for their own gain instead of the benefit of the people. [48]

Both the Mide and the Jiissakid did rock paintings. The characteristic lodges of each practitioner are shown in the paintings, the Mide's long lodge, the Midewigan, where ceremonies of the society took place (Figure 17), and the Jiissakid's little bark conjuring lodge where the manitous met him (Figure 18). These appear on paintings on Lake of the Woods, Ontario, (Figure 19) and Uskik Lake, Saskatchewan (Figure 20).

Maria Seymour of the Ojibway cultural centre in Kenora and Walter Red Sky from Shoal Lake on the Ontario-Manitoba border both identified a rock painting at Picture Rock Island on Lake of the Woods (Figure 21) as Midewiwin. The turtle is Mikinak, the messenger and translator. The snake is "the Great Spirit and lightning"[49] and possibly also a clan name.[50]

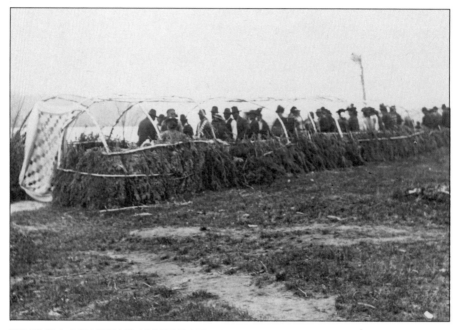

FIGURE 17. A MEDICINE LODGE OF THE OJIBWAY MIDEWIWIN IN NORTHERN MINNESOTA AT THE TURN OF THE 20TH CENTURY. SMITHSONIAN INSTITUTION, NATIONAL ANTHROPOLOGICAL ARCHIVES.

FIGURE 18. A SHAKING TENT WITHOUT ITS BARK COVERING AT KAPISKA, JAMES BAY, IN THE EARLY 20TH CENTURY. HUDSON S BAY COMPANY ARCHIVES, PROVINCIAL ARCHIVES OF MANITOBA.

FIGURE 19. ROCK PAINTING AT PAINTED ROCK ISLAND, LAKE OF THE WOODS, DEPICTING THE RECTANGULAR FLOOR PLAN OF A MIDE LODGE (CENTRE RIGHT) WITH A PATHWAY LEADING OUT THE WEST DOOR. COURTESY OF THE ROYAL ONTARIO MUSEUM, TORONTO, CANADA.

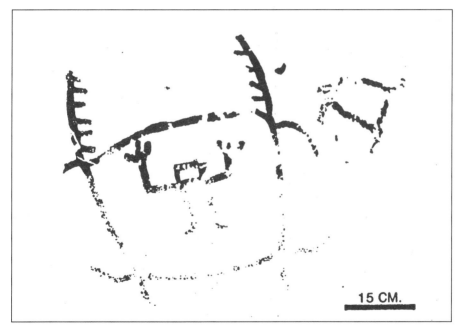

FIGURE 20. USKIK LAKE, SASKATCHEWAN, DEPICTING A MAN IN A SHAKING TENT AND AN ANIMAL MANITOU APPROACHING THE TOP OF THE STRUCTURE WHERE IT WILL ENTER. COURTESY OF TIM JONES.

Algonkian metaphorical thought allows for all three at once in picture writing. The lattice figure is a sign for the Midewiwin society itself,[51] depicting the degree in the society to which the painter belongs.[52] These interpretations agree with that recorded in the last century by W. J. Hoffman for a Mide's birchbark song scroll from Red Lake, Minesota, (figure 22) in which the lattice figure is interpreted as the Midewiwin.[53] The same figure appears on a Mide scroll photographed in Minnesota in the 1930's (Figure 23).[54] Similar figures recur on rock paintings across the Shield (Figures 24 to 27).

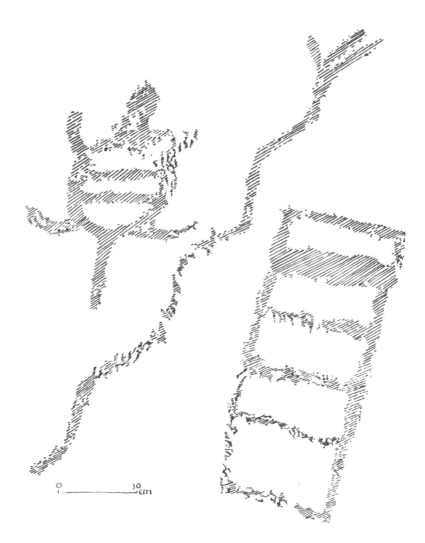

FIGURE 21. A MIDEWIWIN ROCK PAINTING AT WHITEFISH BAY, LAKE OF THE WOODS. THE LATTICE FIGURE AT RIGHT IS A SIGN FOR THE MEDICINE SOCIETY.

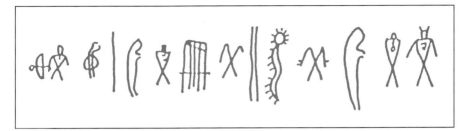

FIGURE 22. A BIRCHBARK SONG RECORD FROM MINNESOTA DEPICTING THE MIDEWIWIN AS A LATTICE FIGURE (CENTRE).

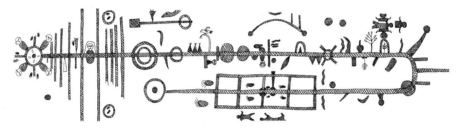

FIGURE 23. A BIRCHBARK SCROLL FROM NORTHERN MINNESOTA SHOWING THE PATHWAY OF THE MIDE CEREMONIES LEADING TO A SIGN FOR THE MIDEWIWIN (LOWER CENTRE).

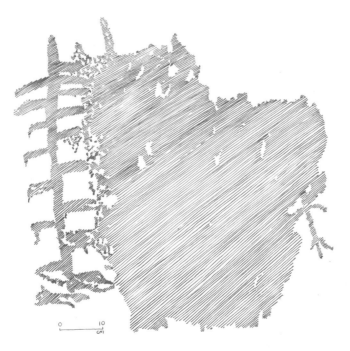

FIGURE 24. KESO POINT ON THE FRENCH RIVER IN NORTHEASTERN ONTARIO, DEPICTING THE LATTICE SIGN OF THE MIDEWIWIN AND A SMEAR OF RED OCHRE. THE PAINT WASH DENOTES THE SPECIAL SPIRITUALITY OF THE SITE.

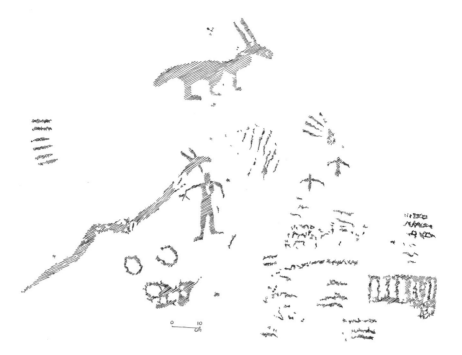

FIGURE 25. WIZARD LAKE, NORTHEASTERN ONTARIO, DEPICTING THE LATTICE FIGURE OF THE MIDEWIWIN (LOWER RIGHT).

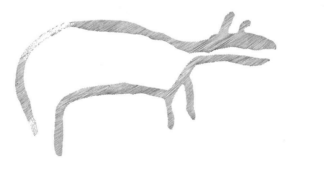

FIGURE 26. KNEE LAKE, MANITOBA, DEPICTING THE LATTICE SIGNS OF THE MIDEWIWIN AND THE BEAR MANITOU, A POWERFUL GUIDING SPIRIT OF THE MEDICINE SOCIETY.

FIGURE 27. MAMEIGWESS LAKE, NORTHWESTERN ONTARIO, DEPICTING A LATTICE FIGURE, EITHER THE SIGN OF THE MIDEWIWIN OR A SHAKING TENT OF THE JIISSAKID.

THE MANITOUS

There were many manitous. Algonkian world view is generally circular, the medicine wheel, with the good manitous inhabiting the top half of the circle, in the heavens and on Earth, and the bad manitous the bottom half, below ground and underwater.[55] The Algonkian universe was layered with Sky, Earth, Underwater and Underground being distinct worlds connected in places such as deep lakes, whirlpools, caves and crevices where a man or manitou could travel from one realm to another.[56] The places where these realms meet, such as the base of a lakeside cliff where sky, earth and water and underground touch, (Figure 28), was the "home of the manitous."[57]

Kitche Manitou, the Great Spirit, was the highest manitou, equivalent to the Christian God, who was responsible for the creation of all things. An anonymous reviewer of this book suggested that the term Kitche Manitou, often spelled Gitche Manitou, was a term written down by the early missionaries and is commonly used, but the correct term is Ge Jem Manitou which means the benevolent spirit who made and watches over everything.

Nanabojou (also called Menabojou, Wenabojou, Nanabush and Weesakejock), as the messenger of Kitche Manitou, made the Earth and

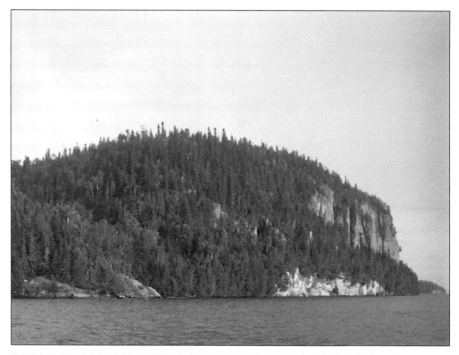

FIGURE 28. SITE OF A ROCK PAINTING AT NIPIGON, ONTARIO, A SPECTACULAR CLIFF THAT IS A MEETING PLACE OF SKY, EARTH, WATER AND UNDERGROUND. COURTESY OF ONTARIO MINISTRY OF CULTURE, TOURISM AND RECREATION.

stocked it with animals. He brought medicine to the people as the foremost medicine manitou, but he was the consummate buffoon too, who brought laughter as well.

Among the good manitous were the Four Winds and Thunderbirds (Pinasiwuk) of the sky realm, and Bear (Makwa) and Wolf (Myeengun) of the earthly realm. The evil manitous included Great Lynx (Mishipizheu) and Horned Snake (Ginebik) of the underground and underwater realms (Figures 6 and 29). But every creature – bird, mammal, reptile or fish – was represented in the manitou world by a "master" animal. For instance, whenever an animal was killed in the hunt, such as a moose, the hunter had to thank the Moose Manitou for providing him with a meal for his family. Among them all, and between the manitous and the people, was Turtle (Mikinak) whose importance lies in his role as messenger between the manitous and the people,[58] and translator among the manitous who speak many different languages.[59]

A white man once had the rare privilege of meeting the manitous. In 1820, fur trader George Nelson was asked if he would like to attend a Cree

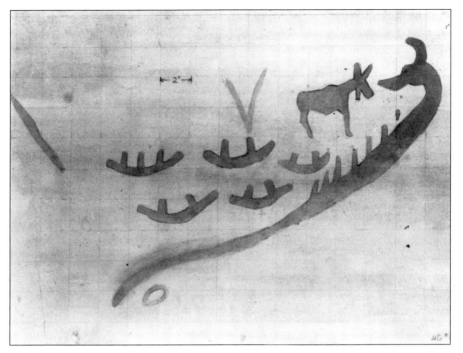

FIGURE 29. A HORNED SNAKE AT DARKY LAKE, QUETICO PROVINCIAL PARK, ONTARIO.
COURTESY OF THE ROYAL ONTARIO MUSEUM, TORONTO, CANADA.

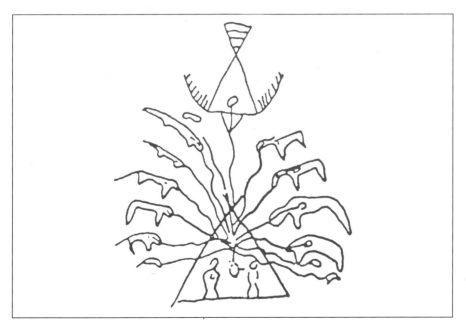

FIGURE 30. BIRCHBARK RECORD OF A SHAKING TENT CEREMONY, THE ANIMAL MANITOUS
ENTER THE TENT WHERE TURTLE (CENTRE) IS TRANSLATING

Shaking Tent ceremony, a form of seance in which the manitous appeared. The ceremony was conducted by a Jiissakid, or medicine man with the best ability to communicate with the manitous, called by the Cree "The Dreamed". The Jiissakid, tightly bound, was placed inside a small tubular bark lodge, big enough for one person, made of six poles. The audience sat in a ring around the lodge. He then called the manitous to ask questions about medical practice, the welfare of absent friends and dead relatives and to predict the future.[60] The manitous entered through the open roof of the lodge, causing a violent shaking of the tent as the powerful spirits crowded in (Figure 30). Nelson gave an account of the conversation inside the tent, often humorous, with the spirits stepping on each other inside the small space and quarreling in several languages until Weesakejock (the Cree Nanabojou) entered and imposed peace. Mikinak could be heard translating and Nelson described him as a "jolly, jovial sort of fellow" who entered the tent first. Buffalo spoke a language unfamiliar to the Cree listeners. Pike and Jackfish spoke French, Sun spoke English, and Dog spoke perfectly distinct Cree.

The ceremony continued for more than three hours, with much banter between the audience and the manitous, and the Jiissakid invited Nelson into the tent during the ceremony to see the manitous for himself. Nelson recalled the following:

> About midnight the Conjurer addressed me and asked if I wished to see any of them (the Spirits). I accepted the offer and thrust my head underneath, and being upon my back I looked up and near the top observed a light as of a Star in a Cloudy night about 1 1/2 inches long and 1 broad; tho' dim, yet perfectly distinct. Tho' they all appear as lights, some larger and other smaller, this one was denominated the Fisher Star, the name by which they designate the Plough, I believe we call it, or Great Bear, from the supposed resemblance to that animal, the fisher.[61]

We also call that constellation the Big Dipper. In 1637, Jiissakids told the Jesuit, Le Jeune, that the manitous in the tent were called "those who make the light" and their eyes are in an oblique line, one above the other,[62] another reference to manitous as star constellations. Le Jeune said he saw big, strong men sweat with exertion when making the tent, shoving the poles deeply into the ground and tightly binding them together, and yet the tent in the ceremony shook so long, even hours, that the missionary was surprised that any human could do it, and concluded that perhaps devils were responsible. The

Jiissakids told him that they became very disturbed during the event: the Earth appeared to open under them and they feared they would fall into an abyss. Le Jeune said they emerged in terror.

CHAPTER 2

DATING ROCK ART

A frequent question about Canadian Shield rock paintings is: "How old are they?" Archaeologists have a tough time with this one because no scientific methods exist akin to radiocarbon dating of wood or bone objects – called "exact dating" techniques – to apply to the rock paintings to get an accurate reading of the date of their creation. Archaeologists must turn to "relative dating" techniques, mainly circumstantial evidence, each scrap of which does not look convincing in itself, but when pieced together, the clues lead to the most probable answer: the tradition of rock painting in the Shield is very old, stretching back 2,000 years.

A useful technique in this "relative dating" game for rock painting researchers is a study of the historic journals and letters of the fur trade period in which missionaries, explorers and Indian agents mentioned rock paintings. Even more useful is archaeological inference generated from the vast array of data gleaned from excavations of Indian encampments in the Shield. The first method takes the tradition of rock painting back to the mid 17th century, about 350 years. Using the analogy of a site excavation, this method allows us to peal off the sod and the top level of earth, maybe five centimetres of soil. The second method goes deep into prehistory, down a metre and back 2,000 years.

To begin at the top, memories remain of people who drew the paintings. The Molson Lake paintings in Manitoba were done by the father of a chief who was still living in the 1880s. Paintings at Hole River, Manitoba, were done by a Mide in 1905.[1] In 1936, a son of a Mide leader on the western side of Lake Winnipeg was named Manzinapkinegewinini (The Man Who Is Painting The Rock).[2] In Saskatchewan, a Lac La Ronge resident who was 79 years old in 1965, told Tim Jones that the paintings were found at the places where dreams occurred to the painters and the figures were their manitous. When in need, the dreamers would go to these places.[3]

In 1972, John Monias told Selwyn Dewdney that Iron Spirit, a shaman his grandfather knew, painted his dreams on the rock at Island Lake in Manitoba.[4]

At Oxford House, Manitoba, researcher C. J. Wheeler was told in 1973 that years previously a woman was very sick. Her family asked an old man named Mistoos Muskego to cure her, upon which he tried many cures but they would not heal her. Finally, the old man said the only hope was to go and ask "the men who lived in the rock" for more powerful medicines. He canoed to a cliff face and used his power to enter the rock, the home of the medicine manitous. They talked for a long time and the old healer was then given a medicine which eventually cured the woman. He said that everyone must remember the men in the rock, and the aid they offered to the people, so he took the people of his band back to the rock face and drew a stick figure with lines running from the head, giving a rabbit-eared appearance.[5] A similar figure is at Crowrock Inlet, Rainy Lake (Figure 31).

The above accounts give an indication of the last times that people painted, the early part of the 20th century. But when did they first paint the rocks? The clues stretch back through the historic period well into prehistoric times. It is clear that the tradition of picture writing on rock is a purely Indian one, uninfluenced by European contact; in fact, that contact helped obliterate the tradition. When Sister Bernard Coleman enquired about the paintings among members of a reservation in northern Minnesota in the 1940s, they said that no one could interpret the characters, but they believed they were messages written by their ancestors.[6]

The most famous memory of a rock painting site in the historic literature is from Sault Ste. Marie. The famous Midewiwin leader, Shingwaukons (Little Pine), who lived at the Sault, told U.S. Indian agent Henry Schoolcraft in the early 1800s of a rock painting at Agawa Rock on the northeast shore of Lake Superior. He said it was the story of a journey across the lake by a Mide he knew named Myeengun (Wolf).[7] He drew his recollection of Myeengun's painting, and the reproduction in Schoolcraft's ethnographic

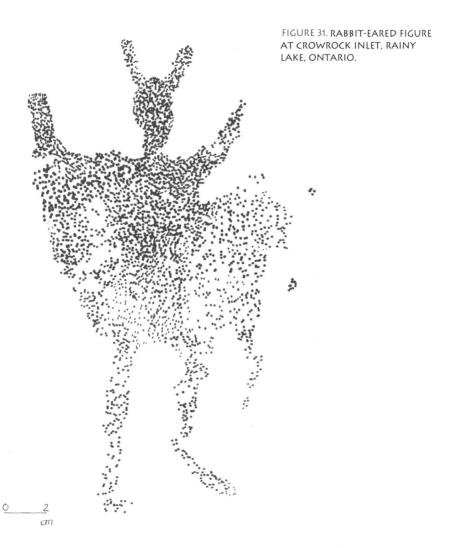

FIGURE 31. RABBIT-EARED FIGURE AT CROWROCK INLET, RAINY LAKE, ONTARIO.

0 ____ 2
cm

reports is clearly a mixture of figures from three separate panels at Agawa Rock. There are thirteen panels at that famous site, however, leaving the question hanging in the air, like Lake Superior fog: "How old are the other panels?"

Several reports of rock paintings show up in the earliest accounts of missionaries and explorers who were sent, following their Indian guides, into the Shield country and beyond, during the first centuries of European-Indian contact, well before Shingwaukons. Explorer Alexander Mackenzie mentioned seeing a painting on the Churchill River system in Saskatchewan in about 1787, but his description is vague. Tim Jones and his colleague, Zenon Pohorecky, recorded five sites in the area that could include the one Mackenzie mentioned.[8] Father Pierre Laure saw a pictograph near the

Manicouagan River in eastern Quebec in 1731. Gilles Tassé, Quebec's rock art expert, has been unable to locate it.[9]

The earliest written account of a pictograph sighting in the midcontinent is from Father Jacques Marquette who travelled to the Mississippi River in 1673 where he spotted one on the river where Alton, Illinois, is located today. His typically biased description in the Jesuit Relations probably refers to a form of Mishipizheu (Mishi=Great; Pizheu=Lynx), often interpreted as the Great Underground or Underwater Wildcat, a figure common throughout central North American iconography, known to both Algonkian and non-Algonkian speakers. The location was called Piasa Rock.

> While skirting some rocks, which by their height and length inspired awe, we saw upon one of them two painted monsters which at first made us afraid and upon which the boldest savages dare not long rest their eyes. They are as large as a calf; they have horns on their heads like those of a deer, a horrible look, red eyes, a beard like a tiger's, a face somewhat like a man's, a body covered with scales, and so long a tail that it winds all around the body, passing above the head and going back between the legs, ending in a fish's tail. Green, red, and black are the three colours composing the picture.
>
> Moreover, these 2 monsters are so well painted that we cannot believe that any savage is their author; for good painters in France would find it difficult to paint so well – and, besides, they are so high up on the rock that it is difficult to reach the place conveniently to paint them.[10]

To trace the age of pictographs further back in time, we leave the safe ground of written accounts and enter the precarious country of archaeological inference. One method compares styles of objects excavated from sites of a known age to similar styles of rock art, and draws the conclusion that rock art can be as early as the objects. For instance, two small but astonishing artifacts were excavated on Odawa sites dating to the early 1600s – several decades before Marquette passed through – on the Bruce Peninsula and Manitoulin Island in Ontario. The Hunter's Point Site on the Bruce, estimated by the site discoverer, William A. Fox, to date to about 1630,[11] produced a brass bracelet with an incised design of a horned snake (Figure 32), similar to horned serpents on rock paintings (Figures 25, 29 and 33).

Earlier still, the Odawa occupied the Providence Bay Site on Manitoulin Island from about 1600 to 1615, and excavations there yielded a small clay

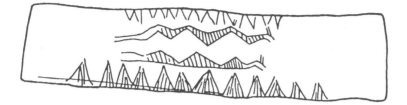

FIGURE 32. A BRASS BRACELET ABOUT 400 YEARS OLD FROM THE HUNTER'S POINT SITE ON THE BRUCE PENINSULA. DRAWING BY WILLIAM A. FOX, COURTESY OF JAMES MOLNAR.

FIGURE 33. SELWYN DEWDNEY'S SKETCH OF A SITE ON WHITEFISH BAY, LAKE OF THE WOODS, ONTARIO, DEPICTING TWO HORNED SNAKES (CENTRE AND FAR RIGHT). COURTESY OF THE ROYAL ONTARIO MUSEUM, TORONTO, CANADA.

pipe bowl with an upraised arm in relief on the side of the bowl.[12] The arms-up sign is everywhere on rock paintings and holds the major key to unlocking the meanings of the paintings. These artifacts are nearly 400 years old and provide the possibility that some of the paintings, so similar in style, are 400 years old as well.

Some may be older. Charles E. Cleland and his colleagues unearthed a remarkable collection of small shale discs from four sites on Lake Huron in northeastern Michigan. Several of the discs are incised with Thunderbirds (Figure 34) like those on the pictographs (Figure 35). The sites were occupied from 800 to 600 years ago, and the Michigan investigators infer that some rock paintings are that old. At least, the discs prove conclusively that several

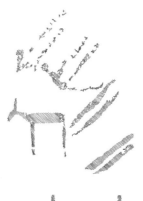

FIGURE 34. SHALE DISC PORTRAYING THE
THUNDERBIRD, ABOUT 600 YEARS OLD,
FROM ALPENA COUNTY, MICHIGAN.
COURTESY OF CHARLES E. CLELAND.

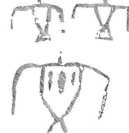

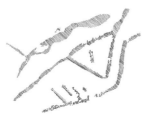

FIGURE 35. THUNDERBIRDS AND SNAKES AT
WIZARD LAKE, NORTHEASTERN ONTARIO.

figures and their associated spiritual context, like those on the paintings, have a time depth in the Great Lakes of at least 600 years.[13]

In Saskatchewan, two archaeologists are using a different inference. David Meyer and S. J. Smailes studied the distribution of the rock paintings in northeastern Saskatchewan and the distribution of archaeological sites of a known age, and concluded that their similar locational patterns in the province is not coincidental.[14] The sites contain prehistoric Cree pottery known to archaeologists as Selkirk, dating as early as about 600 years ago in that province. Thus we can infer, in agreement with the Michigan team's findings, that the rock painting tradition in that province is at least 600 years old.

The dates can be pushed back further. The Selkirk prehistoric culture was one of a number of archaeological cultures that covered the Canadian Shield, from eastern Saskatchewan to western Quebec, from about 1000 years ago to

400 years ago. They were ancestors of today's Algonkian speakers of the same area. The time span is known collectively as the Late Woodland Period. The ancestors of all of these Late Woodland peoples lived throughout the Middle Woodland Period, from about 2,000 years ago to about 1000 years ago; their distinctive artifact assemblages are known to archaeologists as Laurel, and the distribution of Laurel sites[15] is remarkably similar to the distribution of the pictographs all across the shield (Figure 36).

Is it outrageous to infer that Laurel people painted signs on the rocks, that they were the originators of a tradition that lasted for thousands of years? Not really. Valery Chernetsov, a Russian researcher, has dated rock paintings in the eastern Urals by comparing figures on the rock with identical ones on prehistoric pottery from nearby archaeological sites. The pottery is 3,500 years old. The paintings are still on the rock faces of the Urals. Selwyn Dewdney has pointed out that the rock surfaces and climate of the Urals are very similar to the Canadian Shield, so there is reason to assume that some of the Shield paintings can be as old as the Uralic ones.[16]

In Wisconsin, Robert J. Salzer has investigated a painting in a rock shelter in the southwestern part of the state. His excavations of the Gottschall

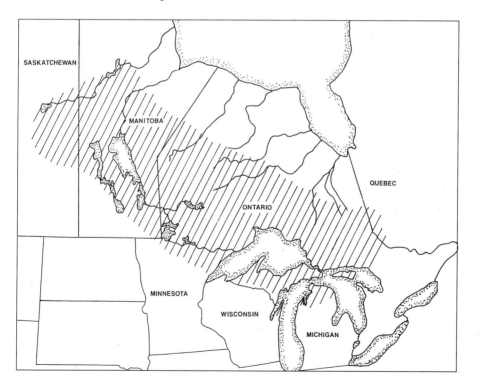

FIGURE 36. THE DISTRIBUTION OF LAUREL SITES, DATING FROM ABOUT 200 B.C. TO A.D. 1,000, IN CENTRAL NORTH AMERICA. COMPARE THIS MAP TO FIGURE 1.

shelter floor unearthed a pigment "splash" identical to that used for the paintings on the walls (Figure 37), and situated immediately below the rock art where it had been dropped during use. The pigment was found with artifacts of known age, about 1,000 to 1,100 years old.[17] The Algonkian Laurel people were just north of them at this time in prehistory, and trade in goods and ideas was far-reaching. The Wisconsin people were painting, so we can infer that their neighbours to the north were painting too.

Moreover, the famous Peterborough Petroglyphs, a rock carving site also known as "The Teaching Rocks" in south central Ontario, may have been created by neighbours of the Laurel people. Hundreds of figures are pecked into the surface of the rock, a horizontal limestone outcrop (Figure 38). The site investigators, Joan and Romas Vastokas, wrote a book about them, pointing out their close resemblance to the figures on the rock paintings of the Shield. In association with the carvings, seven minute pottery fragments were found, the largest measuring two centimetres by one centimetre. These fragments were excavated from the shallow crevices and depressions in the carved limestone. But even the smallest artifacts have their value. One sherd is decorated with "dentate stamps", characteristic of the earlier part of the Woodland Period, and the Vastokases conclude that the carvings can be dated to that time.[18]

The items needed for painting were well known to the Laurel people.

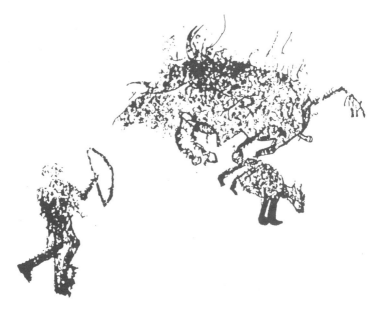

FIGURE 37. A ROCK PAINTING IN THE GOTSCHALL ROCKSHELTER, WISCONSIN, ABOUT 1,100 YEARS OLD. DRAWING BY MARY STEINHAUER, COURTESY OF ROBERT J. SALZER.

Both sturgeon and red ochre abound on their sites. A storage pit in a late Laurel house on a site in Kenora in the heart of pictograph country, contained a red ochre "cup"; the ochre had probably been in a medicine bag that rotted away and left the ochre in the exact shape of the original container. The same house contained a Laurel pottery vessel that sported an incised design, possibly of a plant.[19] The site was the home of a small Laurel band, with three long wigwam-type lodges, housing up to a dozen people each. The lodges were oriented in a fan-shape so that the door of each house, pointing toward the apex of the fan-shape, faced the same object about 20 metres away. This was a large boulder about two metres high, one of many in the area that the Indian people today call "spirit rocks," the residence of a manitou. These Laurel people knew the use of red ochre, were drawing signs, and believed that manitous resided in the rocks. All the elements for a rock painting tradition are at the site in Kenora. On another site nearby, excavators found a large mass of red and yellow ochre in a storage pit dating to the earliest Laurel times.

The use of red ochre is more ancient still than Laurel. Two burials were accidently unearthed in 1989 at Angling Lake Reserve, in northwestern Ontario, during construction of an airport. The mourners had sprinkled the deceased with red ochre before burial. The elders at the reserve can be forgiven for not remembering these graves because the funeral took place 7,000 years ago![20]

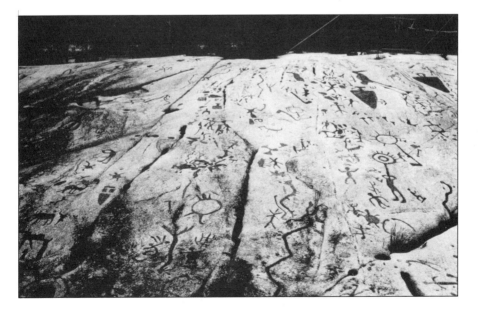

FIGURE 38. THE PETERBOROUGH PETROGLYPHS, A ROCK CARVING SITE PERHAPS 2,000 YEARS OLD IN SOUTHERN ONTARIO. COURTESY OF PETER CARRUTHERS.

The archaeological evidence however, especially the Laurel site distribution across the Shield with rock paintings in the same area, suggests that the tradition of rock painting may be about 2,000 years old. It started with the Laurel people and ended after the Europeans arrived.

The most compelling evidence for the antiquity of some Shield-style rock paintings comes from the Upper Peninsula of Michigan, on the Garden Peninsula that juts into Lake Michigan, separating it from Big Bay de Noc. A steep limestone cliff named Burnt Bluff rises more than 50 metres from the water on the west side of the peninsula. Near its base is a wave-cut niche, Spider Cave, 30 metres long and 10 metres deep. Four paintings are on the walls inside the cave and beside its entrance, three indistinct figures and a fourth human form in red-brown paint (Figure 39). Charles E. Cleland and

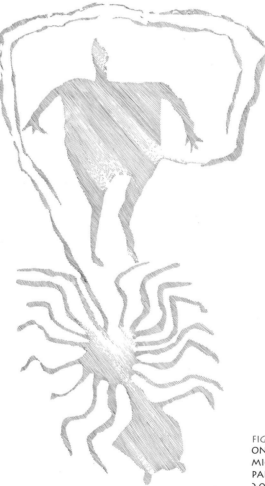

FIGURE 39. THE BURNT BLUFF SITE ON THE UPPER PENINSULA OF MICHIGAN. THIS AND OTHER PAINTINGS AT THE SITE MAY BE 2,000 YEARS OLD.

Richard Peske excavated five small test squares in the cave and studied a local artifact collector's finds, and came up with a startling discovery. About 130 artifacts had been collected from the cave, 105 of them projectile points (spear points or arrowheads).

The archaeologists noted, "Any reader with a familiarity of the materials usually recovered from an archaeological occupation site will note that Spider Cave produced a very unusual assemblage of artifacts." No pottery, stone scrapers, drills, choppers, animal bone or hearths, common on a campsite, were recovered. The vast majority of the finds were stone points. The researchers said, "These facts would be unusual in themselves but are rendered even more remarkable by the huge number of projectile points which were recovered from the very limited excavations."[21]

About 77 per cent of the points had shattered tips from impact with a hard surface like the back wall of the cave, and the archaeologists conclude that they were shot into the cave in some sort of ceremony connected with the site. Several 18th century explorers observed the Ojibway practice of shooting arrows into clefts of certain bluffs as they passed by in their canoes, but the points in Spider Cave are much older than that. Every point with a blunted tip was made during the early part of the Middle Woodland Period when Laurel people and their neighbours occupied the Upper Peninsula. The practice of offering spears or arrows to the cave is at least 2,000 years old, and possibly the practice of leaving dream signs on the walls of Burnt Bluff in the form of rock paintings is that old as well.

Another approach to dating the rock paintings is to study the age of the Midewiwin, some of whose members painted the rocks. The figures on the Mides' paintings can be as old as the Midewiwin itself. However we must keep in mind that medicine men other than Mides, for instance the Jiissakids, also did pictographs.

The age of the Midewiwin is under great debate. Some researchers, mainly non-natives, believe that the society is fairly modern, dating only to about the beginning of the 1700s[22]: a post-contact movement heavily influenced by Christianity, representing new modes of thought, not ancient ones. These arguments rely on some similarities between Christianity and the Midewiwin, including the use of the cross as a sacred symbol: the third (and sometimes fourth) degree post in the Medicine Lodge is a cross. They suggest that the society was formed in reaction to a fear that contact with non-natives would erode native traditions and a strong society was needed to preserve the traditional lore.

Other researchers, mainly native historians, take the view that the Midewiwin is one of the Ojibways' oldest societies.[23] Ojibway writer Basil

Johnston says it was formed in reaction to fears that shamans, working on their own, often used their powers as bad medicine against the people instead of for them, and a strong society was needed to ensure that medicine would be used for the benefit of all and that Ojibway ethics would be widely taught.[24]

Archaeologists tend to agree with the native view of the society's age. The earliest account of a Midewiwin ceremony was by Jesuit missionary Jerome Lalemant who attended in 1642 what he called a "feast of the dead";[25] he didn't recognize it as Midewiwin. He was the first missionary into the northern Algonkian country and the Midewiwin was fully practised before Christianity was introduced to the area.

The Midewiwin had several types of ceremonies and the one Lalemant attended was a funeral ceremony sometimes called the "Ghost Lodge". The day before the ceremony the women made a long lodge, about a hundred paces long with a domed roof, the Midewigan (Mide wigwam). At the beginning of the ceremony they filed in, carrying the bones of their deceased in birchbark boxes decorated with beads, and sat along the long walls of the lodge. Men filed in and danced, then warriors did a dance in complicated patterns after which the women danced. Gifts were exchanged. This closely corresponds to later accounts of Mide ceremonies, always conducted in the long Midewigan that was oriented east-west, and emphasizing the sacred songs and dances of the society, including the complicated dance meant to confuse the evil manitous.[26] In the Ghost Lodge ceremony, the Mide masters exchanged gifts with the people for whom the ceremony was undertaken.

Lalemant repeatedly stressed that the ceremony he attended was very dignified. He talked about the moderation, respect and reserve of the participants: "One would never have thought that he was in the midst of an assemblage of barbarians."[27] This description closely fits that given by later observers of Mide ceremeonies, who invariably comment that the participants were respectful and dignified.

The Midewiwin was widespread among the Algonkians, practised by the Ojibway, Odawa, Miami, Menominee, Illinois, Shawnees and others. Archaeologist Charles Callender suggested we cannot rule out the possibility that aspects of the Midewiwin go back 2,500 years among the Indians of Ohio.[28]

The symbol of the society and of the power of the medicine itself is a tiny white seashell, often a marginella originating on the southeast coast of the United States (Figure 40). These shells, called megis by the Mides, are shown in Midewiwin picture writing in various forms (Figure 41), including a small oval figure with radiating power lines, and it may be on the rock paintings as

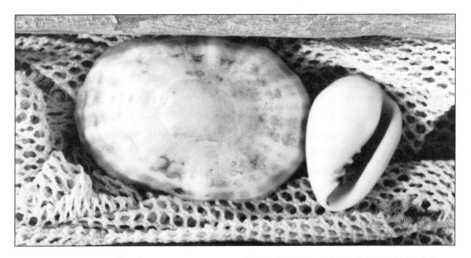

FIGURE 40. A COWRIE (LEFT) AND A MARGINELLA (RIGHT), TINY MARINE SHELLS THAT SYM-
BOLIZED THE MEDICINE OF THE OJIBWAY MIDEWIWIN. THE SHELLS ARE ABOUT THE SIZE OF
THE LITTLE FINGERNAIL. COURTESY OF THE ROYAL ONTARIO MUSEUM, TORONTO, CANADA.

well, possibly at Burnt Bluff (Figure 39). During the ceremonies, the Mides
"shot" the candidates for initiation with the megis and they fell in a swoon as
though dead. Another shot restored them and brought them new life as
Mides themselves. The Mide masters shot the candidate at specific places on
his body.[29] The Burnt Bluff painting may depict the powerful, radiating
megis or medicine entering a medicine man.

The people of the Shield travelled great distances to obtain the shells. The
Odawa (the word means "trader") journeyed throughout the Great Lakes and
surrounding areas, covering vast distances in their bark canoes, exchanging
goods including the shells among the many Algonkian groups.[30] They were
the travelling salesmen of prehistory, and possibly the travelling medicine
show too, bringing rare plants into the Algonkian country from the western
prairies and southern forests.

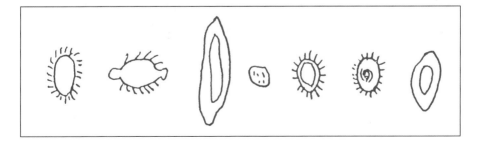

FIGURE 41. MEGIS IN PICTURE WRITING ON THE SONG SCROLLS OF THE MIDEWIWIN.

Basil Johnston says that there is a tradition among the Indians that one band of people travelled toward the Land of Dawn to the sea coast in search of long life which they thought could be obtained there. When they arrived on the ocean shore, they saw a megis shining in the sky like a star and they followed it westward back to their home on the Great Lakes.[31] Could this be a poetic recollection linking Eastern Star = sea = water-of-life = megis, telling a story of an Odawa band travelling to the seacoast to get the shells?

Another characteristic artifact of the society, the birchbark scroll is a purely native concept, dating back before contact with non-natives, and therefore is not an imitation of European books. Kenneth Kidd reported a radiocarbon date for a Midewiwin scroll from Burntside Lake in northwestern Ontario at A.D. 1560+70,[32] about 400 years old. He concludes that a strong case can be made for the precontact existence of the Midewiwin. The scroll was found in a cave among a group of about 200 fragments of birchbark, some with stitching marks from being bound to wooden sticks that formed frames at the ends

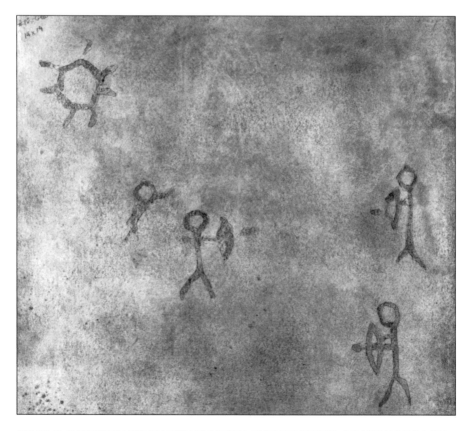

FIGURE 42. BURNTSIDE LAKE ON THE MINNESOTA-ONTARIO BORDER, DEPICTING WAR MEDI-CINE. COURTESY OF THE ROYAL ONTARIO MUSEUM, TORONTO, CANADA.

of the scrolls. One bark fragment has an incised geometric design while the others contain no evidence of design. Also recovered was a heavy stick bearing traces of red paint, and Kidd suggested that the scrolls were originally painted.

It should be noted that Burntside Lake also contains a pictograph (Figure 42) depicting aspects of war medicine. The warriors shoot at each other with their bows and arrows while the Turtle manitou, also in the guise of Sun, is overtop. Turtle was known as powerful in war partly because of his protective shell,[33] but also because the turtle manitou, unlike its earthly counterparts, is swift. We can be sure that the "good guys" on this panel are the ones at the left, protected by Turtle's war medicine.

The painting at Burntside Lake may or may not have originated in the Midewiwin. At least, we know from some of the earliest accounts that the Mides provided war medicine. The Miami Indians of lower Michigan conducted a Midewiwin ceremony in 1686 to ensure the safe return of their warriors who had gone to fight the Iroquois. Thirty days later, one band of warriors arrived safely; they had killed many Iroquois without losing one of their own. The Miami medicine masters told their French visitors, "Believe us, our sort of ceremony has made the Spirit listen to us."[34]

CHAPTER 3

SECULAR AND SACRED PICTURE WRITING

The works of the earliest North American ethnographers are helpful when investigating the subject of picture writing because they collected data when informants still practised the craft; texts written in the 19th and early 20th centuries are emphasized in this book. Some early investigators suggested that picture writing originated in hand sign language,[1] the gestures being picture writing with invisible paint. One observer said that the sign for water, undulating lines drawn in the air by the finger, were afterwards transferred to pictures to denote a river. The semi-circle which the signer described with his hand over his head was put down in pictures to denote sky or day. Some Indians made the sign for a medicine man by raising a hand in a spiral upwards from the head, sometimes with two fingers raised in a 'V' sign.[2] This description fits perfectly a sign on the Annie Island rock painting on Lake of the Woods depicting a medicine man (Figure 7).

The most complete text on sign language was written in 1881 by Garrick Mallery of the Smithsonian Institution. He believed signing was an extremely old tradition in North America despite many Indians' assertions that it originated recently with the Kiowa tribe of the American plains. Mallery

FIGURE 43. OJIBWAY CLOTHING DESIGNS. THE ZIGZAG WAS CALLED OTTER'S TRAIL; THE CENTRAL FIGURE THE HOME OF THE MANITOUS, AND THE LOWER PATTERN OTTER'S TRACK

pointed out that the Iroquois, Huron and Ojibway all used sign language and they very likely did not receive the idea from the Kiowa so far away from them. Some Ojibways denied they had signs but Mallery located informants in Michigan who remembered and supplied him with examples.[3]

The question of which came first, the hand signs or pictures, is a debate not likely to be answered by archaeology. Signs of all kinds have a long tradition and were widespread. Decoration of the body had significance; among the Ojibway, red meant blood (life), and red paint on the body was for long life.[4] Even Indian clothing made a statement. Zigzag lines that edged many Ojibway designs (Figure 43) could be the pattern of lightning or the path of the otter which, when chased, tries to deceive its enemies by varying its course. The zigzag lines were doubled, tripled and overlapped to form cross-hatching and diamonds. Otter's tracks form a long hexagon between diamonds; the animal rises on its haunches to jump, forming the diamonds, then as it leaps it drags its tail making the hexagon. A border of triangles was called "little Ojibway village" and depicted traditional wigwams that had rounded silhouettes but the weaving tended to make them pointed. The Four Winds appeared as a swastika with either straight or spiral arms and Kitche Manitou was in its centre as a circle.[5]

The Thunderbird adorns many modern Indian garments. Formerly, the Ojibways never displayed Thunderbird publicly because of its important role as a messenger of Kitche Manitou bringing rain, thunder and lightning. It frequently appeared on medicine bags either alone or in pairs.[6]

Another old and intricate pattern was "the Home of the Manitous" (Figure 43), the meeting place of sky, earth, water and underground. A hand in the sky represented that of Kitche Manitou and the paw of the Bear, a powerful guiding medicine manitou.[7]

Other designs were not standard but represented individual dreams of the

wearer who displayed them both for protection and in pride of his or her communication with the manitous.[8] The significance of these remained secret, known only to the wearer, and often a man would instruct his wife to embroider a sign on his clothing without telling her why.

A dream was also painted, outlined with beads or embroidered with beadwork on blankets and other possessions of the dreamer, to benefit the dreamer and help others. A man in northern Minnesota in the early 20th century saw a bear in his vision quest when a youth, and he believed that he derived rugged strength from the Bear manitou. As a representation of the dream, he possessed an outline of a bear drawn on white cloth. When his wife was dangerously ill, he spread the cloth over her so she would receive the strength from Bear.[9]

The Indians wrote pictures on wood, stones, copper and birchbark for both secular and sacred purposes. All the people of the band could easily interpret the first type of writing. Secular writing was used by war and hunting parties who left messages along trails recalling an event of great importance that occurred to the group. Lahontan reported in 1703 that, when a party of warriors defeated their enemies, the conquerors would pull the bark off the trees, up to a height of about five or six feet (two metres), at all the overnight camps they made when returning to their own village for the victory celebration. In honour of their victory, they painted certain images with charcoal pounded and beaten with fat and oil. The "arms for the nation and sometimes a particular mark for the leader of the party" were painted on the trees, and the signs would remain there for 10 to 12 years.

Lahontan gives a partial list of the "arms" for the Algonkian nations of the Great Lakes: the Odawa were signified by four moose looking to the four corners with a heap of sand in the middle. The Ojibways of the Sault were indicated by an eagle perched on a rock devouring an owl. The Miami had a bear pulling down a tree, the Pottawotomi a dog lying on a mat. The Fox were known by a winding river through a field with foxes at each end of the river, and the Illini were shown by a beech leaf and butterfly.[10]

The people also left messages along the waterways to those who followed them through the bush to the next encampment. John Tanner, a man with an extraordinary life story, lived among the Odawa and Ojibway in the early 19th century, and learned Indian picture writing. He was a white American boy who was captured by two Odawa and taken from his Kentucky home on the Ohio River when he was about nine years old. They transported him up the Greater Miami River in eastern Ohio all the way to Saginaw Bay in Michigan to be given to the wife of one of the captors as a replacement for her recently deceased son. She treated him abominably, beating and starving

him for a year before he was handed over to another Odawa woman, a well-known and respected medicine woman whom he grew to love as his own mother. He stayed with his new Indian family for most of his life, forgetting his own language and adopting the Indian ways. The family travelled continuously between northern Michigan and the Red River in Manitoba, living off the land in an almost continuous struggle against starvation. Tanner became totally Indian in dress, language and thought. Later in his life, he visited his family in Kentucky but he could not get used to the heat of a house and insisted on sleeping outdoors. The food made him sick and the clothing pinched. Tanner attempted to settle among the whites at Sault Ste. Marie. He stayed there several years but was unable to adjust to the European lifestyle. Through his later years, he gradually returned to the Indian dress until finally he was again totally Odawa in appearance. One night he disappeared, never to be found.

But he stayed in the white community long enough to tell his tale to Edwin James, the local doctor, who wrote a book about him and included examples of picture writing that Tanner knew. Tanner tells of a time on his way to the Red River from his hunting territory:

> As I was one morning passing one of our usual camping places, I saw on the shore a little stick standing in the bank, and attached to the top of it a piece of birch bark. On examination, I found the mark of a rattlesnake with a knife, the handle touching the snake, and the point sticking into a bear, the head of the latter being down. Near the rattlesnake was the mark of a beaver, one of its dugs, it being a female, touching the snake. This was left for my information, and I learned from it that Wa-me-gon-a-biew [Tanner's adoptive brother] whose totem was the Rattlesnake, had killed a man whose totem was the Bear. The murderer could be no other than Wa-me-gon-a-biew, as it was specified that he was the son of a woman whose totem was the Beaver, and this I knew could be no other than Net-no-kwa [Tanner's adoptive mother]. As there were but few of the Bear totem in our band, I was confident the man killed was a young man called Ke-zha-zhoons. That he was dead, and not wounded merely, was indicated by the drooping down of the head of the bear.[11]

The second type of picture writing, the sacred, is more prevalent and has the most significance for the interpretation of the rock paintings, themselves

a sacred tradition. Indian historian, George Copway, noted that picture writing was mostly reserved for medicine songs learned from the manitous in dreams or passed from teacher to student. The pictures acted as memory devices for the songs for hunting, war and healing medicine. Without the songs and accompanying musical instruments, rattles and drums, the medicine was useless as they acted as a direct communication to the manitous who imparted their powers to the Indian. Many of the sacred birchbark scrolls of the Midewiwin recorded the songs.

The famous chief at Sault Ste. Marie, Shingwaukons (Little Pine), had a whole "library" of these scrolls. Unfortunately, before his death, it was said he destroyed "all his birchbarks and painted dreams, songs and dances,"[12] probably in keeping with Mide tradition that one destroyed his works if he felt he had no successor.[13] How wonderful it would have been if he had allowed us to see the "painted dreams" of Shingwaukons! Johann Georg Kohl, a German who toured the Lake Superior area in 1855, was told at Garden River near the Sault that Shingwaukons in his youth dreamed of a manitou, the Sun in human form, who told him he would be a great hero. He was given a pennant as a symbol of his dream (a dream sign on a medicine pole) and he changed his name to Sagadjive-Osse ("When the Sun Rises").[14] Among his accomplishments was a stand alongside Sir Issac Brock at Niagara in the War of 1812, and his family today retains his King George III medal from that battle.

Garden River residents gave Kohl some picture writing that helps us today. Also, in the late 19th and early 20th century, three associates of the Smithsonian Institution – W. H. Hoffman, Garrick Mallery and Frances Densmore – recorded many songs and their pictures with the aid of Ojibway singers. John Tanner, whose mother was a respected Midekwe (Mide woman) also provided his biographer in the 1840s with signs for medicine songs. He called the signs "mezeneneens," little pictures. The word for a painting is "muzzinabigan" and a variant of that word is in Mazinaw Lake that has the largest number of rock paintings in southern Ontario.

The Indians of former centuries based their life on sharing, not buying and selling, with one exception: the knowledge of medicine and the accompanying songs for the collecting, mixing and application of the medicines could be sold. They were never free-of-charge and no one was allowed to take the knowledge and songs without permission. Densmore, a Minnesota music teacher who became intrigued by Indian music when she heard the drums across the waters of the Mississippi River while growing up near a reservation at Red Wing, confessed that once she robbed an Indian of his song. In 1904, she sneaked up behind Geronimo who was singing outside a pavillion at the

St. Louis World's Fair and wrote down the notes to his song. She swore later never to steal an Indian's song again and spent her life recording the music of many tribes, always obtaining the singers' permission and paying for the music as well. The Indians, in return, took pride in the fact that a wonderful tradition would be preserved to help foster an appreciation of their music among both natives and non-natives[15], and their efforts also help us to understand the rock paintings, so similar in style to the pictographs of the songs.

Densmore recorded more than 3,000 songs from Florida to the Arctic Circle, mostly from northern Minnesota. Included are hundreds of Ojibway songs, both the pictures and notes, and all are preserved on tape in the Library of Congress in Washington. One can sit across from the Capitol today and listen to Awunakumigikan from Manitou Rapids Reserve on the Rainy River in Ontario, his clear strong voice still singing with pride 80 years after he sang into Densmore's gramophone.[16]

It is important to understand the enormous contribution of the singers because they considered the singing of one's song and imparting its meaning to be a sacred task, the most serious undertaking. Densmore reported that some medicine men were deeply disturbed by revealing their dream songs to her and couldn't sleep at nights, they were so upset. But they readily agreed to the wrenching task when assured that Densmore meant to help bridge the gap of cultural appreciation between Indian and non-Indian.

But the singers had some fun too, at Densmore's expense. She asked a man at Grand Marais, Minnesota, named Shingibis (a kind of duck) what songs his people sang when hunting. He grinned, "We didn't sing then; we kept still !"[17]

Densmore even tried a couple of songs herself. She observed that Indian singing, unlike European, needs an ability to produce separate tones of different lengths, not by the use of syllables, but by the action of the muscles of the throat. She concluded that non-indians wouldn't be able to sing native music. After her attempt at it, her Indian coach said, "You have the tune alright, but you have not the Indian throat."[18]

Garrick Mallery was a colonel of the American army stationed at Fort Rice on the Upper Missouri River in the autumn of 1876 (that fatal year for Custer) when he obtained a copy of a remarkable series of picture writing on buffalo hide, a calendar of the Dakota nation, known widely today as a "winter count" in which each year was portrayed by a picture commemorating a special event of that year. That work attracted the attention of the Secretary of the Interior and the Secretary of War, who ordered him to report to the Smithsonian to carry out studies of Indian pictography. The result was a two-volume work, published in 1894 entitled "Picture Writing of the American

Indians." It remains today a spectacular work, surely a more productive result than his military career would have given him at the time, considering Custer!

Much of Mallery's discussions of Ojibway picture writing were borrowed from the work of his colleague at the Smithsonian, W. H. Hoffman, who studied the Midewiwin of northern Minnesota and published a description of the ceremonial society in 1891. Hoffman was sent to Minnesota, partly to evaluate material on the Midewiwin collected in the early part of the 19th century by Henry R. Schoolcraft, an Indian agent at Sault Ste. Marie, whose work the authorities at the Smithsonian didn't trust.[19] Hoffman collected many songs in Minnesota and published them in Ojibway, English and picture writing, providing a wealth of information to use when searching for the meanings of the rock paintings.

Ojibway Elder Peter Ochiese, in a lecture in Sault Ste. Marie in 1990, reminded his audience that both natives and non-natives have their medicine wheels, both formed by Honesty, Kindness, Sharing and Strength. He said there are good people in both cultures who, when they share their good will, can do wonderful things. The Ojibway singers and their Smithsonian "biographers" shared their talents, and as a result preserved a treasure so useful today in understanding both music and rock art. Mr. Ochiese showed his audience something else – he wrote his lecture down on the blackboard using picture writing, explaining that people remember his words better when they have the pictures in their heads to remind them. It is certain that every listener still remembers his every word.

INTERPRETING THE ROCK PAINTINGS USING ALGONKIAN PICTURE WRITING

Some researchers despair that Indian picture writing was so idiosyncratic – each person using his own system of symbols – that we can never unlock the meanings of rock art.[1] However, as already discussed, Kohl and Blessing observed some standardized signs known to people over a wide area and Densmore also noticed the ability of one picture writer to read another's work.[2]

In analysing the figures on the rock paintings, I attempted to obtain more than one source in the songs for each device. The song illustrations in this chapter, taken from Copway, Densmore, Hoffman, Kohl, Mallery and James, should make clear that many signs were standard. For instance, Kohl reported the use of a circle around the head to denote superior knowledge. He made his observation in 1855 in northern Michigan. Hoffman noticed the same sign and interpretation in 1885 in Minnesota. Moreover, the Algonkians still practised rock painting at the time when they wrote song scrolls, so the two should coincide.

We must also keep in mind that the songs and the signs were interpreted in several ways, all of them legitimate. For instance, a song sung at a feast prepared for Mide leaders before a major ceremony has the words "I am raising it up," referring to the feast dish offered to the manitou. But Densmore tells us the same song could be sung if a sick person were to be treated by the Mide, and the song referred to the patient.[3] So we should expect that the signs on the cliffs have extra meanings, depending on the many lessons to be drawn out of the dreamer's visions.

THE MOUNTAIN AND THE MEDICINE MANITOUS

Interpretations of the rock paintings should begin with the cliff faces themselves because the mountain itself is especially sacred, not just the rock art. This fact is reflected in many pictographs in the Shield that consist entirely of red ochre "wash" with no actual figures portrayed. Mrs. Seymour said that the "wash" denotes the special spirituality of the site.[4]

Stories from Saskatchewan, Manitoba and Ontario speak of a mountain as the home of the powerful Medicine Manitou, and the account told to Wheeler in Manitoba (discussed in Chapter 2) is crucial to our understanding of the reason why the pictographs occur on cliff faces. Wheeler's informant told him that the old medicine man searching for a cure for a sick woman said he received powerful medicines from the "men who lived in the rock." He drew a picture of one of them, a stick figure with lines running from the head giving a rabbit-eared look. That particular painting has not been identified, but a painting of like description is in Figure 31 from Rainy Lake.

Accounts from across the Shield relate similar experiences. Dewdney was told in Ontario that specially gifted shamans had the power to enter the rocks and exchange tobacco for medicine.[5] A man at Lac La Ronge in Saskatchewan told Tim Jones in 1965 that paintings are found at the places where dreams occurred to the painters and, whenever they needed assistance, they would go to the rock faces where manitous resided.[6]

A much earlier account of the Cree of Lac La Ronge by George Nelson in the 1820s described the abode of the Medicine Manitou in a similar fashion.[7] His home was in a mountain and his house had six doors. They were "so mysteriously constructed that no soul whatever, besides himself and his colleagues, of whom there were a great number can open them." The lock was in the form of a spiral, opened only from the inside of the mountain. Inside the mountain were all the medicines derived from minerals, while out-

side were 40 rivers flowing into a lake beside the mountain. The rivers and mountainside contained all botanical medicines. When the medicine man was favoured, "he appeared first at these rivers, when the head or chief of the mountain [came] out", and after some friendly conversation, took the medicine man inside the mountain. Nelson was told that the journey of the shamans inside the mountain was through dreaming after fasting and "keeping their minds as free as possible from any other thought whatever."

In Nelson's account, the initiate was astonished to find many medicine manitous, physicians of great power from every nation and language on Earth, gathered together. They were seated in four rows in a semicircle, much like a theatre to Nelson's mind. A great many prescriptions of minerals, stones, shells and other substances were hung up in the house, and the apprentice was taught the preparation and songs for each.

There are song scrolls that connect the Mides with mountains. Hoffman received the following songs in northern Minnesota: Figure 44a is the sign for "Going into the mountains" and Hoffman's informant said the singer communes with Kitche Manitou.[8] Figure 44b is sung "There is a mountain, there is a mountain, there is a mountain, my friends." Hoffman's informant said that a powerful Mide sits on a mountain, symbolic of the distinction attained by a Mide. Figure 44c is "I, too, see how much there is"; Hoffman's informant explained that the Mide's power elevates him to the rank of Manitou "from which point he perceives many secrets hidden in the earth." A similar ideogram in Figure 44d is sung "the Spirit has given me the power to see."

Dewdney was told of a connection between the medicine manitous and the little, hairy water creatures known as maymaygwayshiwuk, sometimes interpreted as rock medicine men, who hold the secrets of the medicines.[9] These are known among both the Cree and Ojibway as benign but mischie-

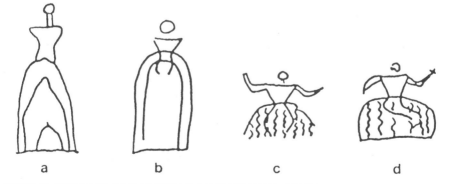

FIGURE 44. BIRCHBARK SONG RECORDS FROM NORTHERN MINNESOTA DEPICTING THE MIDE AND THE MOUNTAIN: A) GOING INTO THE MOUNTAINS; B) THERE IS A MOUNTAIN, THERE IS A MOUNTAIN, THERE IS A MOUNTAIN, MY FRIENDS; C) I, TOO, SEE HOW MUCH THERE IS; D) THE SPIRIT HAS GIVEN ME THE POWER TO SEE

vous spirits who reside in river banks on the prairies[10] and in caves near water in the Shield[11]. They are also known to reside underwater. Dewdney collected a few comments relating the maymaygwayshiwuk to the presentation on the rock paintings of a human form with his arms up in the "surrender" position (see Figures 45 and 46) and to the red handprints on the cliff face (see Figure 47), left there by a maymaygwayshi touching the rock face.[12] Dewdney said informants told him on the one hand that the little hairy manitous had painted the cliffs themselves and, on the other hand, that the medicine men had painted the cliffs after they had been given manitou powers.[13] In Ojibway metaphorical thought in which the Mide took on the powers of the manitou, these two concepts are identical.

Reverend Peter Jones, an Ojibway from southern Ontario, noted in 1861 that his people believed the maymaygwayshiwuk, which he translated as "the hidden or covered beings," were invisible most of the time. When they allowed themselves to be seen, they were described as two or three feet high, walking erect in human form, and with faces covered with short hair.

He said a Scottish family on the St. Clair River, in 1824, had a haunted house that his people attributed to the Maymaygwayshiwuk. The cattle, pigs and poultry took fits and died, stones and pieces of lead were thrown through the windows of the house, and pots and kettles moved around the house without anyone being near them. Live coals began to show up in several rooms and finally the house burned down. The Ojibways said the place was formerly the home of the maymaygwayshiwuk, and when the Scottish family built there, the little creatures moved into a poplar grove behind the house.

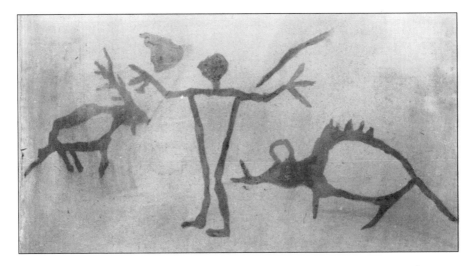

FIGURE 45. BLINDFOLD LAKE, NORTHWESTERN ONTARIO. COURTESY OF THE ROYAL ONTARIO MUSEUM, TORONTO, CANADA.

But the family chopped the grove down and the creatures' patience wore out.[14]

Irving Hallowell was told in Manitoba in the mid-20th century that a man dreamed of the maymaygwayshiwuk who lived in the cliffs and had powers of medicine, and the man later identified on the landscape the precise place he had visited in his dream.[15]

Walter Red Sky of Shoal Lake, Ontario, connects both the maymaygwayshiwuk and Kitche Manitou with the rock paintings. He identified the upraised-arm figure on the pictographs as "rock people," and an upside-down figure of the same as "a rock man the way he appeared in the vision." Mr. Red Sky interpreted some of the rock paintings as "visions of the rock people, always with their arms raised; the handprint is where the rock man closed the door when he came out of the rock." But he interpreted an animal in a pictograph at Whitefish Bay on Lake of the Woods as "the form the Great Spirit took in the vision." He added that a person cannot normally meet "the Great Spirit"; one has to fast first for four days. "If you have no vision, then another eight days, then 12 and so on."[16]

The maymaygwayshiwuk appeared in the Jiissakid's Shaking Tent. In 1914, Arthur Felix of Berens River told Hallowell of a ceremony for Jacob Berens who was ill and asked the conjurer why the medicine given to him didn't work. The conjurer, William Franklin of Poplar River, got in touch with a maymaygwayshi to ask what kind of medicine to give Mr. Berens, still suffering from stomach cramps.

FIGURE 46. KNEE LAKE, MANITOBA.

FIGURE 47. NORTHERN TWIN LAKE NEAR KENORA, NORTHWESTERN ONTARIO. COURTESY OF THE ROYAL ONTARIO MUSEUM, TORONTO, CANADA.

The manitou entered the shaking tent and replied, "I'll give him a little."

Mr. Franklin said, "Can you give it to him tomorrow morning?"

The maymaygwayshi replied, "No, I'll go and get it now." Then, he left the tent.

Mr. Berens asked, "I wonder how far he has to go."

The conjurer replied, "There is only one place to go."

Someone in the audience asked, "Where is that?"

"The maymaygwayshiwuk live at Kickabiskan, High Rock," replied the conjurer. And soon after, the maymaygwayshi returned to the tent with the proper medicine for Mr. Berens.[17] There is a rock painting at High Rock on the Nelson River system (Figure 94).

The maymaygwayshiwuk had a role in the ceremonies of the Midewiwin as well. Densmore recorded the following song in northern Minnesota (Figure 48a): "When I (the singer as Beaver) appear, the men of the deep (maymaygwayshiwuk) will be cast up by the seething waters." Beaver is on the left and a maymaygwayshi on the right.[18]

Nelson reported in 1821 that the Lac La Ronge Cree in those days saw the medicine manitou and the maymaygwayshiwuk as separate entities.[19] Nelson did not name the medicine manitou, although elsewhere he stated that the manitou who gave medicines and their accompanying ceremonies and songs to the people was Weesakejock,[20] another name for Nanabojou.

Kohl observed in 1855 that Nanabojou was never named in the religious

a

b

c

d

FIGURE 48. BIRCHBARK SONG RECORDS FROM NORTHERN MINNESOTA AND NORTHERN MICHIGAN:

A) WHEN I (THE SINGER AS BEAVER) APPEAR, THE MEN OF THE DEEP (MAYMAYG-WAYSHIWUK) WILL BE CAST UP BY THE SEETHING WATERS

B) I WISHED TO BE BORN, I WAS BORN, AND AFTER I WAS BORN I MADE ALL THE SPIRITS

C) I CREATED THE SPIRITS

D) HE SAT DOWN, NANABOJOU, HIS FIRE BURNS FOREVER.

ceremonies although he was known as the restorer of the world, the legislator, the source of all social institutions and the giver of the medicine dance, the Midewiwin. "And yet, all along Lake Superior, you cannot come to any strangely formed rock, or other remarkable production of nature without hearing some story of Nanabojou connected with it." [21]

The role of Nanabojou as the primary giver of medicine is stressed in the Midewiwin. In the accounts of that society, Nanabojou is the foremost messenger, or servant, of Kitche Manitou and he first brought medicine and the Midewiwin itself to the people at Kitche Manitou's bidding.[22] He was aided by Otter and Bear, two manitous who figure prominently in the rituals of the Midewiwin.

Figure 49 is a birchbark song scroll from White Earth, Minnesota, relating the orgins of the Midewiwin. Hoffman was told that, at left, is Nanabojou holding the sacred otter Mide bag, or Pinjigusan. Next are the drummers calling the Kitche Manitou. Next is a female priest, denoting that women also have the privilege of joining the Midewiwin. She holds a snake medicine bag. Next is Mikinak, the Turtle, the messenger, giver of some of the sacred objects. Next is Makwa, the Bear, also a benevolent spirit. Next is a snake medicine bag containing life, and last is the Dog, given by the Mide manitous to Nanabojou as a companion, or by Nanabojou to the people.[23]

Kohl reported that, among the Ojibway of northern Minnesota in 1855 the Dog was important. An informant told him "the dog is our dearest and

FIGURE 49, BIRCHBARK SONG SCROLL FROM WHITE EARTH, MINNESOTA, DEPICTING THE ORIGINS OF THE MIDEWIWIN: NANABOJOU IS AT THE FAR LEFT, HOLDING AN OTTER MEDICINE BAG.

most useful animal," and it was used as a special sacrifice to the Manitous because "it is almost like sacrificing ourselves."[24]

Nanabojou was intimately connected with the Earth. There are many creation stories, almost all relating the fact that he created the ground in obedience to the commands of Kitche Manitou. He supplied the animals for the hunt and the minerals and plants for medicine. And all these things are now in the care of Misakamigokwe, (literally Great Earth Woman) the Earth, great-grandmother who was commanded to remain at home in her lodge so that the people could always call on her for help. For these reasons, the Indians even today never dig up the roots from which their medicines are made without depositing in the earth something as an offering to her, and their medicine songs accompanying the act are addressed to Nanabojou and Misakamigokwe, the ever benevolent Earth.[25]

Stories abound of Nanabojou's connection with the Land. Jesuit Claude Allouez reported in 1669 that Mackinac, where Lakes Michigan and Huron meet, was one of the homes of Nanabojou, known in those days also as Weesakejock and Michabous (Great Hare). He also said that Lake Superior is a pond made by beavers; Nanabojou trod on their dam, smashing it apart, forming the rapids at Sault Ste. Marie.[26]

The cycle of stories relating Nanabojou's sojourn in this world recall his journeys and wanderings throughout Algonkian country, giving names for the trees and animals, learning the skills of the animals to pass them on to the people, often getting into hilarious scrapes, and establishing the sacred contexts of special places on the landscape. For instance, one tale relates that his grandmother, called Toad Woman in some stories, let beavers escape from Lake Superior through the Sault rapids. In a rage Nanabojou killed her at Gros Cap, just northwest of the Sault, and the mountain there is reddened with her blood today. It was thereafter called Toad Mountain.[27] One story

says that the southeastern point of Michipicoten Bay on Lake Superior is called Nanabojou, and one of his homes is beneath an island nearby.[28]

In another story, Mackinac is the place where Nanabojou withdrew from the people after the arrival of the white man. He secreted himself in a large rock in the shape of a sitting hare, and the people as late as 1896 still built their Mide lodge nearby, and left offerings at the rock.[29] Before he departed, he said to his people:

> My friends, I am going to leave you now; I have been badly treated – not by you, but by other people who live in the land about you. I shall go toward the rising sun, across a great water, where there is a land of rocks. There I shall take up my abode. Whenever you build a Midewigan and are gathered together you will think of me. When you mention my name, I shall hear you. Whatever you may attempt in my name shall come to pass, and whatever you ask, I shall do.[30]

Since that time, many people have journeyed in search of Nanabojou. Hoffman was told that one man dreamed that Nanabojou spoke to him and he and seven other Mides decided to go in search of the manitou. The dreamer then blackened his face with charcoal – always done in a dream quest – and they started across a great lake toward the rising sun, to a rocky shore where Nanabojou dwelt. They pulled up their canoes and searched for his wigwam. As they approached it, they saw Nanabojou who invited them to enter. "The door of the wigwam moved up and down, and each time one of the Indians entered, the door closed, then lifted again to allow the next in. Each man asked for medicine powers for curing, hunting, love or war, and all gained them except one who asked for eternal life. Nanabojou turned him into stone so that he would remain that way forever."

In a similar story told to Densmore, Nanabojou lived on an island toward the east, beside a great round stone, and he gave the questers medicine in the form of a snake chain to wear so they could safely travel to the Afterworld to retrieve the daughter of one of the men. In this story, we are told that on Nanabojou's head was a beautiful cedar tree, a sign for wisdom, especially that of the elders.[31]

Nanabojou appears in several songs of the Midewiwin in human form. Figure 48b is sung by Nanabojou: "I wished to be born, I was born, and after I was born I made all the spirits." Figure 48c is the device for a much esteemed song, "I created the spirits." Figure 48d signifies the following: "He sat down, Nanabojou – his fire burns forever." It refers to the manitou seated on the earth near his campfire.[32]

He also is depicted on rock paintings. A Temagami Indian from Bear

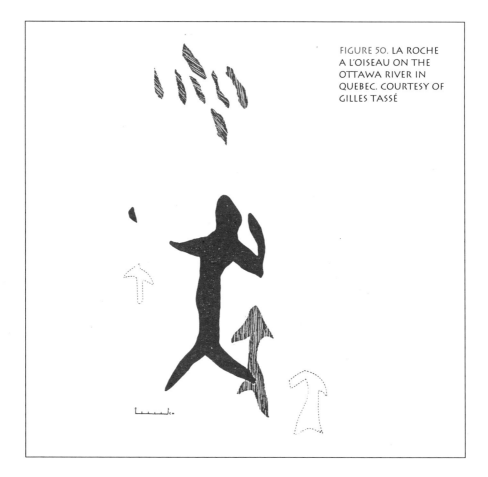

FIGURE 50. LA ROCHE A L'OISEAU ON THE OTTAWA RIVER IN QUEBEC. COURTESY OF GILLES TASSÉ

Island said in 1913 that he had seen a picture of him on a rock along the Ottawa River.[33] Gilles Tassé recorded several figures at Roche à l'Oiseau on the Ottawa, one of which is shown at Figure 50.[34] But it may be difficult for us to recognize Nanabojou every time because he was expert at shape-changing, appearing sometimes in human form but at other times in animal forms, and he even changed into a tree stump once.

Mountains were the homes of many manitous. Hollows in the mountains which surround Burlington Bay in southern Ontario and Cape Gargantua on the northeast shore of Lake Superior were noted to be manitous' homes.[35] The La Cloche Mountains at Manitoulin Island in Lake Huron were the abodes of Thunderbirds.[36]

In another story, Nanabojou in his wanderings passed a high mountain and detected a delightful odour coming from the crevices in the cliffs. Inside, he found a giant, the keeper of tobacco, and he requested some. The giant refused so Nanabojou grabbed a bag of it and escaped, followed by the giant.

He went to the top of the mountain, jumping from peak to peak, reaching one with a steep vertical face. He lay flat on his face and the giant leapt over and fell down the cliff, managing to hang on to the ledge with only his fingers. Nanabojou pulled him up and threw him angrily to the ground, exclaiming, "For your meanness, you will become Papakine (grasshopper), the pest of those who raise tobacco." Then he divided the giant's tobacco among all the nations.[37]

The most famous mountain, although not specifically located, was the one Nanabojou climbed with his grandmother to escape the flooding of the first Earth,[38] caused in most stories by Mishipizheu in retaliation for harm inflicted on him by Nanabojou.

Storyteller Marie Syrette from Lake Nipigon told a story to William Jones in 1905 which said that Nanabojou, after all his wanderings in this world, finally departed, but her stories end on a happy note. He sent his grandmother, the Earth, back to our world to reside here with us while he went his way to another realm. "Nanabojou himself went his way ... but still to this day he must be travelling along, wherever the place he may be now; perhaps even to this day he may be walking."[39]

ARMS UP, ARMS DOWN

The upraised arm figure is arguably the most common figure on the pictographs (Figures 51 to 54). A number of song scrolls interpret an arms-up sign as a depiction of giving and receiving medicine. Figure 55a is the sign for the song "I follow with my arms" and means, as Hoffman was told, that the arms are extended to take up medicine or Mide secrets.[40] Figure 55b is "When I rise it gives me life, and I take it," with the arms reaching into the sky to receive gifts from Kitche Manitou.[41] Figure 55c reads "Whence comes the rain?" Hoffman adds that it depicts the power of making a clear sky, clear weather.[42] Figure 55d is sung "Very seldom I make this request of you"; the spirit is filling the body of the supplicant with knowledge of the secrets of the earth.[43] Figure 55e is "My medicine is the sacred spirit"[44] and Figure 55f is "Your body, I believe it is a spirit, your body," the arm of the supplicant reaching out of the medicine lodge.[45] Figure 55g reads "I am holding this that I bring you"; the bearer of the medicine is inviting the initiate into the midewigan.[46] The pictographs, interpreted using the song scrolls, could denote both the medicine manitou giving medicine and the human receiving the gift. The receiver takes on the power and portrayal of the giver in the metaphor.

Some paintings, for example at Fairy Point on Missinaibi Lake in north-

eastern Ontario (Figure 56) and Blindfold Lake in northwestern Ontario (Figure 57) portray a human figure with arms extended both skyward and earthward. A war medicine song (Figure 58a), recorded by James, depicts a similar gesture and means "I take the sky, I take the earth."[47] Another song recorded by Hoffman (Figure 58b) is sung "I have the medicine in my heart,"[48] the Mide has the medicines from the sky and the earth.

A painting at Obabika Lake in northeastern Ontario (Figure 59) may portray a similar idea of the powers grasped from both above and below, using a different sign, the two circles joined by a line above the human figure. Compare this to the song shown in Figure 90b, "I come up from below; I come down from above; I see the manitou; I see the beavers." [49] The manitou to whom the prayers are addressed in the medicine hunt not only knows where all the animals are but also can create them and cause them to come up out of the earth. A similar double-headed manitou was drawn for Dewdney by James Red Sky who interpreted it as a manitou so powerful that it could see everywhere.[50]

FIGURE 51. A MANITOU WITH ARMS UP, OFFERING MEDICINE, APPEARS OUT OF THE ROCK AT MATAGAMASI LAKE IN NORTHEASTERN ONTARIO. COURTESY OF THE ONTARIO MINISTRY OF CULTURE, TOURISM AND RECREATION.

The arms-down sign in several hand-sign languages denotes a negative response. For the concept "not know," the fist is held shut at the breast then swung down and outward to the side of the body, the fingers flung out.[51] Figure 58c to 58e are songs from Hoffman. Figure 58c refers to medicine yet to be learned;[52] Figure 58d shows a mide who does not yet know where he is going;[53] and Figure 58e is a boaster who has not received instruction in the Midewiwin.[54] Figure 58f, from James, refers, like 58c, to medicine yet to be learned, and is sung "Two days you must sit fast, my friend; four days you must sit fast, my friend." The two lines on the breast refer to two days but are understood to mean two years, and the four lines across the legs are four years, the knowledge requiring rigid attention and serious condsideration.[55]

The arms down don't always denote negativity. A song recorded by Hoffman (Figure 58g), showing a human figure with arms down, denotes reaching for medicine in the ground.[56]

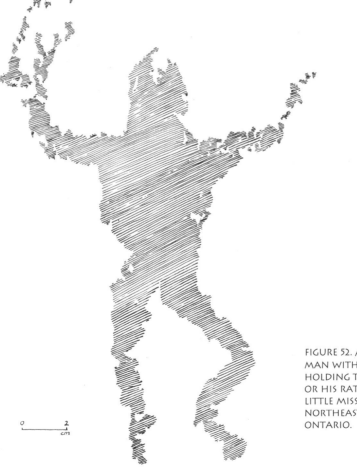

0 — 2 cm

FIGURE 52. A MEDICINE MAN WITH ARMS UP, HOLDING THE MEDICINE OR HIS RATTLE, AT LITTLE MISSINAIBI LAKE, NORTHEASTERN ONTARIO.

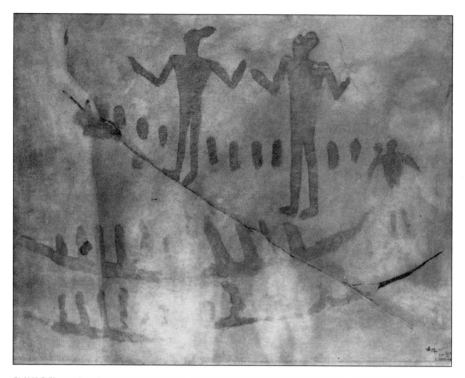

FIGURE 53. MANITOUS/MEDICINE MEN AT CACHE BAY, QUETICO PROVINCIAL PARK. COURTESY OF THE ROYAL ONTARIO MUSEUM, TORONTO, CANADA.

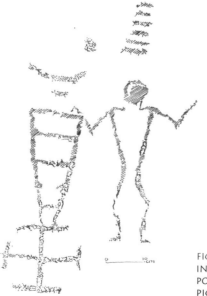

FIGURE 54. A MIDE WITH ARMS UP OFFERING OR RECEIVING MEDICINE BESIDE A POSSIBLE SIGN FOR THE MIDEWIWIN AT PICTURE ROCK ISLAND, LAKE OF THE WOODS.

FIGURE 55. BIRCHBARK RECORDS FROM NORTHERN MINNESOTA ASSOCIATING UPRAISED
ARMS TO GIVING/RECEIVING MEDICINE:
A) I WILL FOLLOW WITH MY ARMS; B) WHEN I RISE, IT GIVES ME LIFE AND I TAKE IT
C) WHENCE COMES THE RAIN?; D) VERY SELDOM I MAKE THIS REQUEST OF YOU
E) MY MEDICINE IS THE SACRED SPIRIT; F) YOUR BODY, I BELIEVE IT IS A SPIRIT, YOUR BODY
G) I AM HOLDING THIS THAT I BRING YOU.

FIGURE 56. FAIRY POINT,
MISSINAIBI LAKE,
NORTHEASTERN
ONTARIO.

FIGURE 57. BLINDFOLK LAKE, NORTHWESTERN ONTARIO. COURTESY OF THE ROYAL ONTARIO MUSEUM, TORONTO, CANADA.

a

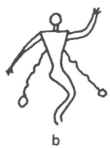

b

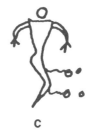

c

d

e

f

g

FIGURE 58. BIRCHBARK SONG SCROLLS FROM NORTHERN MICHIGAN AND NORTHERN MINNESOTA:
A) I TAKE THE SKY, I TAKE THE EARTH
B) I HAVE THE MEDICINE IN MY HEART ;
C) THERE IS MUCH MEDICINE YOU MAY CRY FOR;
D) I DON'T KNOW WHERE I AM GOING
E) WHO IS THIS GRAND MIDE, YOU HAVE NOT MUCH GRAND MEDICINE, WHO IS THE MIDE?;
F) TWO DAYS YOU MUST SIT FAST, MY FRIEND, FOUR DAYS YOU MUST SIT FAST, MY FRIEND;
G) THE GROUND IS WHY I AM A MANITOU, MY SON

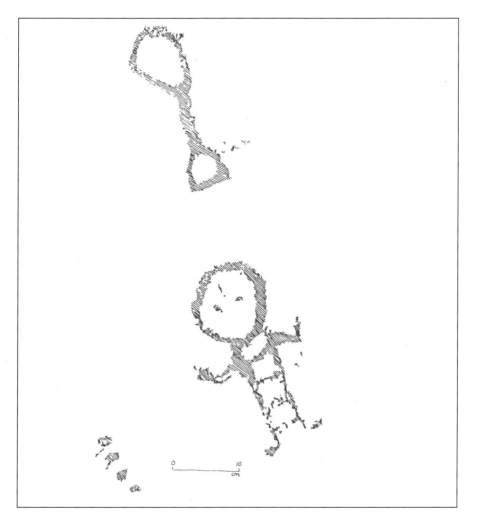

FIGURE 59. A PAINTING AT OBABIKA LAKE, POSSIBLY REFERRING TO A CONCEPT LIKE THE SONG, I COME UP FROM BELOW, I COME DOWN FROM ABOVE.

THE HANDPRINT

The handprint is an ancient symbol in North American Indian pictography. Stone tablets, found at Adena Culture sites (probably Algonkian) 2,500 years old in Ohio and used as palettes for red ochre paint, contain on one side depictions of handprints with concentric circles in the palm.

The handprint (Figures 60 and 61) is a common figure on the pictographs of the Shield and has several meanings. Densmore noted that a buckskin cut-out of a hand was filled with moss and tobacco and smeared

with red paint, then carried by a messenger to summon the Ojibway to war against the Dakota.[57]

Mallery noted that a black hand on a garment indicated the wearer had killed an enemy and it was worn to show bravery.[58] Mrs. Seymour also suggested the handprint on rock paintings could mean that a warrior was killed nearby.[59]

The buckskin hand was also used to seal agreements, often placed on top of bales of trade goods, and stood for the honour of the Ojibway nation.[60]

In his discussion of the use of sign language among the Ojibway of the last century, Kohl provided another meaning appropriate to the context of the

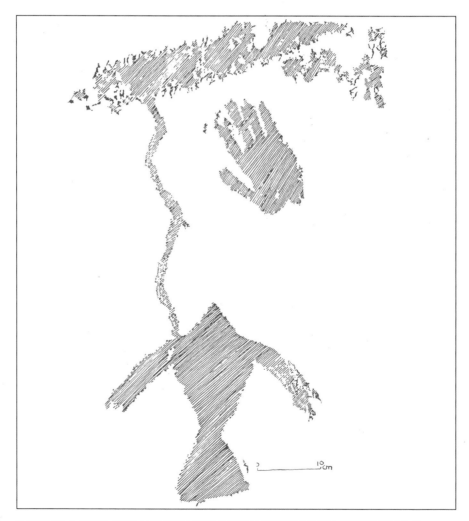

FIGURE 60. A HAND, BIRD AND COMMUNICATION LINE TO THE SKY AT PICTURE ROCK ISLAND, LAKE OF THE WOODS.

rock paintings. The flat hand pressed to the lips and then moved upward to heaven indicated prayer or address to the deity.[61] Mallery, who collected a large volume of gestures of the North American Indians, noted that the sign for "pray" in several languages was the open palm of the hand held toward the sky.[62]

The handprint appearing on old Ojibway clothing patterns (see Figure 43) denoted the hand of Kitche Manitou and the paw of Bear, the guiding spirit of the Midewiwin, in the sky.[63] Robert L. Hall made an interesting observation about the eastern Algonkian Delaware tribe. He noticed that the Creator's abode is high in the sky at the top of the sacred tree, or centre post,

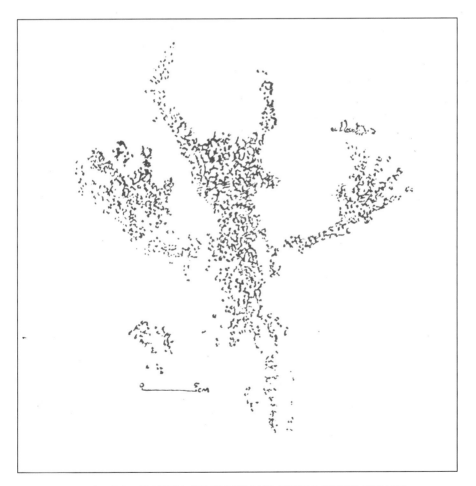

FIGURE 61. A MANITOU/MEDICINE MAN AT DEER LAKE, NORTHWESTERN ONTARIO.

of the lodge used for the bear sacrifice ceremony. The centre post extended from the lodge to "the hand of the Creator in the sky." Hall suggested the hand may have been seen as a star group, perhaps the end of the Little Dipper at the Pole Star.[64]

FIGURE 62. BIRCHBARK SONG RECORDS FROM NORTHERN MICHIGAN AND NORTHERN MINNESOTA:
A) MY PAINTING MAKES ME A MANITOU
B) WE MAY LIVE BY IT ALWAYS, MY MIDE BRETHREN, IT IS SPIRITUAL, THE INSPIRATION WE RECEIVE
C) I HAVE GAINED SUCH SPIRIT-POWER THAT I CAN TAME IT IN MY HAND, IT IS TRUE, EVEN OUR WHITE SHELL, I CAN TAME IT IN MY HAND.

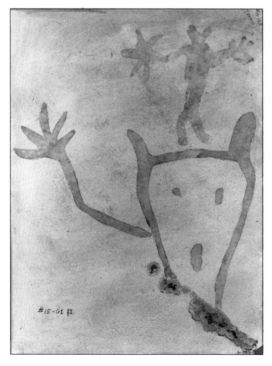

FIGURE 63. PICTURED LAKE NEAR THUNDER BAY, ONTARIO COURTESY OF THE ROYAL ONTARIO MUSEUM, TORONTO, CANADA

An Ojibway song collected by James at Sault Ste. Marie (Figure 62a) is "My painting makes me a manitou," referring to the medicine man painting the face of a patient with a medicine mixed with red ochre.[65] The "fingers" of the figure are the sticks used for painting, and they perhaps appear at Pictured Lake near Thunder Bay (Figure 63), very similar to the song.

CIRCLES AND SPIRALS

The circle is at the centre of Algonkian symbolism, gathering within it numerous meanings, each leading to, overlapping, and finally including all the others in a vast medicine Wheel.

Medicine itself was symbolized by the megis shell in the Midewiwin (Figure 40), often depicted on the scrolls as a circular object (Figure 41). The Midewiwin was intimately associated with water,[66] as the megis shell indicates. Megis is the Ojibway word for the saltwater cowrie or marginella, tiny shells about the size of the little fingernail. The cowrie was an ancient symbol among many peoples of the world, representing long life and good luck.[67] In North America, the shells occur off the southeast coast of the United States. The Algonkians treasured them: they appear on archaeological sites at least

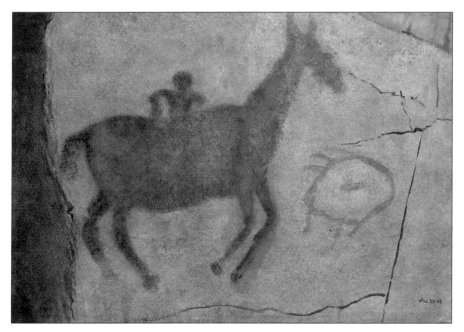

FIGURE 64. MEGIS GUIDING A HORSE-AND-RIDER AT AGAWA ROCK, LAKE SUPERIOR. COURTESY OF THE ROYAL ONTARIO MUSEUM, TORONTO, CANADA.

two thousand years old, often in ritual contexts, as adornment on special clothing and in medicine bundles. People of the Hopewell culture elaborated on the water image, wearing not only strings of shells but also pearls. Perhaps they considered pearls – produced in shells – the freshwater equivalent of the saltwater megis shells.

Densmore and others collected many songs about megis. One song, "My body lies in the east," refers to the eastern origin of the shell, the land of sunrise and the abode of Nanabojou, the giver of medicine and long life. Figure 62b is sung, "We may live by it always, My Mide brethren; it is spiritual, the inspiration we receive"; the Mide holds a megis.[68] Figure 62c is sung "I have gained such spirit power that I can tame it in my hand; it is true, even our white shell, I can tame it in my hand." The sign depicts the Mide holding a megis, the power of which is indicated by a manitou rising from it.[69]

We may have already met the megis at a rock painting at Burnt Bluff, Michigan, (Figure 39) that may date as early as Laurel times, perhaps 2,000 years old. Megis appears again at Agawa Rock on Lake Superior (Figure 64) leading a horse and rider, an obviously historic painting done after the introduction of horses to the area. Megis still guided the Indian after 2,000 years.

The circle could symbolize also the medicine and the medicine dish. Figure 65a reads:"I took with two hands what was thrown down to us," and Hoffman adds that the speaker grasped life, i.e. the megis, to secure the mysterious power he professes.[70] Figure 65b is sung "Almost crying because the medicine is lost"; the eyes are weeping over the circle denoting the place where the medicine is supposed to exist, and the whole ideogram means that information has been forgotten through the death of those who possessed it.[71] Figure 65c reads "That which I live upon has been put on this dish by the Spirit"; Kitche Manitou provides the speaker with a feast or medicine.[72]

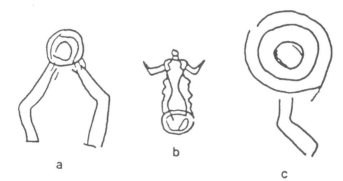

a

b

c

FIGURE 65. BIRCHBARK SONG RECORDS FROM NORTHERN MINNESOTA:
A) I TOOK WITH TWO HANDS WHAT WAS THROWN DOWN TO US;
B) ALMOST CRYING BECAUSE THE MEDICINE IS LOST;
C) THAT WHICH I LIVE UPON HAS BEEN PUT ON THIS DISH BY THE SPIRIT.

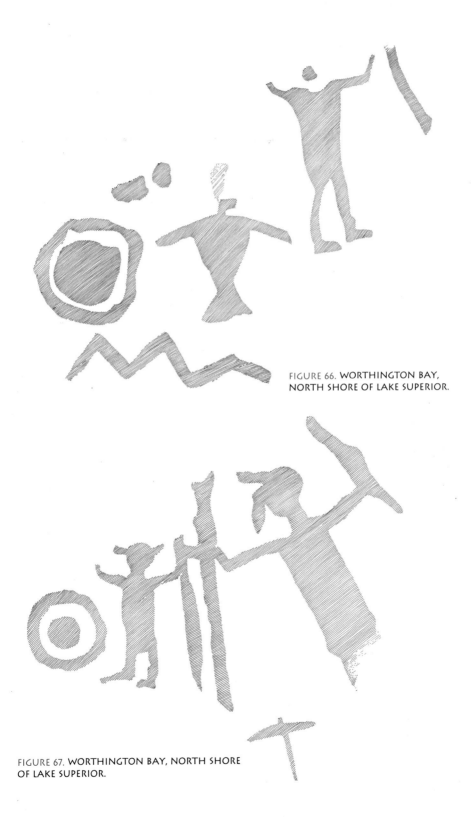

FIGURE 66. WORTHINGTON BAY,
NORTH SHORE OF LAKE SUPERIOR.

FIGURE 67. WORTHINGTON BAY, NORTH SHORE
OF LAKE SUPERIOR.

The same notion of medicine as a circle may be at rock paintings at Worthington Bay on the north shore of Lake Superior (Figures 66 and 67), the Upper Molson River, Manitoba (Figure 68), Ferris Lake in northeastern Ontario (Figure 69), Deer Lake in northwestern Ontario (Figure 70), and Cuttle Lake, also in northwestern Ontario (Figure 71).

These circles may also denote the original earth or island where Nanabojou alighted to bring medicine down to the people.[73] In the song scrolls, it is depicted as a simple circle, a circle-within-a-circle and a filled-in circle. Densmore added that the circle can mean sky, earth, and lake.[74]

The circle, often with a dot in the centre, means also the Kitche Manitou. It appeared with this meaning on clothing and sacred items, in the centre of a swastika or cross, denoting Kitche Manitou as Sun and as the source of the four cardinal directions, the four Wind Manitous, and universal power.[75] Copway shows a circle with four projections (Figure 72a) and translates it as "the Great Spirit Everywhere."[76]

From this notion, the Sun is also a circle, or circles-within-circles, because it stands for Kitche Manitou, that is, all that is good – heat, light and warmth. Lahontan asked the Odawa in 1703 why they adored God in the Sun, and they replied that "they chose to admire the deity in public by pointing to the most glorious thing that Nature affords."[77]

The drum sometimes also forms a circle, sometimes with inside "spokes"[78] (Figure 72b), and two small "spoked" wheels at the Cuttle Lake pictograph in Ontario (Figure 73) may indicate two drums. The drums are the means of communication with Kitche Manitou, and an affirmation of the medicine given to the people. All meanings of the circle become one circle within the drum.

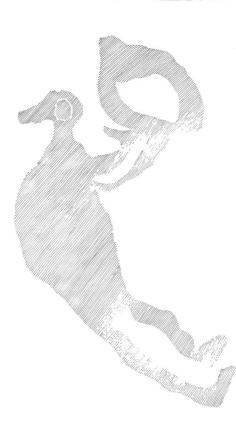

FIGURE 68. UPPER MOLSON RIVER, MANITOBA.

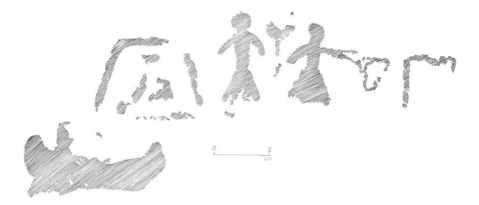

FIGURE 69. FERRIS LAKE, NORTHEASTERN ONTARIO, POSSIBLY TWO MIDEKWE BESIDE A LODGE OR MOUNTAIN, ONE HOLDING THE MEDICINE.

FIGURE 70. DEER LAKE, NORTHWESTERN ONTARIO.

Johnston adds to the complex of associations by noting that the megis was first seen by the people as a brightly shining star:[79] star equals megis equals medicine.

The spiral is an elaboration of the circle as medicine, as a medicine song recorded by Densmore shows (Figure 72c). The song, referring to Lake St.

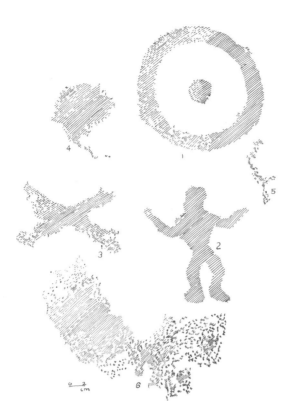

FIGURE 71. CUTTLE LAKE, NORTHWESTERN ONTARIO.

Clair on the border between southern Ontario and Michigan, is sung "I am gathering that which I will treat myself; in the Lake of the Eddying Waters I will obtain it."[80] It is interesting that Nelson mentioned in Saskatchewan in the early 19th century that the lock on the door of the medicine manitou's lodge is a spiral.

The spiral is also ancient in North America. The Hopewell people who lived in Ohio two thousand years ago used huge whelk shells as bowls in their ceremonies, and the whelk itself is in the natural form of a spiral. Also, the largest and finest effigy mound (an earth mound in the shape of an animal) in North America, built in Ohio perhaps 2,500 years ago, is in the shape of a huge serpent snaking over half a kilometre of hilltop in Ohio, ending in a tail curved into a spiral.

The circle, like the handprint, is an ancient symbol. In southeastern Ontario archaeologists discovered a clay pot dating to about 1500 years ago that had an incised circle-within-a-circle on it.[81] What better item on which to draw the sign for medicine and a feast than on the bowl containing them! Concentric circles, crosses, swastikas and spirals adorn prehistoric shell arti-

FIGURE 72. PICTURE WRITING FROM NORTHERN MINNESOTA AND
NORTHERN WISCONSIN:
A) A SIGN FOR KICHE MANITOU;
B) A DRUM;
C) I AM GATHERING THAT WITH WHICH I WILL TREAT MYSELF, IN
THE LAKE OF THE EDDYING WATERS I WILL OBTAIN IT.

a

b

c

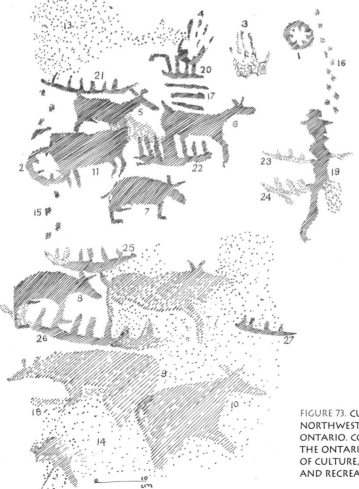

FIGURE 73. CUTTLE LAKE,
NORTHWESTERN
ONTARIO. COURTESY OF
THE ONTARIO MINISTRY
OF CULTURE, TOURISM
AND RECREATION.

facts of a culture known as Mississippian – its major centres were along that river – beginning about 1,000 years ago.[82] Even their early villages were laid out with the concept of cross-and-circle. They built their houses in a circle and, in the centre of the courtyard, were four centre poles forming the shape of a cross, one planted in the ground at each cardinal direction, forming the cross-within-a-circle.[83]

THE ENCIRCLED HEAD

Mrs. Seymour has offered a possible interpetation for a pictograph at Annie Island, Lake of the Woods (Figure 7). The story is that of someone who took a long and difficult journey that lasted a month. The arduousness of the journey is in the long, crooked line, its duration indicated by the crescent moon.[84] As the arms of the figure are up in supplication, we may add to Mrs. Seymour's interpretation that the journey was possibly into the cliff in search of medicine.

Kohl recorded Figure 74a, a scroll depicting a Mide master and his student. The circle around the head of the student on the right denotes the head is filled with knowledge.[85] Looking again at Figure 7, where the circle around the head also appears, we can assume the quest for medicine was successful. Kohl's informant called the device "the Circle of Heaven." A similar device is on a rock painting at Scotia Lake in northeastern Ontario (Figure 75).

James recorded Figure 74b, the words for which are "Notwithstanding you speak evil of me, from above are my friends, my friends." James was told that the Circle of Heaven denoted that the person's help and protection are from above, and he has received strength to defy those who deride him or seek to kill him with bad medicine.[86]

Mallery recorded Figure 74c, a depiction of a Jiissakid curing a sick woman. He has a sucking tube in his mouth and holds his rattle. The circle around his head denotes "more than an ordinary amount of knowledge."[87] These interpetations should put to rest any notions viewers might conjure up about spacemen!

HORNS AND LINES FROM THE BODY

There are devices in the song scrolls designed to indicate power or spirituality, elevation above the mundane plane of existence, and these appear on the pictographs as well. Figure 76a portrays a horned Mide, and it means

FIGURE 74. BIRCHBARK SONG RECORDS FROM NORTHERN MICHIGAN AND NORTHERN
MINNESOTA SHOWING A CIRCLE AROUND THE HEAD:
A) A MIDE AND HIS STUDENT WITH A CIRCLE OF HEAVEN;
B) A MEDICINE MAN WHO HAS GAINED STRENGTH FROM ABOVE;
C) A JIISSAKID CURING A SICK WOMAN.

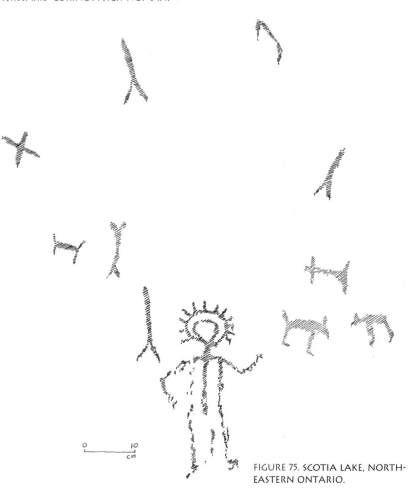

FIGURE 75. SCOTIA LAKE, NORTH-
EASTERN ONTARIO.

"We are talking to one another." Hoffman was told that the horns denote superior wisdom and power, and the lines from the mouth are speech. The Mide is conversing with Kitche Manitou.[88] Figure 76b is "I hear but they hear it not," meaning the singer has power, shown by the horn and lines, but the uninitiated do not.[89] Figure 76c is "In my house I see," showing lines from the eyes to denote sight and horns to portray the superiority of the singer.[90] The horns and lines from the head are common on rock art. They are seen, for instance, at Burditt Lake near Fort Frances, Worthington Bay on Lake Superior, Painted Rock Island on Lake of the Woods, and Nipigon Bay on Lake Superior (Figures 77 to 80).

The opposed crescents with a line between them on the Nipigon painting occur on other pictographs at Lake of the Woods, the Donnelly River and Pictured Lake in Ontario. James Red Sky of Shoal Lake interpreted a number of scrolls for Dewdney, and the reproductions of them are in the Royal Ontario Museum. A pencilled notation on one depicts the opposed arcs and the quotation, "God opens the way for you,"[91] probably referring to the entrance to the medicine lodge. The signs on the rock art, then, may indicate the entrance to the home of the manitou in the rock face.

Many song scrolls depict lines running from the body, usually called power lines. Figure 76d depicts a song sung as "Listen, I shall also be blessed and my life prolonged like those of the Mide whom I now behold." The heart

FIGURE 76. BIRCHBARK SONG RECORDS FROM NORTHERN MINNESOTA:
A) WE ARE TALKING TO ONE ANOTHER B) I HEAR BUT THEY HEAR IT NOT ;
C) IN MY HOUSE I SEE D) LISTEN, I SHALL ALSO BE BLESSED AND MY LIFE PROLONGED ;
E) IS IT THAT WHICH MY VOICE RESEMBLES, EVEN METAL, THE SOUND OF MY VOICE ;
F) WHO IS SICK UNTO DEATH WHOM I RESTORE TO LIFE
G) YOU WILL RECOVER, YOU WILL WALK AGAIN.

FIGURE 77. BURDITT
LAKE NEAR FORT
FRANCES, ONTARIO.
COURTESY OF THE
ROYAL ONTARIO
MUSEUM, TORONTO,
CANADA.

of each figure is shown and the straight lines indicate strength.[92] Figure 76e
is sung "Is it that which my voice resembles? Even metal, the sound of my
voice." The wavy lines are the song and the straight lines are strength.[93]
Figures 76f and 76g show two patients recovering through the power of the
medicine, the straight lines on the body. Figure 76f is "Who is sick unto death
whom I restore to life"[94] and Figure 76g is sung, "You will recover, you will
walk again. It is I who say it, my power is great. Through our white shell I
will enable you to walk again." [95] The power lines on the body are shown in
a panel at the Burnt Bluff Site in Michigan, possibly one of the oldest paint-
ings in the Great Lakes area (Figure 81).

Mallery suggested that horns and power lines may have originated in
hand sign language. Whichever came first, the pictures or the signing, the
horns in the pictures may be related to the sign for power and medicine man

– passing the separated index and second fingers of the right hand upward from the forehead in a spiral indicating "superior knowledge." Another sign for a Mide's power was passing the hand upward before the forehead with the index finger loosely extended, combined with the sign for sky – passing the index from east to west across the sky.[96]

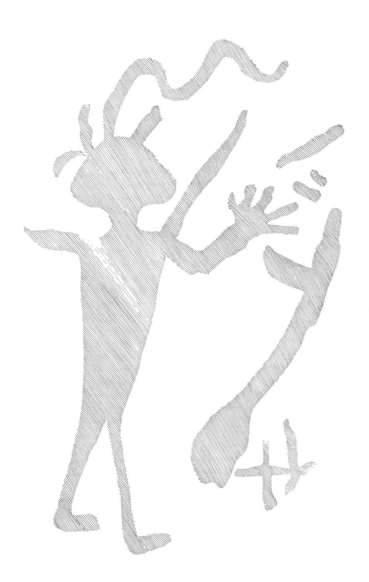

FIGURE 78. WORTHINGTON BAY ON THE NORTH SHORE OF LAKE SUPERIOR.

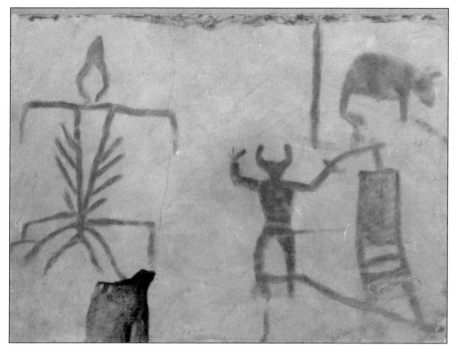

FIGURE 79. PAINTED ROCK ISLAND ON LAKE OF THE WOODS. COURTESY OF THE ROYAL ONTARIO MUSEUM, TORONTO, CANADA.

FIGURE 80. NIPIGON BAY ON THE NORTH SHORE OF LAKE SUPERIOR.

FIGURE 81. BURNT BLUFF ON THE NORTHERN PENINSULA OF MICHIGAN.

THE ANIMAL MANITOUS

The animal "masters", or spirit animals, display power lines on the rock paintings, for example the Mishipizheu at Agawa Rock (Figure 82) and the possible moose at Deer Lake (Figure 83). The moose at Crooked Lake (Figure 84) combines three concepts in the line running from the neck – the characteristic "bell" of skin that hangs from the moose, the horned snake and the power line. The figure at Wizard Lake (Figure 85) combines the power line with a long, snake-like neck, horns and cat tail, possibly a combination of characteristics the manitou adopted in the medicine man's dream.

Another common device in both the scrolls and on the pictographs (Figure 21) is a line (or lines) through the body of the animal. Mrs. Seymour says the line denotes spirituality,[97] an intepretation in agreement with the scrolls recorded by Hoffman. Figure 86a is sung "The Wolf Spirit".[98] Figure 86b is "I am the strongest medicine, is what is said of me"; Hoffman's informant notes that the speaker compares himself to the Bear Manitou.[99] Figure 86c is sung "Makes a great noise, the Bear, the reason I am of flame" and Hoffman explains that the band across the body indicates spiritual form.[100]

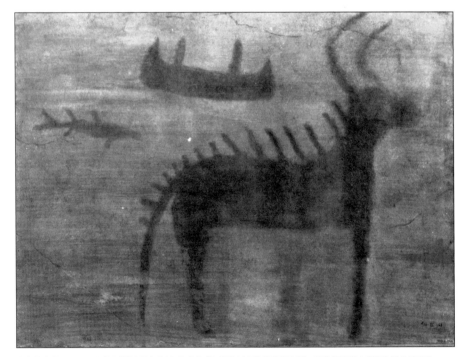

FIGURE 82. MISHIPIZHEU AT AGAWA ROCK ON LAKE SUPERIOR. COURTESY OF THE ROYAL ONTARIO MUSEUM, TORONTO, CANADA.

FIGURE 83. DEER LAKE, NORTHWESTERN ONTARIO.

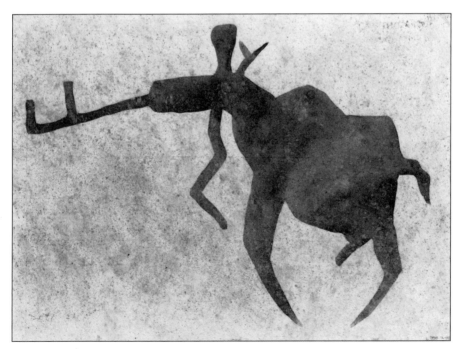

FIGURE 84. CROOKED LAKE, MINNESOTA. COURTESY OF THE ROYAL ONTARIO MUSEUM, TORONTO, CANADA.

In Figure 86d, the song for the otter medicine bag is "I am helping you," referring to the Otter Manitou.[101]

Another way to depict spirituality of the animal is to show it communicating with another figure. In Figure 86e, the Bear, the powerful medicine manitou, is in the midewigan taking power from the megis shell. The song is sung, "I have tried it, my body is of fire."[102] This probably refers to the White Bear, Owasse. The word has the sense not only of white but of light as in a bear glowing with fire. The device of lines-from-the-mouth is at Cow Narrows, Saskatchewan (Figure 15), where the bison manitou may be depicted giving medicine to a healer.

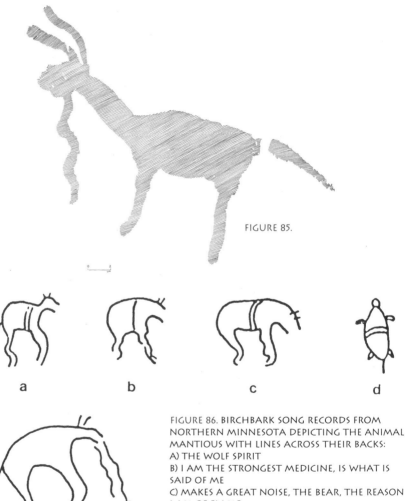

FIGURE 85.

a b c d

e

FIGURE 86. BIRCHBARK SONG RECORDS FROM NORTHERN MINNESOTA DEPICTING THE ANIMAL MANTIOUS WITH LINES ACROSS THEIR BACKS:
A) THE WOLF SPIRIT
B) I AM THE STRONGEST MEDICINE, IS WHAT IS SAID OF ME
C) MAKES A GREAT NOISE, THE BEAR, THE REASON I AM OF FLAME
D) I AM HELPING YOU
E) I HAVE TRIED IT, MY BODY IS OF FIRE

The above examples refer to the particular animal manitous. We have previously noted the shape-changing of manitous, Nanabojou included, into various animal forms.[103] Walter Red Sky identified one animal on a rock painting on Lake of the Woods as the way the manitou chose to appear in the dream.[104]

The animal manitous lived much like the Indians, holding feasts at prescribed times of the year. An Indian at Quebec told Le Jeune in 1636 that the birds usually made their feasts on the shortest nights of the year, the moose on the longest and the beavers at the equinoxes.

Prominent among the manitous was Otter, a guide of the Midewiwin and guard of the first degree; Sturgeon, the chief of the fishes who once swallowed Nanabojou; Moose, the most difficult animal to kill;[105] and Skunk, known as a hunter, wanderer and warrior and therefore warriors were allowed to wear its skin.[106]

The bones of animals received special treatment so as to not offend the animal manitou. For instance, the Montaignais in 1634 burned bear bones in the fire and buried the offal beneath the fire. They never threw bones of animals taken in a net – beaver, porcupines and birds – to their dogs. They burned them or, in the case of beaver, threw them into the river.[107] They couldn't spill beaver blood on the ground if they wished good hunting.[108] During feasts, they were careful to throw whatever was left in their dishes into the fire for their deceased relatives. But Allouez reported in 1671 that the Odawa never threw fish bones into the fire.[109] Thus, Indian etiquette was complex, and a non-native could easily appear rude at a feast.

TURTLE

Mikinak, Turtle, was chief messenger between the people and the manitous and is shown in that capacity at Picture Rock Island, Lake of the Woods (Figure 21).[110] It also was a warrior and protected the medicine stone of the second degree lodge,[111] and is depicted at Obabikon Narrows, Lake of the Woods, between two threatening serpents (Figure 87).

Warriors received powerful medicine for battle. For example, Sky In Terrible Commotion erected a sign on a medicine pole (Figures 13 and 14) after receiving a war medicine song in a dream. Some rock art was done in receipt of war medicine, as the Burntside Lake painting (Figure 42) shows. Turtle, as warrior, protects the archers on the left side of the painting.

Coleman was told in Minnesota in the 1930s that Ojibways built a turtle-shaped mound of earth near Cut Foot Sioux as a memorial to a decisive

FIGURE 87. OBABIKON NARROWS, LAKE OF THE WOODS. COURTESY OF THE ROYAL ONTARIO MUSEUM, TORONTO, CANADA.

victory over the Dakota. The medicine man built the mound with its head pointing in the direction taken by the retreating enemy. Turtle was chosen, Coleman was told, either because of its role as warrior or because it was the leader's dream sign.[112] This story offers some interesting explanations for other effigy mounds and rock alignments in the shapes of animals found in the Great Lakes area: 1) they were done by the medicine men, 2) they celebrated a particular special event, and 3) the figures represent dream signs of the important people involved or they are animal manitous chosen for their specific role in the event.

MISHIPIZHEU

One of the most spectacular figures on rock paintings is the manitou known as Mishipizheu, or Gitche-anahmi-bezheu, translated as Great Lynx, Great Underground Wildcat and Great Underwater Wildcat. The creature was always portrayed as a cat with the horns of power on its head. It often also had power lines resembling scales emanating from its body.

Mishipizheu was known as the chief manitou of the underwater realm, controlling storms on the lakes and the weather. Tanner knew it as the ruler of the seasons. But it was an underground manitou as well. Perrot was told that Mishipizheu "always dwells in a very deep cave" and "when he goes to

drink the waving of his tail stirs up high winds." The Indians prayed to Mishipizheu when they set out on voyages, smoking a pipe and uttering, "You are master of the winds; favour our voyage and give us pleasant weather."[113]

Hoffman was told that the Mishipizheu's "wigwam" was a mountain. Small wonder that pictographs of this manitou occur on cliffs. In a story told to Hoffman, a man named Piskineu entered a mountain and found an old man sitting opposite the entrance, wearing a breechcloth of the skin of a wildcat. He was one of the underground manitous, "the enemy of mankind." His feast dish contained a mass of eyeballs taken from his victims.[114] The cat manitou, known for its excellent eyesight, in this account blinded its enemies.

But the manitou had many powers and medicine men and women gained those powers. Songs recorded by James at Sault Ste. Marie included the following (Figure 88): "I am Manitou. Roots and Shrubs make me Manitou. Snakes are my friends; Underground Wildcat is my friend."[115] Compare this series of songs about roots-snake-Mishipizheu with a panel at Agawa Rock near the Sault (Figure 6) picturing the same figures, and perhaps referring to the attainment of the power of these creatures for medicines like the song. Agawa Rock was undoubtedly a home of a Mishipizheu and therein lay its importance as a sacred place.

Cat's powers were venerated for centuries. A perforated lynx canine tooth was discovered on a Laurel site on the Rainy River, dating back 2,000 years,[116] and Mishipizheu remained important, alternately threatening and guarding the initiates of the Midewiwin, at the end of the 19th century.[117]

Mishipizheu's power is in copper. Claude Dablon recorded a story in 1669 about four men who lost their way on Lake Superior and landed on an island near Michipicoten. They found many copper nuggets and loaded their

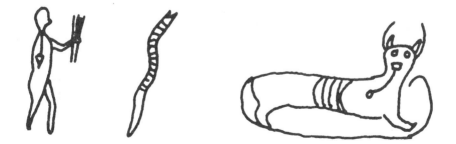

FIGURE 88. BIRCHBARK SONG RECORD FROM SAULT STE. MARIE, SOUTH OF THE AGAWA ROCK PAINTINGS: I AM MANITOU, THE ROOTS AND SHRUBS AND WEEDS MAKE ME MANITOU; SNAKES ARE MY FRIENDS; UNDERGROUND WILDCAT IS MY FRIEND. COMPARE TO FIGURE 6.

canoes with them, but they had not gone far when a voice said, "Who are those robbers carrying off my children's cradles and toys?" They believed the voice was a Mishipizheu, the guardian of the copper, accompanied by may-maygwayshiwuk, and they were so terrified that one man died. Later a second died, then a third, and finally, after telling the story, the fourth died of fear as well. By 1669, the Indians dared not go to the island.[118]

In 1665, Claude Allouez was told that the Odawa of Lake Superior made sacrifices to Mishipizheu to still the water and bring sturgeon, and they took copper nuggets from the Superior shores for their medicine bags. Some Indians possessed the nuggets "from time immemorial" in their families.[119] Among the Winnebago, a Siouan tribe which adopted the Midewiwin and called it the "medicine dance," water spirits' "bones" (probably copper) were prized possessions, endowed with remarkable powers.[120]

In an Ojibway story, a Mishipizheu attacked two women in a canoe. One hit the creature with a special paddle, knocking off part of its tail. It fell into the boat as a nugget of copper and thereafter it had powers for good luck,[121] as one of Mishipizheu's medicines. Mishipizheu came up at the canoe from a whirlpool, a form of spiral, a sign for medicine and the path to the manitou's presence. Two Mishipizheus with spiral tails appear on a rock face at Barbara Lake in northwestern Ontario (Figure 89).

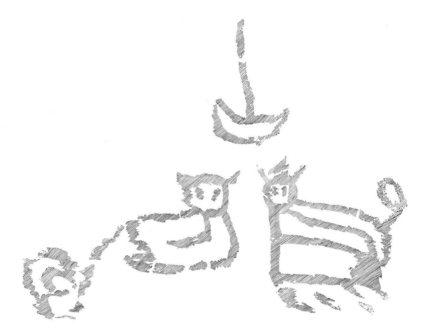

FIGURE 89. MISHIPIZHEUS AT BARBARA LAKE, NORTH CENTRAL ONTARIO.

In 1765, an Indian guide took Alexander Henry up the Ontonagon River near the Keewenaw Peninsula to see a huge copper boulder weighing about 5 tons.[122] Miners later transported it to the Smithsonian Institution in Washington where it stands today outside the National Museum of Natural History. In 1855, Keatanang, chief of the Ontonagon Band, told Kohl that a huge lump of copper in the bush was considered a great treasure in his family. "It is our hope and protection. Through it I have caught many beavers. Through its magic assistance, I have been victorious in all my battles, and with it I have killed our foes. Through it, too, I have always remained healthy and reached the great age in which you now find me."[123]

Unlike other manitous portrayed in profile, Mishipizheu is often drawn facing outward, looking straight at the viewer, and the reason for this may be contained in a story collected by Le Jeune in 1634 from the Montaignais at Quebec who said an evil manitou protects those it looks upon. The Montaignais prayed that it would not look at the Iroquois, their enemies.[124]

Some songs depict Mishipizheu simply as a face peering out at the viewer. Three songs recorded by James are in Figure 90. The first is "I come to change the appearance of the ground, this ground; I make it look different in each season"[125] and Figure 90b is "I come up from below, I come down from above."[126] It is a manitou who can see everything and may refer to Mishipizheu who has great eyesight. Figure 90c is another song about the cat, showing the full body with the head turned toward the viewer, having pierced the surface of the ground. It is "Now I come up out of the ground, I am wildcat."[127] Rock paintings that portray only the full face of a manitou, for instance at the Hickson-Maribelli Site in Saskatchewan (Figure 91) and Lenallen Lake in Manitoba (Figure 92), may refer to Mishipizheu.

a b c

FIGURE 90. BIRCHBARK SONG RECORDS FROM NORTHERN MICHIGAN:
A) I COME TO CHANGE THE APPEARANCE OF THE GROUND, THIS GROUND, I MAKE IT LOOK DIFFERENT IN EACH SEASON
B) I COME UP FROM BELOW, I COME DOWN FROM ABOVE ;
C) NOW I COME UP OUT OF THE GROUND, I AM WILDCAT.

FIGURE 91. THE HICKSON-MARIBELLI SITE IN SASKATCHEWAN. COURTESY OF THE ROYAL ONTARIO MUSEUM, TORONTO, CANADA.

FIGURE 92. LENALLEN LAKE, MANITOBA.

Mishipizheu's form blends with Snake and with other water creatures. A young man at Quebec in 1636 caught a fish that Le Jeune said resembled a great lizard with four feet and a long tail. His companions told him it was wrong to catch the animal because it caused fierce winds on the water.[128]

SERPENT

The snake's traditional role is that of the enemy of Thunderbird in an eternal struggle between the upper and lower worlds. It is often depicted with horns to signify its great power. The serpent, one of the ancient symbols in North America, could be a great threat to people, but if a medicine man or woman gained some control over it, it could release great power.

Le Jeune reported in 1637 that the Algonkians told him that thunder is caused by the Thunderbird vomiting up the Serpent, and lightning is the Serpent falling, or being flung, to the ground. [129]

Serpent plays an important role in medicine. The Midewiwin scrolls often depict it threatening the candidate's entry into the medicine lodge, and after his initiation, guarding the lodge for him, as in a pictograph at Wasawakasik Lake, Saskatchewan (Figure 93). It also appeared in the Shaking Tent, as possibly portrayed on a rock face at High Rock in Manitoba (Figure 94).

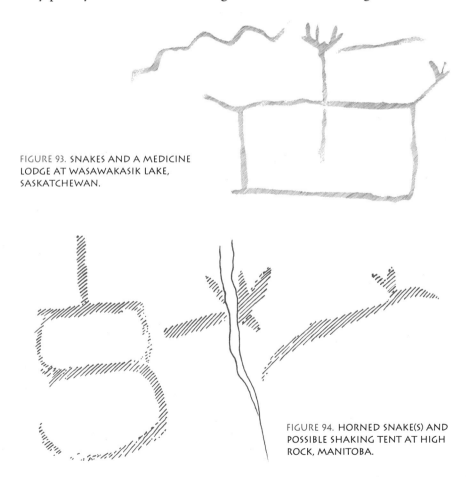

FIGURE 93. SNAKES AND A MEDICINE LODGE AT WASAWAKASIK LAKE, SASKATCHEWAN.

FIGURE 94. HORNED SNAKE(S) AND POSSIBLE SHAKING TENT AT HIGH ROCK, MANITOBA.

Snake's beneficial aspect shows up in the signs for many medicine songs, some of which are shown at Figure 95. The first is sung "Some one, I hear him; but I make myself black snake, my friend."[130] The medicine man who sings it hears a bad medicine man who is threatening his patient's life and, to oppose him, the medicine man uses the power and craftiness of the black snake.

The second song is the figure of a snake running over the ground with the words, "Long ago, in the old time, since I laid myself down, you are spirits."[131] The singer is another manifestation of Misakamigokwe, the Earth, Great Grandmother, sometimes Toad Woman, to whom songs are always addressed when people take up plants for medicine.

The third song is "That is a spirit which comes both from above and below,"[132] possibly referring to the fact that the Snake comes in the form of lightning from above as well as from the earth.

Conway has discussed the belief that long white quartz veins that run across rock faces are marks left by lightning striking the earth, and he noted that many rock paintings occur in direct relationship to the veins, often surrounded by them, or touching them.[133] The Wizard Lake Site (Figure 25) portrays a large horned serpent that was painted with its head placed on a quartz vein. It, of course, is the power in the vein. Conway notes that at Wizard Lake there are 80 figures but only two serpents, the only two figures touching quartz patches.

FIGURE 95. BIRCHBARK SONG SCROLLS FROM NORTHERN MICHIGAN:
A) SOME ONE, I HEAR HIM, BUT I MAKE MYSELF BLACK SNAKE, MY FRIEND ;
B) LONG AGO, IN THE OLD TIME, SINCE I LAID MYSELF DOWN, YOU ARE MANITOUS ;
C) THAT IS A MANITOU WHICH COMES FROM BOTH ABOVE AND BELOW;
D), E) AND F) OTHER DEPICTIONS OF THE SERPENT MANITOU.

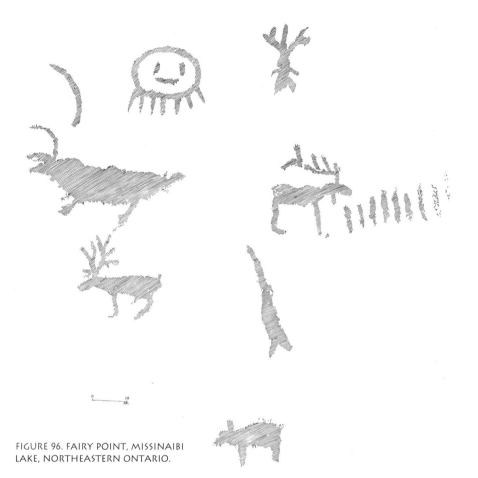

FIGURE 96. FAIRY POINT, MISSINAIBI
LAKE, NORTHEASTERN ONTARIO.

At Fairy Point on Missinaibi Lake (Figure 96), quartz veins frame the bottom of the rock face in a "V" shape. The figures point to the quartz vein with the serpent actually touching it.

Alexander Henry, who lived with an Ojibway family for a year in upper Michigan and travelled through Lake Superior country in the 1760s, said that while he was travelling with some Ojibway traders in 1764, they stopped on the north shore of Lake Huron to camp overnight. While he was gathering wood, he discovered a rattlesnake not more than two feet from his bare legs, its body coiled and head raised, rattling. Henry ran for his gun but the Ojibways stopped him. Instead they took their pipes to the snake, surrounding it and addressing it in turn, calling it their grandfather. They blew pipesmoke over it and Henry said it appeared to receive the tribute with pleasure. "It stretched itself along the ground in visible good humour." One Ojibway asked the snake to take no notice of the insult given by the

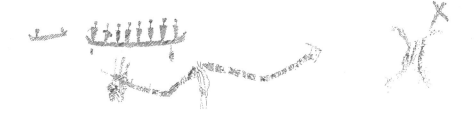

FIGURE 97. PICTURED LAKE NEAR THUNDER BAY, ONTARIO.

Englishman, but to take care of their families in their absence. They said it was the first time any one had seen a rattlesnake so far west of the French River and they inferred that this manitou had come to meet them.[134]

Perhaps the guardian nature of the snake is portrayed on a panel at Pictured Lake, northwestern Ontario (Figure 97) where the serpent appears to accompany the people travelling in the canoe toward the place with the sign for the entrance to the cliff, the opposed arcs.

While travelling on Lake Superior, Henry was told that an island near Michipicoten, probably Caribou Island, was called the Island of Yellow Sand where dwelt huge snakes guarding a treasure. When he visited the place, he found neither yellow sand nor snakes, but Henry suggested they might have turned themselves into hawks; manitous are good at shape-changing. There were plenty of hawks hovering around the crew and even pecking at them. They covered their faces in alarm. One hawk actually took the cap right off Henry's head in apparent anger at his intrusion. [135]

THUNDERBIRD

Birds, and especially Thunderbird, are also ancient symbols in North America. There are effigy mounds in bird shapes as well as serpents, turtles and other creatures. Birds have a prominent place on pipes, pottery, and other artifacts. One researcher has noted that the interconnection between bird, serpent and cat, widespread in the New World, was already present in the Hopewell Culture of Ohio 2,000 years ago.[136]

Thunderbird is often portrayed with outstretched wings. Lines resembling feathers, but more correctly translated as power lines, run down from the wings denoting the knowledge and power given from above to those below. But Thunderbird was portayed in several other ways. Le Jeune said in

1632 that when Nipissing Ojibways saw a picture of the Holy Spirit as a dove in his church at Quebec City, they immediately assumed it portrayed Thunderbird.[137]

Ojibways of northern Minnesota told Coleman that Thunderbird is the most powerful manitou, shown sometimes as two, sometimes as four, representing the four winds created by Kitche Manitou to make things grow. One informant said they are not evil; they aid people by driving away malevolent manitous of the earth and water. The Thunderbird design was considered so sacred that the Ojibways in the early part of the 20th century protested when it was displayed on a band in the Cass Lake Museum.[138] Since that time, the design has become more public.

One of Densmore's informants, Madjigijig (White Earth), told her that before attacking a Dakota village, a war party would call on Thunderbird to send rain to keep the Dakotas at home in their village and discourage them from changing camps because, in so doing, they might detect the approach of the Ojibway warriors.[139]

There were times, though, when Thunderbird could be menacing. Le Jeune was told in 1637 that Montaignais rested their spears point-upwards against the outside of their lodges so Thunderbird would turn away and not come near.[140]

Thunderbird played a major role for both the Mide and the Jiissakid. It was in charge of the 2nd degree lodge of the Midewiwin as well as the Jiissakid's Shaking Tent.[141]

The song scrolls depict different birds in similar fashion, and it is often impossible to recognize the exact bird in the signs. Figure 98 shows the signs for three songs about Loon, Hawk and Sparrowhawk. The bird with outstretched wings on pictographs may not always be Thunderbird. In addition,

a

b

c

FIGURE 98. THREE SONGS ON BIRCHBARK DEPICTING LOON, HAWK AND SPARROWHAWK.

the bird depicted may not refer to a bird manitou; it may also refer to a person. Kohl was told by an Ojibway called Little Wasp that his dream pictograph was a Thunderbird, indicating himself, with a large heart denoting his courage to fast for nine days.[142]

Birds, just as Turtle, had special relevance for warriors. The charm usually worn on a cord around the neck of the Ojibway warrior consisted of the skin of a bird, dried and filled with a medicine known only to the wearer, probably suggested to him in a dream. Densmore recorded the following warrior's song, "It is wafted upward, my bird plumage. They will be flying, my balls." The first part refers to his charm, the second to the heads of his enemies. Madjigijig made a war charm for Densmore using "the smallest kind of bird that flies in the evening," a kingbird known for its fearless aggression, even towards eagles, hawks and owls.[143]

For birds on Shield rock paintings, we have many options for interpretation: some to do with the receipt of rains, some for receipt of powers against evil manitous, some as guardians of the Mide lodge or the Shaking Tent, and others for war medicine.

BEAR

Bear was always special among the Algonkians. Bear teeth perforated for suspension as ornaments were found at a Laurel site on the Rainy River.[144] Bear's image was sometimes blended with that of a bird. At the Hopewell Site in Ohio, the namesake site of the Hopewell Culture, excavators found a bear canine tooth with pearl insets on either side near the tip of the tooth, forming the image of a bird's head. The Edwin Harness Site in Ohio had bear bones engraved with both a bear's head and wings. These early finds are perhaps the equivalent of the Mide song recorded by Densmore many centuries later (Figure 99a) that sings about Bear but portrays a bird: "I who live in a cave, Our Grandfather, arms he has with feathers, I who live in a cave."[145]

Hoffman was told by the Menomini that bears killed in the hunt are servants of the Bear manitou who dwells in a "lofty, long mountain."[146] When a bear was killed, the body remained for the people but the shade of the bear returned to the mountain, "the Bear chief's wigwam."

A Menomini Mide told Hoffman that Nanabojou once went toward the rising sun where he saw a large white bear, Owasse, basking in the sun atop a high mountain. He was one of the most powerful underground manitous. Nanabojou approached cautiously, drawing an arrow from his quiver. He fixed it to his bowstring and shot the bear. Its blood ran down the moun-

FIGURE 99. BIRCHBARK SONG RECORDS ABOUT BEARS:
A) I WHO LIVE IN A CAVE, OUR GRANDFATHER, ARMS HE HAS WITH FEATHERS, I WHO LIVE
IN A CAVE
B) THE SOUND OF THUNDER IS THE WHITE BEAR OF FIRE ;
C) I AM ABOUT TO WALK

tainside and stained it so that it is visible even today. The Mide said, "There we get some of the medicine which is used by the Mides."[147] North of Dryden, Ontario, there is a rare white rock painting, not surprisingly of a bear.

Bear was important in the Midewiwin as the Manitou guarding the third degree lodge, and Hoffman was told that the Mide personifies Bear when entering the lodge.[148] Densmore was told the same and she recorded a song about the occasion, "The ground trembles as I am about to enter."[149]

Other songs deal with Bear and White Bear. Figure 95c is "I am about to walk," and the lines on the back of Bear indicate his spirit character. Figure 99b is "The sound of thunder is the White Bear of fire."[150] Perhaps the "sun-face" on a rock painting at Fairy Point (Figure 96), like Figure 99b from the songs, portrays not Sun but the White Bear.

BEAVER

It is not surprising that Beaver, a powerful water animal, appears in several songs. The song shown in Figure 100a is sung "Verily, I am a spirit to be able to become visible, I who am a male beaver."[151] Beaver appears again in a song about one of the special places for the Midewiwin, the rapids at Sault Ste. Marie. Figure 100b says, "At the long rapids, I am called to go in, my Mide brethren."[152] The Sault rapids was the Beaver's dam destroyed by Nanabojou. This area has a long history. Large Laurel sites, dating back about 2,000 years, are located both on Whitefish Island on the Canadian side of the rapids[153] and on the shore of the St. Mary's River on the American side of the rapids.[154] The beaver manitou, with lines across its back to attest to its spirituality, appears on

a b

FIGURE 100. BIRCHBARK SONG RECORDS FROM NORTHERN MINNESOTA:
A) VERILY, I AM A SPIRIT TO BE ABLE TO BECOME VISIBLE, I WHO AM MALE BEAVER;
B) AT THE LONG RAPIDS, I AM CALLED TO GO IN, MY MIDE BRETHREN

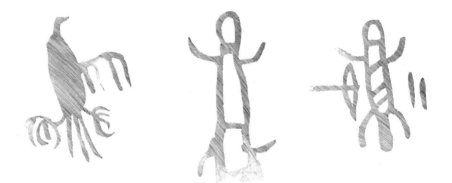

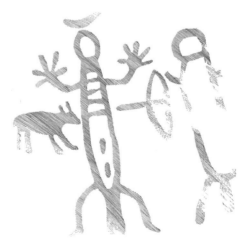

FIGURE 101. FRANCES LAKE, NORTHWESTERN ONTARIO, POSSIBLY A VERY EARLY PAINTING.

a painting on Frances Lake in northwestern Ontario (Figure 101) and Dewdney suggested that both style and content point to a very early date for this painting, a hypothesis still to be tested.[155]

HUNTING MEDICINE

The Ojibway hunters had many hunting medicine songs (Figure 102) and some of the rock paintings clearly record hunting medicine in a similar manner (Figures 10). The Algonkian song recorded by a European was a hunting medicine song possessed by an Algonquin named Pigarouich who learned it in a dream and sang it for Le Jeune in 1637. Le Jeune set it down as "Iagoua mou itoutaoui ne e-e" but he did not receive the translation.[156]

The hunter's luck could be enhanced by hunter's medicine, depicted on the scrolls as a "life line" to the heart of the animal, controlling the life of the subject. Figure 10 from Deer Lake in northwestern Ontario depicts the hunted animal in this fashion. Hoffman's informants told him that a hunter seeking help

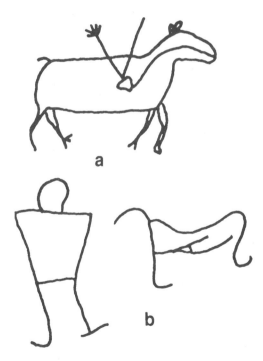

a

b

FIGURE 102. HUNTER'S MEDICINE SONGS FROM NORTHERN MICHIGAN AND NORTHERN MINNESOTA DEPICTING HUNTERS MEDICINE SONGS WITH A LIFE LINE TO THE HEART OF THE ANIMAL

would approach a Mide who would present a pipe offering to Kitche Manitou and to the manitou who controls the class of animals sought in the hunt. Then he would sing a song and draw the animal on bark. At the place of the heart, "a small quantity of vermilion is carefully rubbed, this colour being very efficacious."[157]

John Tanner drew for his biographer some hunter's songs that were given to him by a medicine man (Figure 103). Tanner said that once his people were so reduced by hunger that they had to conduct a medicine hunt.

> Nah-gitche-e-gumme sent to me and Ogemahweninne, the two best hunters in the band, each a little leather sack of medicine consisting of certain roots, pounded fine and mixed with red paint, to be applied to the little images or figures of the animals we wished to kill... A drawing, or little image is made to represent the... animal on which the power of the medicine is to be tried, then the part representing the heart is punctured with a sharp instrument, if the design be to cause death, and a little of the medicine is applied.[158]

The drawing of the animal was called muzzineneen (muzzineneenug in the plural, meaning images) and was traced on birchbark, wood and sometimes on the ground.

Another time, Tanner again resorted to the medicine hunt. He sang and prayed half the night then lay down to sleep. A beautifully dressed young man came to him in his dream and showed Tanner tracks of two moose and one bear and said to him, "I give you those to eat."[159] Tanner awoke and asked

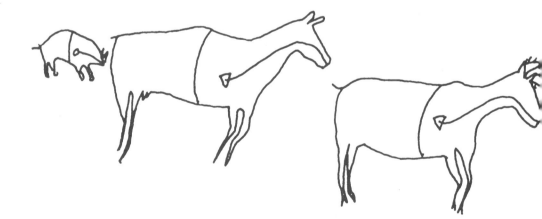

FIGURE 103. JOHN TANNER'S DREAM DURING A MEDICINE HUNT.

his companion to smoke with him, then he prepared the muzzineneenug, as shown in Figure 103. Tanner said that the Odawa with whom he lived determined the skill of hunters by the number of moose they killed, the moose being the most difficult of all animals to capture.

Not all of the hunted animals are depicted in this way. Mrs. Seymour suggested that, in the the pictograph from Cuttle Lake near Fort Frances (Figure 73), there is significance in the fact that all are land animals and the whole painting probably denotes a hunt.[160]

Densmore noted that some animals in the scrolls are not the objects of the hunt but are totem marks. For the living, the animals are depicted upright and for the dead, they are inverted,[161] like a painting at Bigshell Lake, Manitoba (Figure 104).

The bear hunt was special for many bands. Le Jeune learned in 1636 that the Algonquins adorned the bottom of their garments with bear's claws to let them easily take bears in the hunt.[162] Perrot learned in the late 17th century that the Indians of Lake Michigan conducted a special feast on the occasion of a bear hunt. It was a custom that a chief declared before his band that he desired to go on a bear hunt and he told them the day he would set out. He fasted for eight days so that the Bear would be favourable to the chief, then held a feast at which the members of the hunting party partook of the food but not the chief. On the day of their departure, they blackened their faces

FIGURE 104. BIGSHELL LAKE, MANITOBA.

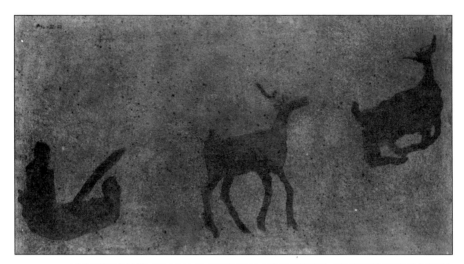

FIGURE 105. HUNTING PANEL AT AGAWA ROCK ON LAKE SUPERIOR. COURTESY OF THE ROYAL ONTARIO MUSEUM, TORONTO, CANADA.

like a war party and all fasted until evening when they were allowed a little to eat. The next morning they set out.[163] Perrot's account shows us that bears, as at Cuttle Lake, indicate a special hunt, no doubt accompanied by a feast.

A panel at Agawa Rock (Figure 105) may also portray the hunt. On the scrolls, the same figure can appear twice, denoting movement through time. The caribous at Agawa may be one beast, first alive and then a carcass. The line projecting from the canoe is similar to one on another painting on the Upper Molson river in Manitoba (Figure 106). They probably represent

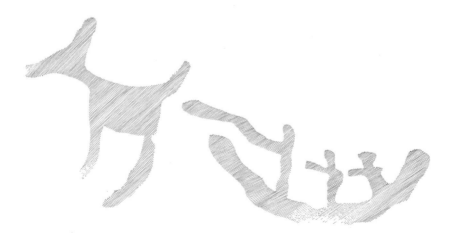

FIGURE 106. HUNTING SCENE ON THE UPPER MOLSON RIVER, MANITOBA.

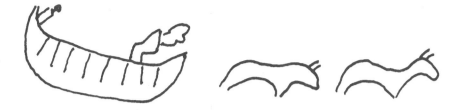

FIGURE 107. A NIGHT HUNTING SCENE RECORDED ON BIRCHBARK IN NORTHERN MINNESOTA DEPICTING THE HUNTER IN A CANOE, WITH TORCH IN FRONT.

torches for night hunting as shown in a song recorded by Hoffman (Figure 107). He was told that the hunter in the picture is at the back of the canoe; the front figure is a pine torch placed in the bow of the canoe because it was a night hunt. The animals represent the hunted beasts.[164]

DRUMS AND RATTLES

The Algonkian people used a number of musical instruments, shown in Figure 108, taken from Densmore's two volumes, *Chippewa Music*.[165] The medicine drum was a small wooden cyclinder filled with water and struck with a

FIGURE 108. OJIBWAY MUSICAL INSTRUMENTS (LEFT TO RIGHT): BIRCHBARK SONG SCROLLS, RATTLE AND DRUMSTICK, MEDICINE DRUM AND STICK, RATTLES. SMITHSONIAN INSTITUTION, NATIONAL ANTHROPOLOGICAL ARCHIVES.

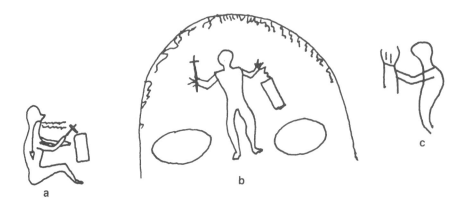

FIGURE 109. BIRCHBARK SONG RECORDS DEPICTING THE MEDICINE DRUM:
A) A MIDE SINGS AND BEATS THE DRUM,
B) A MIDE PLAYS THE DRUM BETWEEN TWO LAKES WHILE RAIN FALLS FROM THE SKY; AND
C) MUSIC RISES FROM THE MIDE'S DRUM.

curved or cross-shaped stick, and portrayed often in the scrolls (Figure 109). We have seen it in Figure 8, Sassaginnigak Lake, Manitoba, and it may also be in Figure 110, Namakan Narrows in northwestern Ontario. The explanations for Figure 109 are the following: (a) a Mide singing and playing the drum;[166] (b) the arch is the sky from which rain is falling and the Mide beats the drum between two lakes;[167] and c) a sign meaning "I have finished my drum," showing the medicine man holding the medicine drum with sound ascending from it.[168]

A scroll from northern Minnesota depicts the medicine drum as a spoked wheel (Figure 72) so two spoked circles on a rock painting at Cuttle Lake (Figure 73) may indicate the drums and songs as offerings to a manitou.

Densmore also shows a war drum (Figure 11, left) shaped like a tambourine, sometimes used with curing songs. Rattles were small cylinders of bark shaken in the hand (Figure 111) or larger tambourine shapes filled with stones and struck on the ground. Rock art also portrays rattles (Figures 12 and 52).

Like other sacred objects, the drums were decorated with significant signs. Coleman was told that only certain designs could be portrayed on the musical instruments. On the drums she saw were

FIGURE 110. A DRUM AND DRUMSTICK AT NAMAKAN NARROWS, NORTH-WESTERN ONTARIO. COURTESY OF THE ROYAL ONTARIO MUSEUM, TORONTO, CANADA.

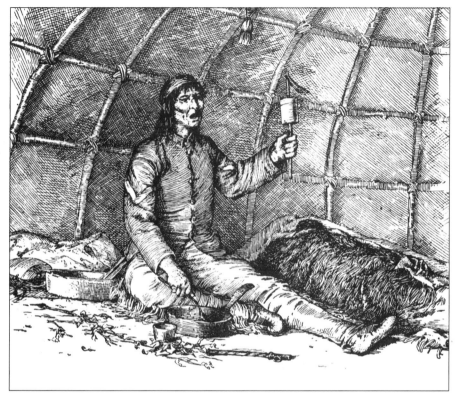

FIGURE 111. A MEDICINE MAN PREPARING MEDICINE. SMITHSONIAN INSTITUTION,
NATIONAL ANTHROPOLOGICAL ARCHIVES.

star, moon, sun, thunderbird, heart, cross, medicine man's eye, hand, bear
paw and others. The Minnesota Ojibways told her that formerly the "abode
of the manitous" (Figure 43) was also used. Loon and owl were common on
drumsticks, and rattles showed the Four Winds, the hand and the heart,
among others.[169]

A Mide named Odjibwe from Leech Lake told Densmore that a man
invented the use of the drum, and the lightning on Odjibwe's war drum
(Figure 11) is a picture of that man's dream. The sound of the drum is like
the thunder.[170]

The medicine drum is called the mitigwakik, wooden kettle. In former
times, clay pots filled with water were used as well, as Radisson saw in the
1660s at the west end of Lake Superior.[171] Perhaps the few clay vessels exca-
vated from archaeological sites that have unusual designs on them, like the
pot with the plant from the site in Kenora dating to the Laurel period, were
used in a special way, as a drum.

Drums, drumsticks and medicine bags were also decorated with tinkling cones, little cone-shaped twists of copper, brass and other metals that gave off a loud, pleasant jingle. Mrs. Seymour said that in her youth at Lac Seul, Ontario, the children were told never to touch the drum or the spirits would hear the tinkling cones and curse them.

She said a woman not long ago dreamed that her dress should be decorated with the cones, so she made a garment with numerous rows of tinkling cones covering the entire surface. It became known as a jingle dress and today is popular among young women who wear it for special dances. Mrs. Seymour said some of the older women remember the sacred nature of the dress and decline to wear it if not qualified.

PIPES

Pipes appear on many rock paintings, for instance in Figure 112, a painting from Lac La Croix in Quetico Provincial Park. The pipe remains one of the most profoundly sacred possessions of the Indians across North America. The stem was painted with symbols and adorned with symbolic items precious to the owner, and originally may have had importance with or without a clay or stone bowl attached.[172] The pipestone itself was considered to have living power, called "medicine" by some Indians.[173] The Ojibway language has both animate and inanimate words, and the word for stone pipe, assiniop-wagan, is animate. The bowl also was sometimes decorated with signs important to the owner. The little pipe discovered at Providence Bay, an Odawa site on Manitoulin Island mentioned in Chapter 2, depicts the arms-up sign of giving and receiving medicine, similar to the rock paintings.

FIGURE 112. A PIPE SMOKER AT LAC LA CROIX, QUETICO PROVINCIAL PARK. COURTESY OF THE ROYAL ONTARIO MUSEUM, TORONTO, CANADA.

MEDICINE BAGS

Many rock paintings depict the healers holding their medicine bags, such as the famous figure that Dewdney dubbed the "Bloodvein Shaman" (Figure 113), with radiating power lines from his head and an otter bag in his hand at a spectacular site on the Bloodvein River in northwestern Ontario (Figure 114). The songs portray the bags in a similar manner. The pictures in Figure 115 depict Mides holding (from left) an otter medicine bag[174], a snake medicine bag,[175] yellow ochre,[176] an otter bag,[177] and a walking stick to denote an Elder.[178] The bag, like the pipe, was treated with profound respect. A Sauk explained their attitude in the following:

"You know that we always carry medicine bags about us and in these we place the highest confidence. We take them when we go to war; we administer their contents to our relations when sick. The great veneration in which we hold them arises from our deeming them indispensible to obtain success against our enemies. They have been transmitted to us by our forefathers who received them at the hands of the Great Master of Life himself."[179]

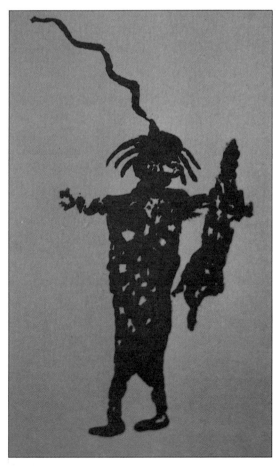

The bags were made from the whole skin of small animals, often the otter, muskrat, snake or bird, with head, legs and tail attached so that the animal's form was retained. Le Jeune found a bag owned by a Montaignais at Quebec made of the hand of an Iroquois, the Montaignais' enemy, "so skillfully prepared that the nails remain."[180]

FIGURE 113. A SHAMAN WITH RADIATING POWER LINES AND A MEDICINE BAG ON THE BLOODVEIN RIVER, NORTHWESTERN ONTARIO.

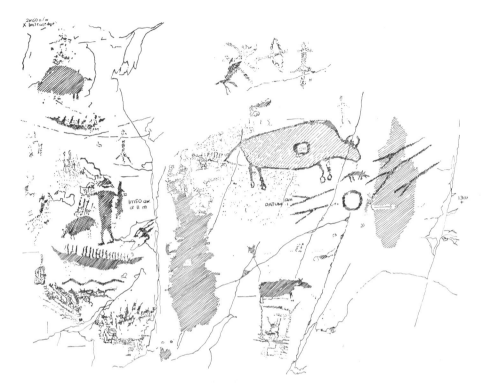

FIGURE 114. THE BLOODVEIN RIVER ROCK PAINTINGS.

a b c

d e

FIGURE 115. BIRCHBARK SONG RECORDS DEPICTING MEDICINE BAGS AND OTHER ITEMS (LEFT TO RIGHT): MIDES HOLDING AN OTTER BAG, A SNAKE, BAG, YELLOW OCHRE, AN OTTER BAG AND A WALKING STICK.

Hoffman heard among the Menominis of Michigan that wonderful feats were performed by the medicine men and women in the old times when people had the power to obtain "stronger medicine." Lewis Cass, governor of Michigan, attended a meeting of the Odawa medicine society in the early 19th century. Toward the end of the day, Cass observed an old Ojibway medicine woman who had actively participated in every dance. He asked someone nearby why the woman took such an active part because she appeared to him rather uninteresting and had nothing to say, and with apparently nothing to do except shake her snake-skin bag. The woman heard the remark and was offended because she was a respected Midekwe. In an instant she threw the bag at Cass and the skin became a live serpent. It rushed at Cass and ran him out of the lodge. Then it returned to the medicine woman who picked it up and it returned to its state as a skin bag.[181]

Jesuit Jerome Lalemant reported in 1648 another tale possibly relating to an otter medicine bag. A medicine man of an unnamed Algonkian band in Quebec "who had killed an otter," wound the otter "while still warm" around the neck of a Frenchman. He at once fell down unconscious. The medicine man then took the otter by the hind legs and struck the Frenchman with it on the stomach and he regained consciousness immediately.[182]

In the bags mentioned by the Jesuits, the people carried plants and minerals for the medicines along with other items deemed important to them, including some stones given to them by the manitous that carried power for healing, hunting or other tasks. No one disturbed another's bag, just as no one sang another's song.

Other medicine bundles contained similar objects. Le Jeune was shown one owned by a Montaignais containing iron pieces, arrowheads, "little pieces of wood shaped at both ends like a serpent's tongue" and sticks "made in the shape of spindles except that they were heavier and had something like teeth in certain places." The bundle also contained a foot of a porcupine and the bone of another animal.[183] The sticks with snake's-tongue ends may be portrayed at Figure 75, a rock painting at Scotia Lake in northeastern Ontario, where there are snaky lines with forked ends.

TRIANGLES AND CONES

The Hopewell people of Ohio made peculiar objects of polished stone about handsize and cone-shaped. No practical explanation has been put forward for these apparently nonutilitarian objects, but a possible meaning may be in Le Jeune's letters for 1634 regarding the beliefs of the Montaignais. A

FIGURE 116. A TRIANGULAR OR CONE-SHAPED OBJECT AT LAC WAPIZAGONKE, WESTERN QUEBEC.

Jiissakid decribed for him the "air spirits as large as a fist with a body of stone and rather long." Le Jeune gathered that they were cone-shaped, large at one end and tapering, with no feet or wings. When he asked how they flew into the shaking tent if they had no wings, the Jiissakid answered tersely, "In truth, this Black Robe has no sense!"[184]

Triangles on rock paintings (Figure 116) may be depictions of these spirits. They may also be indications of the heart, the source of life in the man or animal, almost always shown as a triangle on the birchbark records of the Midewiwin.

CANOES

The birchbark canoe (Figure 117) appears on rock art across the Shield. It was an invention greatly honoured by the Indians who attributed its origin to Nanabojou.[185] The Jesuit missionaries found the bark canoe an excellent craft in the hands of skilled paddlers but they had troubles themselves when asked to help manoeuvre the boats. They hadn't the strength of the Indian paddlers and often couldn't keep up, so they took sails along with them to act as the "missionaries' paddles". The Indians would have none of that, usually making them use wooden paddles as well.[186]

Romas and Joan Vastokas, the researchers of the Peterborough Petroglyphs of southern Ontario, noted that the boat in world shamanic tradition is often

FIGURE 117. OJIBWAY BIRCHBARK CANOE PHOTOGRAPHED ABOUT 1895, PROBABLY IN NORTH-ERN MINNESOTA. SMITHSONIAN INSTITUTION, NATIONAL ANTHROPOLOGICAL ARCHIVES.

the vehicle of spirits or shamans in the journeys to other worlds. They suggested that at least some of the canoes in Shield rock art refer to these trips, especially those depicting occupants with upraised arms in supplication to the manitous.[187] It is interesting that Densmore recorded an instance of the Midewiwin in which the four Mides who conducted the initiation rites were described as occupants of a canoe. The first man to "shoot" the candidate for initiation was called Nemitamaun, a word translated for her as "the man who sits in the bow of the boat to watch which way the boat is going." The last man to initiate the candidate was Wedaked, "like the steersman who sits in the stern of the boat and guides it."[188]

An Indian of the Dakota nation, some of whom adopted the Midewiwin, drew for Kohl his dream in which an exact duplicate of the above idea is shown (Figure 118), depicting the wise men, warriors and chiefs in the medicine lodge as occupants of a canoe. The square in the centre of the boat is the door of the structure, and the small circle above it is the great stone in the centre of the medicine lodge. The dreamer also saw a peace pipe hung from a large tree. Then he saw two canoes floating in the air above him, each with two Ojibways whom he knew he was to kill; their faces were blackened and they had sung their death songs. The canoes floated close to the door of the lodge, then suddenly a large hole opened in the ground, the square in the middle of the picture, and the men paddled into it and were swallowed up before his eyes.[189]

The above accounts show that canoes on rock art may not always refer to

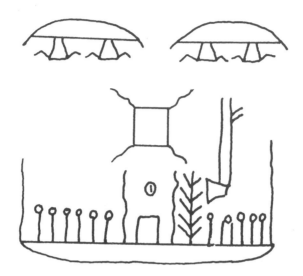

FIGURE 118. A DAKOTA INDIAN'S DREAM, ABOUT 1855, SHOWING PEOPLE IN THE MEDICINE LODGE (BOTTOM) AS OCCUPANTS OF A CANOE.

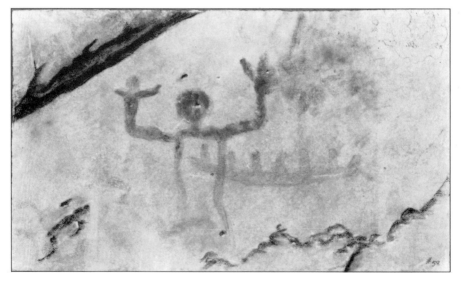

FIGURE 119. DEER LAKE, NORTHWESTERN ONTARIO. COURTESY OF THE ROYAL ONTARIO MUSEUM, TORONTO, CANADA.

FIGURE 120 AGAWA ROCK, NORTHEASTERN ONTARIO. THE ANIMALS PROBABLY DEPICT TOTEMS OF THE OCCUPANTS.

FIGURE 121. DRYBERRY LAKE, NORTHWESTERN ONTARIO.

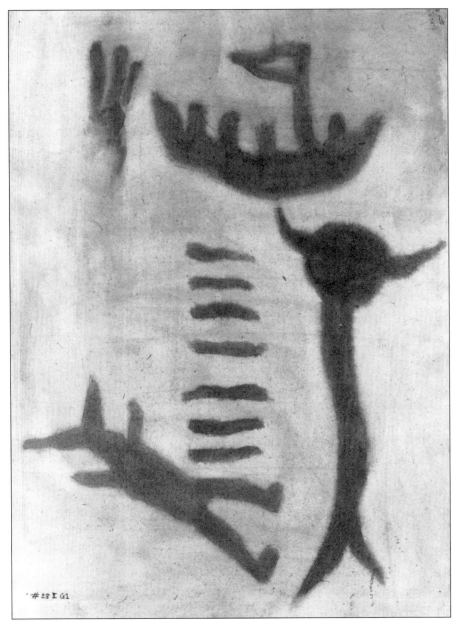

'#28 I G1

FIGURE 122. A ROCK PAINTING IN WHITEFISH BAY, LAKE OF THE WOODS. COURTESY OF THE ROYAL ONTARIO MUSEUM, TORONTO, CANADA.

FIGURE 123. CROOKED LAKE, NORTHERN MINNESOTA. COURTESY OF THE ROYAL ONTARIO MUSEUM, TORONTO, CANADA.

the crafts for travelling through this world. Paintings from across the Shield (Figures 119 to 123) depict canoes possibly entering or leaving the cliffs, taking the medicine men on their important journeys.

POLES, FLAGS

Several rock paintings depict what appear to the European eye to be flag poles, for example at sites on Lake of the Woods, Dryberry Lake and Crooked Lake, Minnesota (Figures 121 to 123), but most of them probably refer to signs for medicine or medicine poles in common use among the Ojibway (see Figures 13 and 14).

Copway reported the sign for powerful medicine as a vertical line with horizontal lines streaming out from it, as in Figure 124. The first two pictures

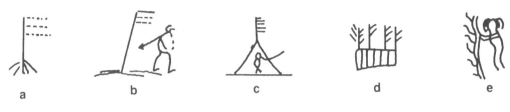

FIGURE 124. BIRCHBARK SONG RECORDS:
A) POWERFUL MEDICINE,
B) POWERFUL MEDICINE AND SPIRIT,
C) THE MEDICINE LODGE,
D) THE MEDICINE LODGE,
E) MIDE HOLDING POWERFUL MEDICINE.

stand for the power of the medicine, and the third for the medicine lodge with the same sign attached to it like a flag.[190] The next figure, from Mallery,[191] depicts the medicine lodge in floor plan complete with either sacred trees or the sign for the power of the medicine, or both. The last figure, also from Mallery, shows the Mide with a powerful medicine root.[192]

Densmore visited Lac du Flambeau, Wisconsin, in the early 20th century where residents still continued to erect medicine poles beside their houses. They told her the custom of erecting poles had its orgin many generations ago when a young man fasted and dreamed of thunderbirds on a tall tree. He returned home, cut down a tree, trimmed off the branches to make a pole,

FIGURE 125. A MEDICINE POLE LAID HORIZONTALLY TO COMPLY WITH THE DREAMER'S VISION, AT LAC DU FLAMBEAU, WISCONSIN. SMITHSONIAN INSTITUTION, NATIONAL ANTHROPOLOGICAL ARCHIVES.

drew the picture of his dream on a deerskin and attached it to the pole.

Later, the custom changed. Young men did not erect poles as soon as they had fasted but waited to see whether their dreams came true. They usually concerned war and if they went to war and fulfilled the dreams they still did not put up poles. But, if they didn't go to war and had no need of the power of the songs of their dreams, they portrayed their dream songs on poles as notice that they had great powers. They were known to have power especially over the greatest enemy – death – so were supposed to have special abilities to cure the sick.[193] When friends of a sick person were anxious about his condition, they put tobacco in one of his garments and fastened it high on one of the poles.

Densmore saw another form of pole, erected by Medweyasun (The Sound of the Wind) at Lac du Flambeau. It was an uprooted tree (Figure 125) laid between forked poles, specifically placed that way because Medweyasun in his youth dreamed he was leader of a war party and leapt over a fallen tree in pursuit of the enemy. By the time he grew up, the tribes were at peace and he did not have to go to war, but he still possessed the song of his dream. He was a very old man and was ill when Densmore visited Lac du Flambeau. The residents had tied several pieces of his clothing to the pole in efforts to prolong his life.

Similarly, the people of Garden River erected a pole near the home of Shingwaukons, the great chief and medicine leader in the Sault area, when he was dying of old age in the mid-19th century. Kohl said "they wished to do something to save him and hit upon the idea" of putting up a new pole.[194] They erected a medicine pole beside the flagstaff holding the British flag.

Schoolcraft, who lived on the American side of the St. Mary's River at the Sault said many people had medicine poles outside their houses. One day, the officers at Fort Brady, the U. S. army post, ordered their men to get new tent poles. The men saw the medicine poles in the Indian village, and not understanding their importance and thinking them convenient, collected all the poles for their tents. Naturally, the next day, the villagers retrieved their medicine poles and put them up exactly as they had been.[195]

A figure on a painting on Lake of the Woods was interpreted by Dewdney as possibly a European fort with its flagstaff, perhaps Fort St. Charles built by LaVerendrye in 1732 (Figure 33, far left). However, it may in fact be a portrayal of a medicine lodge or home with a medicine pole erected outside.

In light of the fact that some rock art sites portray "flags" on canoes, it is interesting to note that Tanner's adoptive mother, described as the foremost Odawa chief and a powerful and respected Midekwe, "always carried a flag in

her canoe" and "whenever she came to Mackinac she was saluted by a gun from the fort." Tanner may have been referring to a British or American flag but chances are that it was one of her dream signs on cloth because when she buried her son, Keewatin, at Grand Portage beside her husband's grave she "hung up one of her flags at his grave."[196]

CROSSES

The cross, like the circle, is ancient on this continent, dating back at least 2,500 years in Indian symbolism. Adena stone tablets from the Ohio Valley are carved with designs using the cross as the basic element of design organization. It is on rock paintings, for instance at Fairy Point on Lake Missinaibi, northeastern Ontario, and a site east of Sassaginnigak Lake in Manitoba (Figures 126 and 127). When Marquette first visited the Green Bay area of Lake Michigan, he discovered a village of Miamis, Mascoutens and Kickapoos who had erected a cross in their midst and adorned it with many white skins, red belts, and bows and arrows, offerings to Kitche Manitou in thanks for good hunting the previous winter. Marquette thought it was a Christian cross, but Hoffman, the researcher of Minnesota Midewiwin, pointed out that the post that is symbolic of the fourth degree of that society is the cross, and concluded that the one the missionary saw had no doubt been erected long before the Jesuits entered Algonkian country.

The cross is depicted on the song scrolls with various meanings, all connected by metaphor. Both James and Densmore observed drumsticks in the shape of crosses among the medicine men. Figure 128a is a Mide with his drumstick singing "I am a manitou, what I have I give to you in your body."[197] Figure 128b is the midewigan with the medicine stone and pole in the centre. The lines denote the people gathered

FIGURE 126. FAIRY POINT, MISSINAIBI LAKE, NORTHEASTERN ONTARIO. COURTESY OF THE ROYAL ONTARIO MUSEUM, TORONTO, CANADA.

FIGURE 127. SITE EAST OF SASSAGINNIGAK LAKE, MANITOBA.

FIGURE 128. BIRCHBARK SONG RECORDS SHOWING CROSSES IN OJIBWAY PICTOGRAPHY FROM
NORTHERN MICHIGAN, WISCONSIN AND MINNESOTA:
A) A MIDE WITH HIS DRUMSTICK;
B) A MIDE LODGE WITH THE POST AND STONE AT THE CENTRE;
C) THE TREE OF LIFE, AND
D) THE EAST AND SOUTH WINDS.

for the ceremony, and the song is "You shall now behold the Midewiwin in practice."[198] Figure 128c is Loonfoot's drawing for Kohl who said he didn't quite understand what Loonfoot meant when he interpreted the scroll. Kohl thought the sign looked like a drumstick but Loonfoot said it was "an emblem of life", the tree of human life: "Like trees we grow up, and like trees we pass away again."[199]

The cross, like its elaboration, the swastika, also indicated the four cardinal directions and the four Wind Manitous. A song recorded by Densmore (Figure 128d) depicts two figures crossed, the horizontal one representing the East Manitou and the vertical one the South Manitou; in Indian pictography, one always faces south so that east is at the left and west at the right. The song is, "Where is the dwelling of the greatest spirit? My Mide brethren, in the east is the dwelling of the greatest spirit, My Mide brethren. Here toward the east is his dwelling."[200] The East Manitou, often equated with Nanabojou whose home is toward the east, was the orginator of the Midewiwin, bringer of life like the sunrise. Thus the crosses on rock paintings may signify a Midewiwin connection.

The crosses could also indicate trade as in hand sign language – the index fingers or hands crossed, usually in front of the breast.[201]

The cross sometimes also indicated action in battle. The Sauk and Fox of Wisconsin erected a pole over the grave of a warrior on which were painted crosses to denote the number of people he killed.[202] This interpretation is interesting when applied to Figure 127, which also has a handprint. Both Mallery and Mrs. Seymour suggested the handprint could denote the death of a warrior.

DOTS, LINES AND TRACKS

Journeys – the Quest – are a major Algonkian theme, "the heart of Ojibway religion,"[203] as can be seen in the quest for a guardian manitou, in the passages through the stages of initiation into each degree of the Midewiwin, and in the search for medicine or the medicine manitou. Nanabojou was the original Quester, and perhaps is still travelling, as Mrs. Syrette said in her story.

Journeys are depicted in several forms on the scrolls. Crooked lines are common; Figure 129a, from Kohl, is the flight path of a bird;[204] Figure 129b, also from Kohl is the right path, the path of life;[205] and Figure 129c shows the Mide as Bear holding his medicine bag and standing on the ground that radiates with the power of the plants. The Mide travels around the lodge, as

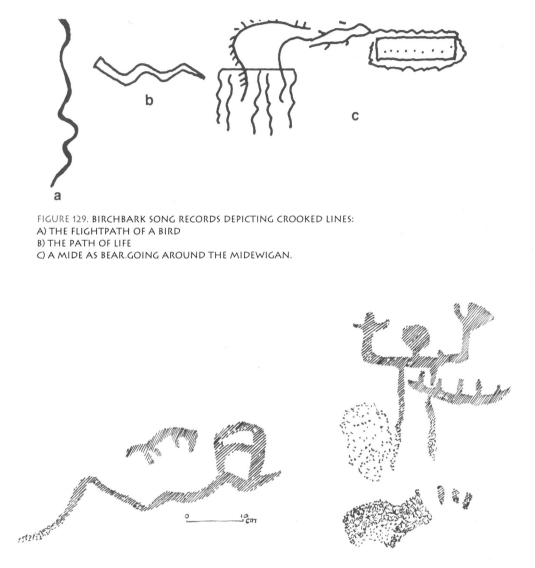

FIGURE 129. BIRCHBARK SONG RECORDS DEPICTING CROOKED LINES:
A) THE FLIGHTPATH OF A BIRD
B) THE PATH OF LIFE
C) A MIDE AS BEAR GOING AROUND THE MIDEWIGAN.

FIGURE 130. DEER LAKE, NORTHWESTERN ONTARIO.

shown by the crooked lines.[206] The rock paintings use this device as well. Mrs. Seymour interpreted the snaky line on the Annie Island painting, Lake of the Woods (Figure 7), as a long and difficult journey. The crooked journey line also appears at Deer Lake (Figure 130) and at Picture Rock Island, Lake of the Woods (Figure 131).

Communion with the spiritual plane on the scrolls is also depicted with lines as in Figure 30, a scroll of the Jiissakid who conducted the Shaking Tent

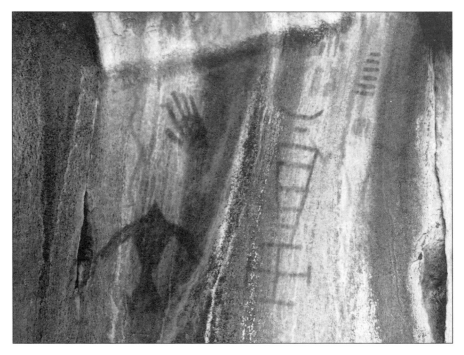

FIGURE 131. PICTURE ROCK ISLAND, LAKE OF THE WOODS. COURTESY OF THE ONTARIO
MINISTRY OF CULTURE, TOURISM AND RECREATION.

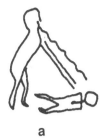

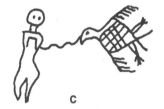

FIGURE 132. BIRCHBARK SONG RECORDS DEPICTING LINES OF COMMUNICATION:
A) THOUGH YOU SLEPT VERY FAR OFF, THOUGH YOU SLEPT ON THE OTHER SIDE
B) A JIISSAKID HOLDING HIS RATTLE TREATING A PATIENT;
C) A MIDE GAINING LIFE FROM HIS MEDICINE BAG;
D) LET US COMMUNE WITH ONE ANOTHER
E) A MIDE INSTRUCTING A BOY.

FIGURE 133. BIRCHBARK SONG
RECORDS OF JOURNEYS DEPICTED
AS FOOTPRINTS:
A) I AM GOING FOR MY DISH
B) I GO THROUGH THE MEDICINE
LODGE.

ceremony.[207] The Jiissakid is shown inside the bark lodge with Turtle in the centre communicating with the other manitous via the crooked lines. The same device is used in the song scrolls. Figure 132 illustrates songs from Minnesota, Wisconsin and Michigan, depicting the lines of comunication. They are the following: (a) "Though you slept very far off, though you slept on the other side," referring to the singer's lover who, if she slept across the lake, the singer's arms and voice could still reach her;[208] (b) a Jiissakid holding his rattle and treating a patient;[209] (c) a Mide gaining life from his powerful bird medicine bag;[210] (d) "Let us commune with one another," referring to a Mide and a manitou conversing;[211] and (e) a Mide instructing a boy, with lines from his heart going through his mouth to the boy and the boy's answer returning to the Mide's heart. [212]

Thus the lines in Figures 7 and 131 can be both a path and a line of communication; the path is communication in the Ojibway metaphorics. The painting at Cow Narrows (Figure 15) uses the same device, showing us that the bison in this panel is definitely not a common animal but a manitou who can tell the people of its medicine.

Animal tracks and dots indicating footprints also signify journeys both real and metaphorical. Figure 133a depicts bear tracks for the song "I am going for my dish"; the singer likens himself to the Bear manitou and intends to make a feast. Each person at a feast brought his own special dish. Figure 133b shows footprints as well for the song "I go through the medicine lodge";[213] the singer has passed through several degrees of the Midewiwin. Dots and animal tracks are common on both rock paintings and carvings, for instance in Figure 134, a painting at Deer Lake, northwestern Ontario.

Journeys or quests were important in the Algonkian world. Kohl observed that a person could win praise as a brave or hero not only by warfare. Many Indians received the honour after they undertook long and dangerous journeys.[214] But journeys had great symbolic significance too. Copway said his people talked of the code of ethics of the Ojibway people as a "path made by the great spirit."[215] The Midewiwin scrolls often depict the right path as a

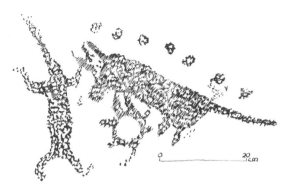

FIGURE 134. DEER LAKE, NORTHWESTERN ONTARIO.

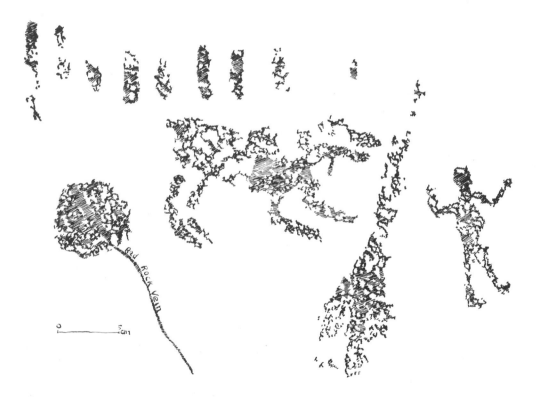

FIGURE 135. DEER LAKE, NORTHWESTERN ONTARIO.

straight line, a difficult path as a wavy line, and the wrong path as a line with several branches leading off the straight one.

Common on rock paintings across the Shield are short strokes, or lines in groups, usually vertical, like the panel in Figure 135 from Deer Lake. These are usually called tally marks. Little Wasp told Kohl the tally marks in his dream sign stood for the number of days he fasted,[216] and this interpretation would fit the signs on the rock faces well. Mrs. Exavier Commanda of North Bay, Ontario, told a story to Col. G. E. Laidlaw in 1922 with a similar interpretation of short, vertical lines. She said the stripes on a partridge's tail in the story were the number of days the young man of the tale fasted.[217] Hoffman was told that dots in the Midewiwin scrolls refer to the steps or stages of progress of the ceremony, equal to as many days.[218]

Figure 134 from Deer Lake may be a story of a journey for medicine, for several elements are present: two shamans/manitous giving/receiving medicine, an animal spirit or clan name, Mikinak, the messenger and translator, and the footprints along the path of the journey. Densmore noted that in birchbark pictography, the same figure may appear twice in the same picture, denoting progressive action – a journey or progress in ceremony.[219] It may be that the two human figures in the rock painting represent one person progressing through the action.

In Figure 130, there is a progression through a medicine lodge or shaking tent, possibly by a person whose totem was the animal above the line. He appears to have canoed to the medicine manitou who gave him medicines. The event took three days, as shown by the three tally marks.

Similarly, for Figure 135, a possible interpretation is that a person whose totem was the animal portrayed fasted nine days (tally marks) for the medicine (the round figure), and broke through some barrier (the rock face?) to meet the medicine manitou.

The panel at Picture Rock Island, Lake of the Woods (Figure 131), at first appears bizarre, but it really isn't. The human on the far right has his arms up, one touching the sign for the Midewiwin with its cross. The six tallies say he fasted six days, or the event took place over six months, as shown by the crescent moon above the Mide sign. On the left is a handprint probably signifying prayer to Kitche Manitou, and beside that is a bird, a possible totem, communicating with the heavens above, sending a prayer or receiving blessings, or both.

There must have been songs to accompany these dream visions, to be sung with the medicines that the manitous bestowed on these occasions. The paintings at Picture Rock Island (Figure 131) are unusually beautiful and poignant, especially the red bird beseeching heaven beside the handprint, the

sign for prayer and Kitche Manitou at the same time. How wonderful it would have been to hear this painting!

CHAPTER 5

A STONE IS FILLED WITH SPIRIT POWER

A common explanation for rock art world-wide is "hunting magic". In a sense, this is true, at least for some of the paintings, but what do we mean by the term?

The people painted pictographs in the quest for many medicines, one of which was surely flint. The Algonkian people used the word "medicine" in a wide sense, to denote not only remedies to cure illness but also anything that was revered. Highly valued stone, formerly flaked or ground into tools for hunting and war, was a medicine of great antiquity, enduring from the times when the stone-tipped spear was the lifeline of the Indian, his means to a meal and his family's defence. Nanabojou was the first stone-tool maker and all later flint-knappers copied him. Medicine songs praise the powers in the stone and some of the rock art was probably done in respect for the gathering of this prized medicine. Some even portray the stone points themselves (Figure 38), and others depict the ancient spears and bows-and-arrows (Figure 50, 101, 136).

Good tool-making stone is of the silica family of lithics, outcropping in many places throughout the north in several varieties including flint, chert, quartzite and jasper. Archaeologists take care to locate the outcrops to compare their

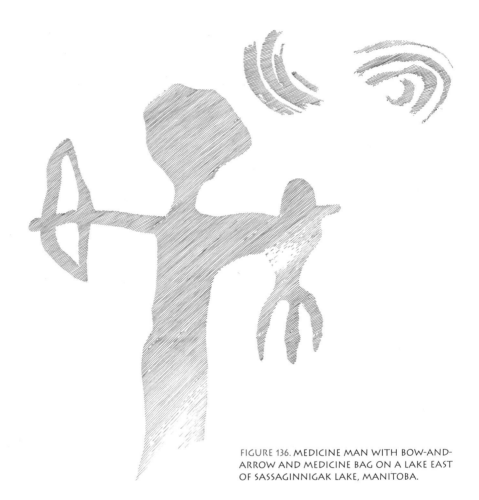

FIGURE 136. MEDICINE MAN WITH BOW-AND-ARROW AND MEDICINE BAG ON A LAKE EAST OF SASSAGINNIGAK LAKE, MANITOBA.

raw materials to tools from archaeological excavations, a good way to understand trading patterns among precontact peoples. For instance, a famous quarry in Yellowstone National Park produces a beautiful black obsidian, a natural glass created by volcanoes in the park, and the perfect flaking stone. Archaeologists find tools of this material all over North America. From this evidence we know that the Indians for millenia greatly valued the black glass and traded it widely. Obsidian is such a perfect flaking stone that a tool maker two thousand years ago at the Seip Site (pronounced "sipe") in Ohio made a huge point more than a half metre (1 1/2 feet) long and only a centimetre (1/2 inch) thick without breaking it in the process. It now graces the Ohio Historical Centre in Columbus, a startling legacy of pre-Columbian skill.

In the Canadian Shield, the people worked several major stone quarries and many lesser ones. Among the most amazing is the Sheguiandah Site (pro-

nounced "Shegwinda") on Manitoulin Island, a dazzling site consisting of a mountain of shining white quartzite quarried since the Palaeo-Indians, the first First-Nation, arrived in the north nearly 10,000 years ago. A visitor to the site literally walks over history, over piles of quartzite flakes scattered across the top of the high hill, broken off the mother mountain by tool makers in search of the best, most-workable medicine. Near Thunder Bay, Ontario, the Cummins Site covers 200 acres, abounding in glossy maroon jasper taconite, also used since Palaeo times and traded widely along the Boundary Waters between Ontario and Minnesota. Off the Shield in North Dakota is the famous quarry of Knife River flint, and tools of this toffee-coloured stone show up on archaeological sites across central North America as far away as Ohio. But stone sources exist all across the Shield, and their names spin off an archaeologist's tongue like a rolling tour of the north: Swan River, Cat Head, Lake of the Woods, Knife Lake, Hudson Bay Lowland, Gordon Lake, Wikwemikong, and more.

Rock art exists on or near several stone quarries. In Wisconsin, two rock paintings adorn Silver Mound, the source of Hixton silicified sandstone, used for stone points since Palaeo times,[1] although the rock art there is probably not that old. In Ontario, the Worthington Bay rock painting (Figures 66, 67) on the north shore of Lake Superior, the only painting for hundreds of miles between Nipigon and Agawa Rock, is also near the location of Rossport chert, the only chert source on the north shore.[2] There are two rock paintings across the bay from the Sheguiandah quarry, and the Stephen Lake painting near Lake of the Woods in Ontario is just up the shore from the Stephen Lake chert quarry.[3] These and other quarry-related paintings help date some of the pictographs: they may be from the North American "stone age" before the introduction of European metals into the tool-making tradition.

The most spectacular evidence for the connection between points and paintings is the Burnt Bluff Site in Michigan, discussed already in Chapter 2, where archaeologists Charles E. Cleland and Richard Peske discovered more than 100 stone points in a cave with rock paintings on the walls (Figures 39 and 81). The majority had broken or blunted tips from hitting the walls or floor after being shot into the cave. The points were made of locally available chert and were probably intended to be offerings in receipt of the stone, and possibly for receipt of hunting and war prowess as a result.

Another site that may testify to the stone as medicine is Ohio's Newark Track petroglyphs, or rock carvings, located near Flint Ridge, a major source of flint quarried throughout the prehistoric era. The petroglyphs were on a vertical sandstone face in a rock shelter and consisted of more than 70 "bird tracks" and a couple of obvious arrows. Researchers in the 19th century col-

lected many artifacts from the shelter floor, including arrowheads, charcoal, fragments of stone axes, shells, bone and "much pottery, some thin, some thick and coarse." The pottery and points would help us date the petroglyphs if they were associated with the rock art, but they were not described and have since disappeared. One researcher, Daniel Brinton, who described the petroglyphs in 1884, called the "bird tracks" arrowheads, an interesting conclusion considering the site's proximity to Flint Ridge. Modern-day Ohio rock art expert, James L. Swauger, concludes that "Brinton may be right; i.e., the carver or carvers may have thought they were creating arrowheads" when they carved the bird track figures on the walls.[4] The site was destroyed by the widening of the local highway in the mid-1960s.

There are a few references, surviving into historic times, to the Indians' respect for their stone sources. The Siouan-speaking Winnebago, neighbours of the Algonkians of Wisconsin, considered a stone naturally sharpened in any way to be sacred and offered tobacco for it.[5]

David Arthurs, an archaeologist researching the Nipigon Bay paintings on the north shore of Lake Superior, reports, "One of the interesting things about the site is the number of references in exploration and turn-of-the-century 'travel' literature to the paintings and to a fabled red pipestone quarry [nearby]. Some mention one, some the other, but several suggest a connection between the two."[6]

The most complete description of the Indian respect for some types of stone comes from George Catlin, a painter who travelled through central North America from 1832 to 1839. While in Minnesota, he admired a "very beautiful" red stone smoking pipe owned by one of the chiefs, made from steatite, or soapstone, from a quarry in southwestern Minnesota. Archaeologists thoughout a wide area of central North America unearth objects made of this particular stone, now often called "catlinite" after the painter who described it.

He said, "I have already got a number of most remarkable traditions and stories relating to the 'sacred quarry,' of pilgrimages performed there to procure the stone, and of curious transactions that have taken place on that ground. It seems, from all I can learn, that all the tribes in these regions, and also of the Mississippi and the Lakes, have been in the habit of going to that place, and meeting their enemies there, whom they are obliged to treat as friends, under an injunction of the Great Spirit."[7]

Catlin was told the Peace Pipe was born there. The Great Spirit called the Indian nations together and, standing on a cliff of the red pipestone, broke a piece from the quarry wall and made a huge pipe by turning it in his hand, then he smoked it over all the nations to the north, south, east and west. He

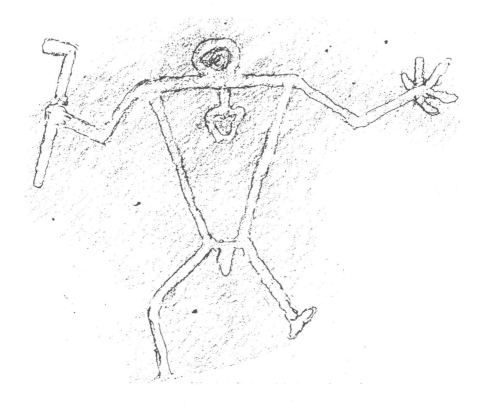

FIGURE 137. RUBBING OF A ROCK CARVING AT PIPESTONE QUARRY, MINNESOTA, DONE IN 1892. SMITHSONIAN INSTITUTION, NATIONAL ANTHROPOLOGICAL ARCHIVES.

told them that the red stone belonged to them all, so the war-club must not be raised in this sacred place. He placed two female spirits inside the rock of the quarry to answer the prayers of the medicine men.[8]

One of the Dakota Indians from whom Catlin received information told him that the Indians were afraid the white man would have no respect for the quarry, "I speak strong, my heart is strong, and I speak fast; this red pipe was given to the Indians by the Great Spirit – it is a part of our flesh, and therefore is great medicine."[9]

Catlin described the Indians conducting ceremonies at the base of five huge granite boulders a little distance beyond the quarry, asking the guardian spirits of the place, with sacrifices of tobacco, for permission to take away a small piece of the red stone for a pipe.[10] In 1892, W. H. Holmes of the

Smithsonian Institution did rubbings of carvings on some of the boulders at Pipestone. They are no longer at the quarry; "they had to be removed from the site to protect them from relic hunters and inscription cranks,"[11] the Dakotas' worst nightmare, but the rubbings remain in the Smithsonian in Washington. They depict medicine men with arms up in the sign of giving-and-receiving medicine and holding pipes (Figure 137), and one boulder had a Midewiwin sign or a shaking tent,[12] notice that Algonkian Indians attended the Great Spirit's pow-wow.

Among the Algonkians, special stone, as medicine, deserved and got the same treatment as all other medicines, not only paintings but also songs. Densmore said that Ojibway warriors prepared for battle by dipping their arrow points in red medicine while singing, "Scarlet is its head."[13] It would be interesting to find a paint-smeared point in archaeological excavations.

Edwin James recorded a medicine song at Sault Ste. Marie in the mid-19th century that uses the device of a feathered and flint-tipped arrow (Figure 138b) for the words, "A spirit is what I use." He said Nanabojou, creator of arrows, speaks in the song and all who follow must heed his instructions in their use.[14]

Densmore recorded a medicine song in northern Minnesota in 1907, the picture of which is a man holding a bow and stone-tipped arrow (Figure 138a), a memory device for the following words: "Here I stand. Behold, a stone is filled with spirit power. With it I shoot."[15] The circle below the arrow tip is the stone from which the tip was made.

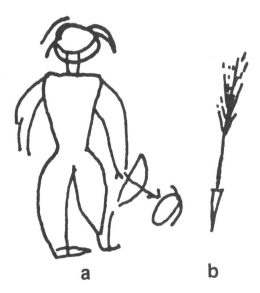

a b

FIGURE 138. BIRCHBARK SONG RECORDS FROM NORTHERN MINNESOTA AND NORTHERN MICHIGAN:
A) HERE I STAND; BEHOLD, A STONE IS FILLED WITH SPIRIT POWER
B) A SPIRIT IS WHAT I USE.

FIGURE 139. STANLEY RAPIDS, SASKATCHEWAN. COURTESY OF TIM JONES.

But whose power is in the flint? A Menomini story about the first flint-knapper tells the tale. Nokomis (accent on the first syllable), the Earth, is grandmother of Nanabojou, called Manabush in Menominee. The flint grew out of Nokomis and was alone. Then the flint made a bowl and dipped it into the earth; slowly the bowlful of earth became blood, and it began to change its form to Wabos (or Waboose), Rabbit, and he grew into human form. Thus was Nanabojou made but he was angry because he was alone on the Earth and his enemies, the underground manitous, were constantly trying to destroy him. Then he shaped a piece of flint to make a tool, and while he was grinding the edges with sandstone he heard the rock make peculiar sounds, "Ke Ka, Ke Ka, Ke Ka, Ke Ka, goss, goss, goss, goss." He soon understood that he had no father, mother, brother or sister. That is what Flint told him while he was rubbing it.

While he was concentrating on this, he heard the sound of something approaching, and when he looked up he saw Wolf who said to him, "Now you have a brother, for I too am alone. We shall live together and I shall hunt for you."[16] In this story, wolf is the spirit and power of the flint.

The Peterborough Petroglyphs, a rock carving site in southern Ontario, depict several triangular forms (Figure 38), some with stems and notches that resemble stone points from the Middle Woodland Period – about 2,000 to 1,000 years ago. The researchers of the site could not make up their minds if they were stone points or spirits in stylized form; they noted that some manitous in Algonkian art are depicted in abstract style, their bodies in triangular

form with small projections for heads.[17] The researchers may be right on both counts: an Algonkian Indian would say that the triangular figures are both points and spirits at the same time, for "a stone is filled with spirit power." It is also interesting to note that the Montaignais, as discussed in Chapter 4, described the "spirits of the air" as triangular or conical with a stone body. We must always remember multiple meanings when dealing with Algonkian pictography, so we may also add the bird tracks from Ohio to the complex associations here, drawing birds – air spirits – into an equation with Wolf's sharp tooth to make the feathered and tipped arrow a powerful tool.

Stories from the Ojibway of Ontario confirm the identity of the Wolf spirit power in flint and tell us why.

John Pinesi, chief of the Fort William Band near the Lakehead in 1904,

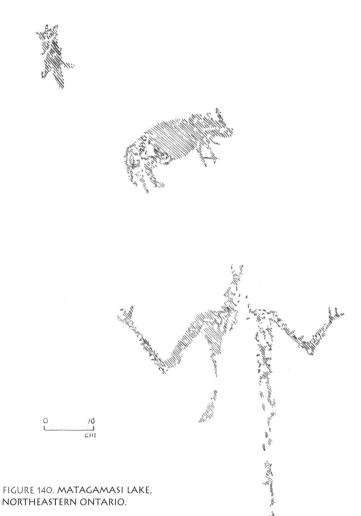

FIGURE 140. MATAGAMASI LAKE,
NORTHEASTERN ONTARIO.

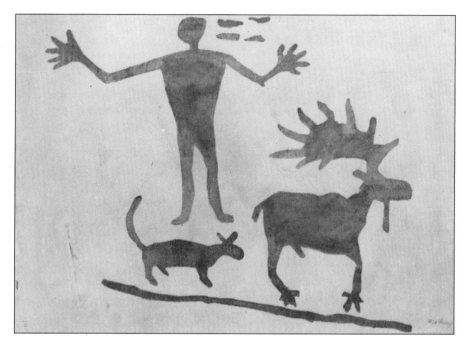

FIGURE 141. HEGMAN LAKE, NORTHERN MINNESOTA. COURTESY OF THE ROYAL ONTARIO MUSEUM, TORONTO, CANADA.

told researcher William Jones a story of the wolves teaching Nanabojou to hunt. Pinesi, whose surname is a short form of his Indian name, Kagige Pinesi (Forever Bird), was a famous story teller who was familiar with tales from Manitoulin Island to Lake of the Woods. In the story of the wolves, we learn the arrow point has the power of Wolf's canine tooth, and the arrow is a combination of Tree and Wolf, shaft and point. In Pinesi's story, shortened here, the following happened:[18]

Once upon a time, Nanabojou decided to go on a journey. He went straight toward the region of the north wind and came out upon a lake where he saw three wolves running along. He cried out to them, "Hey, hold on, my friends! Wait for me!"

The Old Wolf, his brother, said to the two little wolves, "That is Nanabojou, don't speak to him. Keep on going! Keep on going!" But Nanabojou persisted, running with great speed, whereupon the Old Wolf stopped and waited for him.

Nanabojou asked to join the pack; they were heading for a cache of meat and grease that his nephews had stored last summer. But the Old Wolf said, "Oh no! You can't keep pace with your nephews."

Nanabojou replied, "Don't worry. I'll run myself too!"

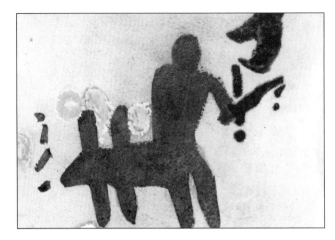

FIGURE 142. CUTTLE LAKE NEAR RAINY LAKE, NORTHWESTERN ONTARIO. COURTESY OF THE ROYAL ONTARIO MUSEUM, TORONTO, CANADA.

Then off they went running until evening when they made camp. It was exceedingly cold by the shore of a lake and they used no fire. The wolves each dug a shallow nest in the snow and lay down to sleep, so Nanabojou did likewise. He was very tired and sweating from the exertion of running and soon began to chill. The Old Wolf told his son, "Hey there, lend him one of your blankets." So the little wolf threw his tail over Nanabojou to make him warm.

When dawn appeared, Nanabojou heard the sound of the wolves rising, shaking themselves and starting away. Up he went with them, running with great speed all day, but often he was left behind and the wolves had to stop and wait for him. The next day they came to a lake. The Old Wolf stopped, raised his head and sniffed, for he smelled the scent of a moose. So Nanabojou did the same.

"How many are there?" asked the wolf.

Nanabojou replied, "There are three, a cow and two calves."

"No, said the wolf, "There is but one moose."

So they started off for the moose, and the wolf said to Nanabojou, "As you go keep a careful look." And sure enough, as they were running along, they spotted something, a wolf tooth sticking out of a tree. Then the Old Wolf said, "Hey Nanabojou, take up your nephew's pointed arrow!"

Nanabojou, still not understanding, scorned the offer. "What am I to do with a dog tooth?"

The wolf pulled the tooth out of the tree and shook it and it became a wonderful pointed arrow. When Nanabojou saw it, he changed his mind. "Let me carry my nephew's arrow as we go along!"

"Only a moment ago you called it a dog tooth," chided the wolf. "Now get going!" And off they went.

Further along, the wolf spoke to Nanabojou, "I will give you one of your

nephews, and he will be the one for you to accompany when he goes to hunt." A rock painting depicting the hunter, accompanied by Wolf, and chasing his prey, is at Stanley Rapids, Saskatchewan (Figure 139).

In a continuation of the story, we learn that flint has Wolf's power to start a fire as well as hunt. The pack split up; the Old Wolf and one nephew ran off toward the cache while Nanabojou and the other nephew went on to hunt. In this story, Nanabojou learned that the flint and wood must be used sparingly, and we learn that the spark from flint is Wolf leaping across the wood. Before he left, the Old Wolf said to Nanabojou, "I will also give you fire. After a while, when you go into camp and have gathered the firewood, then you may leap over the place where the wood is, and the blaze will start up." He warned, however, "Do not try it merely for the sake of doing it."

Nanabojou could not wait to try his new power and, while the young wolf was away on the hunt, he gathered wood and leapt over it but no fire lit up. Again he leapt over with no results, and he leapt and leapt until night came on. When the young wolf returned, he could hear the sound of somebody thumping and thumping on the ground. "What are you doing," he howled at Nanabojou. "Maybe you have been kindling fires without any reason?"

"No! No!" panted a bushed Nanabojou.

The little wolf then leapt over the wood and a fire blazed up. As Nanabojou, now chilled to the bone, slumped before the flame, the wolf scolded, "Don't ever do it again, not until you go into camp; then you may do it."

Wolf's lesson to conserve one's flint and wood is still remembered in humour in the Lake of the Woods area where any huge bonfire is called "a white man's fire"; in the last century, observers noted that some Indians considered themselves inferior to Europeans but certainly not the Ojibways who had a common expression to describe any one who did a foolish thing, "as stupid as a white man"![19]

In this cycle of Nanabojou stories, we also learn that Wolf in the flint has power for war and revenge.

Further along in their journey, the nephew fell into a lake and met his death at the hands of the underwater manitous. Nanabojou looked for him everywhere but had no luck. He spotted a white loon and a kingfisher looking into the water, and he asked, " What are you watching for?"

"Manitous dwell in this place and they took Nanabojou's nephew," they answered. "Now the skin of that wolf, which they use for a flap over the doorway of their lodge, is what we are looking for."

That infuriated Nanabojou who swore revenge. He took off into the bush to make a bow and some arrows, then went to a place opposite an island where the underwater manitous habitually came up to sun bathe, and he

turned himself into a tree stump to watch for their appearance when the sun rose high and the island warmed. At nearly noon, all sorts of manitous came out and they spotted the unusual stump. "Did you ever see that before?" some asked. "Woe to us if Nanabojou should take on such a form."

White Bear attacked the stump by shaking it; Big Serpent twined around it in an affort to strangle it, but all finally agreed that it was just wood. Then the chief manitous, two Mishipizheus, crawled out and curled up in the sun to sleep.

Meanwhile two painted turtles had some advice for Nanabojou. "Do not shoot straight at the mantous," they whispered. "Shoot them at the place where they cast their shadows."

Quickly, Nanabojou returned to his own form, hurried to the island, shot at their shadows and severely wounded the chiefs. Now, the manitous recognized him and he fled into a woodchuck hole.

But Nanabojou continued to seek revenge and, as he was walking along, he heard a woman singing a medicine song, "From the ends of the world do I come with the sound of my rattles." It was Toad Woman, a form of his grandmother, the healer of the manitous. She carried her medicines and wore rattles attached to her clothing, continuing on her way to heal the chief manitous now dying in their lodge with Nanabojou's arrows deep in their souls.

Nanabojou had a plan. He asked the old healer to give him the "nature of her song," that is, to reveal her powers, then he slew her, flayed her and put on her skin. On he went to the Mishipizheus' lodge where, not recognized because he wore the costume and carried the medicine bag and rattles of a healer, he was allowed entry. He approached the chiefs and, in revenge for killing Wolf, he took hold of the flint-tipped arrows sticking out of the evil manitous and shoved them in further, working them back and forth. He killed the manitous with the power of Wolf.[20]

The underwater manitous, in retaliation, caused a flood to cover the Earth, and the story of Nanabojou's creation of the second Earth, the present one, follows. It is said Wolf wished to return to Earth but Nanabojou instead sent him to the world of the dead to be their chief, and his name was fittingly changed to Naqpote, Expert Marksman.[21]

A rock painting at Matagamasi Lake near Sudbury, Ontario (Figure 140) includes a manitou/medicine man and a wolf. While it may not relate directly to the stories told here, we must keep in mind all the possibilities because the paintings, like the stories, have many meanings.

Other paintings may relate to the concept of manitous in the tools. A pictograph at Hegman Lake in northern Minnesota portrays a human, moose and possible wolf (Figure 141) similar to the Stanley Rapids painting (Figure

139). A painting at Frances Lake near the Ontario-Manitoba border (Figure 101) has a similar theme including hunter, wolf and hunted animal, in this case the beaver manitou with spirit lines across its body. Dewdney considered this panel "among the oldest [he] recorded anywhere."[22]

A discovery in Wisconsin has close similarities to Frances Lake, Hegman Lake and Stanley Rapids. The Gotschall Site, the rock shelter discussed in Chapter 2 containing wall paintings estimated to be about 1,100 years old, has a painting depicting a hunter with a bow, a bison stricken by arrows and possibly Wolf running from his prey (Figure 37). Its similarities with Algonkian Shield rock art are striking. It may be that the story of Wolf-Flint is an ancient one, preserved for centuries in Algonkian tales.

So the pictographs, stories and archaeological evidence combined, especially the discoveries at Burnt Bluff where marskmen shot points into the cave and perhaps the Gottschall Site, tell of a long and elaborate tradition connected with hunting medicine, rock art and stone tools. No longer can we speak of a simple "hunting magic" as the reason for these paintings. The connotations in hunting medicine are far more complex than that. Each painting reflected a hunter's dream, which in turn reflected the legends he knew, the manitous he met and the assurance he sought from them. His family would be fed and that was good medicine.

The evidence also tells us not to interpret archaeological artifacts in a simplistic fashion. Stone points must not only be measured, weighed and photographed, they must also be understood, for their significance in the ideology of the people was immense. The arrow combined the feathers from birds for flight, the shaft from trees for strength and the tooth of Wolf copied in stone for skill in the hunt.

There is an interesting artifact from the Adena culture, the early Ohio mound builders, in the Ohio Historical Centre at Columbus. About 1,500 years old, it is an upper jaw of a wolf with the sides cut off, leaving only the centre portion containing the front teeth. Excavations at the turn of the century unearthed the artifact with the remains of a man who had his upper front teeth removed during life so that he could insert the wolf jaw into his mouth. The jaw was undoubtedly part of his ceremonial mask, probably including a wolf-fur headpiece. The man literally changed his appearance into Wolf. This ancient artifact is startling when we consider a painting at Cuttle Lake near Rainy Lake in northwestern Ontario (Figure 142), showing a man holding a tool and changing into Wolf.

CHAPTER 6

CONCLUSIONS: "MY PAINTING MAKES ME A MANITOU"

We have made a case for Shield rock art as a type of sacred writing, done by the medicine people – Mides, Jiisakids or others – upon receipt of powers from the manitous who resided in the cliffs, a hypothesis based on historic references to such events from Saskatchewan, Manitoba and Ontario. We infer from archaeological data that the practice was widespread and extended back into prehistoric times.

The method used to arrive at these conclusions belongs to a theoretical approach called "contextual" or "cognitive" archaeology,[1] a relatively new discipline that attempts to go beyond analysis of the artifact, to reconstruct what was in the minds of the producers. It tries to provide a plausible explanation of what the people thought as well as did when they made the objects, whether paintings, arrowheads or whole villages. The most useful approach is to compare the archaeological data – in this case the rock paintings – to historic documents of people living in the same area as the sites to give the paintings a "cognitive context," the painters' own world view. We have used ethnographic accounts of the Algonkian people and compared the paintings

to the song scrolls of the historic Ojibway. The similarities are so close as to provide a plausible context, the practice of medicine. The emphasis is on the word "plausible" because, as British archaeologist Ian Hodder has pointed out, "contextual" archaeology arrives at conclusions that cannot be absolutely proven.[2]

There is no "litmus test," but we can conduct three important tests of the hypothesis. First, ask ourselves if our hypothesis explains all the phenomena associated with Shield rock art; second, consider the alternative solutions; and third, make predictions, based on the preferred hypothesis, that can act as future tests.

First, does our hypothesis that puts the paintings in the context of medicine answer all the whys ? Why does Shield rock art occur on cliff faces and why only particular cliffs? Our hypothesis provides the answer through ethnographic accounts that say the people believed that powerful medicine manitous – Nanabojou, Mishipizheu, White Bear and the maymaygwayshiwuk among others – lived in some mountains. Therefore, rock art occurs where the manitous lived.

Why does Shield rock art occur beside the water? Because the places where sky, earth, water, underground and underwater meet were especially important, called "the home of the manitous" on Ojibway clothing designs, as recorded by Coleman. They allowed the manitous and medicine people to pass into each other's worlds. These places also symbolized all the sources of the medicines, both minerals and plants, that could be picked from the mountainside, the lakes, rivers, and the rocks themselves, just as Nelson described the home of the medicine manitou in northern Saskatchewan.

Why are the paintings done mainly with red ochre? Because that mineral was considered a powerful medicine itself and used in some cures. One of the songs of the Midewiwin of the Sault Ste. Marie area, sung when a medicine man painted the body of the patient, is sung "My painting makes me a manitou," referring to the strength of the red paint medicine.[3]

Rock art in the Shield was rarely done using colours other than red ochre and should have special significance. For instance, why is a painting north of Dryden done in white paint? Because it likely depicts Owasse, White Bear manitou, powerful in medicine.

Why paint these particular figures? Because, as part of the tradition of picture writing associated with medicine, dreams and accompanying songs, they refer to specific experiences of the medicine people. They are the conceptual equivalent on rock of the song pictures on birchbark of the Midewiwin, and one medium can inform us about the other. While the figures on birchbark are from personal dreams, they contain an element of pic-

tography that is shared by the majority of picture writers, a standardized ideography. By analogy, the rock art must contain both deeply personal and standardized figures.

The Mazinaw Lake pictographs in eastern Ontario are puzzling to this author. The repeated "honeycomb" or "picket-fence" signs (Figure 143) do not occur elsewhere in Shield rock art, so the site appears to be unique, perhaps somebody's deeply personal dream. On the other hand, similar designs occur on the birchbark scroll from Burntside Lake, discussed in Chapter 2, that was radiocarbon dated to the sixteenth or seventeenth century A.D. Further research may show that the seemingly personalized signs were, in fact, readable by many people back in the old days.

Why did the people paint pictures at all? Because they wanted to leave lessons. Schoolcraft reported that his mother-in-law, Ojawashkodawakwa (Woman of the Green Valley), daughter of the celebrated war chief, Waubojeeg (White Fisher) from Chequamegon, told him in 1839 that picture writing on the rocks was designed "to convey instruction."[4] An instance of this is in a story, discussed in Chapter 2, in which a medicine man named Mistoos Muskego from Manitoba took his people to a cliff and, showing them his rock painting, instructed them on the powerful and helpful nature of the manitous who resided there.

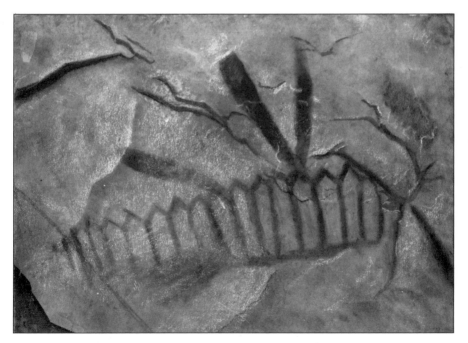

FIGURE 143. MAZINAW LAKE IN EASTERN ONTARIO. COURTESY OF THE ROYAL ONTARIO MUSEUM, TORONTO, CANADA.

Researchers have posted alternative explanations for rock art. Are these better than the hypothesis above? For instance, we know from Tanner and others that the Algonkian people left picture writing on bark and trees along their travel routes designed as secular messages, some to commemorate special events. Could rock art be the same? It could, but the occurrence of recognizable manitous and religious items such as the Mide lodge, the Shaking Tent, medicine bags and symbols for the medicine itself on many panels suggests rock art has greater than secular significance.

Shingwaukons (Little Pine), the famous chief at Sault Ste. Marie, told Schoolcraft that the Agawa Rock painting depicted a journey by a Mide named Myeengun (Wolf) across Lake Superior. At first glance, this explanation looks like a secular message, a commemoration of a special event. But Schoolcraft, in retelling Shingwaukons' account, did not emphasize the most important part of his explanation – the journey was by a Mide and Schoolcraft did not ask why Myeengun made the journey, nor why he chose to commemorate his special experience particularly at Agawa Rock. The spectacular setting of Agawa Rock with its deep canyon-like crevices in the mountainside, plus the occurrence of the megis shell and Mishipizheu on the rock face, suggest the place was an entrance to the other world, a place with powerful manitous, like Mishipizheu on one panel, and equally strong medicines as symbolized by the megis on another.

Could the rock paintings be mere doodlings, equal to our scribblings on rock cuts beside highways, native equivalents of "Kilroy was here"? The ethnographic literature, including the reports from Ojawashkodawakwa and Shingwaukons, cited above, tell us that picture writing was anything but casual; it had important lessons. A birchbark song scroll from northern Minnesota depicts a medicine man and a learner, enclosed within one circle, to designate the words: "Diligently listen to those who speak."[5] It could stand for the overall message of Shield rock art.

Can we make predictions for future research to verify or refute? We have inferred that rock art is part of the practice of medicine, dating as old as 2,000 years. If we are right, then eventual excavation of items connected with rock art on prehistoric habitation sites, perhaps red ochre and painting sticks, or even stones painted with Shield-style figures, will be in contexts that are unusual, in the remains of medicine bundles or bags, or in special places set off from the ordinary living spaces of the people. Ethnographic sources and modern informants say the regalia of the medicine people were venerated, not to be touched by ordinary mortals, and given a place of their own. Copway reported the Ojibway medicine people's records were written on slate, copper, and lead as well as bark, and they were deposited in special places for safe-

keeping, sometimes in deep pits in the ground.6 The chief of Lac Court Oreilles told Copway's uncle in 1836 of one of the depositories that he knew. We would expect to find evidence of rock painting in places like these with an unmistakably religious context, in depositories of ancient age, long forgotten or abandoned since Middle Woodland times.

The floors of prehistoric lodges unearthed by archaeological excavation may exhibit evidence of places set aside for the practice of medicine. Le Jeune reported such as place in 1634 among the Montaignais. He said a medicine man who wanted to pray for a dead man "entrenched himself, covered by robes and blanket walls in one corner of the lodge so neither he nor his companions could be seen [and] a woman with them marked on a triangular stick half a spear in length, all the songs they recited."7 In these places, we would expect to find artifacts related to medicine – megis shells, paint, sucking tubes and the clues to rock art recording as well.

Archaeologists have discovered many Middle Woodland encampments near rock art sites in the Shield, preliminary excavations which so far have not produced the link of prehistoric people to painting. But there are hundreds of habitation sites in the Canadian Shield, few of which have been subjected to full-scale excavation. An archaeologist some day may discover the missing link that will establish the great antiquity of rock art.

Excavations of the floors of rock shelters directly beneath paintings offer the best opportunity for dating Shield-style rock art. Salzer's excavations deeper into the deposits may give us evidence to date the paintings even earlier.

Cleland and Peske's preliminary excavation of Spider Cave at Burnt Bluff in Michigan produced about 100 Middle Woodland projectile points in the same cave where Shield-style paintings occur. So far we cannot definitely link the points and paintings, but future excavations, should they be undertaken, will have the challenge to do so.

What is certain is that native people have an important role in archaeology. Archaeologists with various backgrounds pose different questions leading to different answers. A continuing study of the Algonkian peoples' own history and philosophy, combined with ethnographic sources, will establish better interpretations than those proposed here. The interpetations in this book may not be correct in every case; they are approximations of the meanings. The important point is that the paintings are intimately connected to Algonkian beliefs, legends and songs. It is not good enough to decribe the paintings as "hunting magic" or medicine men's doodlings. They are much more than that. Rock art studies have matured beyond the antiquarian, amateur approach and entered the field of legitimate professional scrutiny. Who better to carry out the study than the people themselves, combining their own

sensitivity and delight in the stories and songs with scientific rigour. Thus, archaeology, especially rock art research, offers an excellent opportunity for natives and non-natives to work as a team.

"Contextual" archaeology in particular, with its emphasis on aboriginal points of view, offers a path for present-day Anishnabeg interested in archaeology. In this light, it is noteworthy that Schoolcraft described Shingwaukons as "the aboriginal archaeologist,"[8] in reference to the famous chief's interest in his own ancient heritage including rock art. Modern-day native archaeologists will add an important perspective to the discipline and will be walking in the steps of the great chief himself.

FOOTNOTES

CHAPTER 1

1. Powell 1881: 75
2. For instance, see Vastokas and Vastokas 1973; Jones 1981; Rajnovich 1989.
3. Allen Tyyska, personal communication; Tyyska and Burns 1973
4. The debate centres around the issue of continuity between the Laurel culture of the early part of the Woodland Period and later cultures including Blackduck, Selkirk and Mackinac. For instance, Rajnovich (1983) and Meyer and Russell (1987) hypothesize a continuum in pottery styles between Laurel and the later Selkirk culture of Saskatchewan, Manitoba and Ontario. Polly Koezur and James V. Wright (1976) and K. C. A. Dawson (1976) have excavated ceramics that they accept as transitional types linking Laurel and Blackduck cultures in Ontario. Holman (1984) and Cleland (1992) have suggested a continuum in ceramic styles between laurel and mackinac in Northern Michigan. Wright (1972) suggests that linguistic affiliations for the Woodland Period other than Algonkian, such as Siouan or Iroquoian, are not logical choices. Peter Denny (1992) suggests that linguistic analysis shows the Woodland Period people to be Algonkian. Lathrap and Troike (1988) suggest the Algonkian language spread into the Shield during the previous Archaic Period. On the other hand, Lugenbeal (1977) and Arthurs (1986) state that a transition between Laurel and Blackduck is inconclusive, and McPherron (1967) perceives an actual cultural gap between earlier and later Woodland groups in the eastern Lake Superior-northern Lake Michigan area.
5. Maria Seymour, personal communication
6. Hallowell 1981: 21; Densmore 1926: 63
7. Hallowell 1981: 21
8. Warren 1970: 56
9. See Jones 1981 for a summary of the evidence.
10. Warren 1970: 35-36
11. La Potherie, 334-336
12. Warren 1970: 44-53; James1956: 314-315; Perrot, in Blair 1911: 153-154; Jones 1861: 138
13. Kenyon 1986: 64
14. Dragoo 1963: 97-100
15. For instance, Layton 1992; Rajnovich 1991; Lewis-Williams 1986.
16. For instance, Gjessing 1978; Sanger and Meighan 1990; Martynov 1991
17. Kohl 1985: 446
18. Copway 1850: 124
19. Dewdney and Kidd 1973: 69
20. Copway 1850: 124
21. Densmore 1910: 77
22. Hoffman 1891: 267
23. Dewdney 1975: 89
24. Coleman 1947: 77-80; Dewdney 1975: 78

25. Johnston 1976: 8
26. Hoffman 1891: 191
27. Brown and Brightman 1988: 58-59
28. Blessing 1963: 94
29. Copway 1850: 127
30. Jones 1861: 204-205
31. Hallowell 1981: 40
32. Hallowell 1981: 42
33. Thwaites 1896 Vol. 12: 10-11
34. Seymour, personal communication
35. Densmore 1913: 250
36. Honigman 1981: 719
37. Copway 1850: 20
38. Densmore 1913: 63. For the use of Bizhikiwuk, see also James 1956: 122-123.
39. Schoolcraft 1851: 678; Keesing 1971: 219; Radin 1923: 261.
40. Thwaites 1896 Vol. 71: 261
41. Gilles Tassé, personal communication
42. Michelson 1917: 399
43. Johnston 1982: 95
44. Johnston 1982: 96
45. Densmore 1950: 4
46. The spellings of the Ojibway words in this text are mostly from historic texts with additional suggestions from present day speakers. I do not know the language. I am grateful to an anonymous reviewer for suggesting the term Jiisakii anini as the proper term.
47. Hallowell 1942: 59
48. Johnston 1982: 115
49. Walter Red Sky, personal communication
50. Seymour, personal communication
51. Red Sky, personal communication
52. Seymour, personal communication
53. Hoffman 1891: 186
54. Coleman 1947: 76
55. Johnston 1976, 1982; Blessing 1963; Hoffman 1891; Kohl 1985; Brown and Brightman 1988; Barnouw 1977; Densmore 1979.
56. Johnston 1982; Charles E. Cleland, personal communication
57. Coleman 1947: 12
58. Seymour, personal communication
59. Brown and Brightman 1988
60. Hallowell 1981: 59
61. Brown and Brightman 1988: 106
62. Thwaites 1896 Vol. 12: 17

CHAPTER 2

1. Jones 1981: 70

2. Hallowell 1936: 47
3. Jones 1981: 72
4. Dewdney 1974: 2
5. Wheeler n.d.: 2-3
6. Coleman 1947: 47
7. Schoolcraft 1853
8. Jones 1981: 67
9. Tassé 1977: 37
10. Thwaites 1896 Vol. 59: 139
11. William A. Fox, personal communication
12. Conway n.d.: 80
13. Cleland et al: 1984: 244
14. Meyer and Smailes 1975: 51-52
15. Reid and Rajnovich 1991: Figure 18
16. Dewdney 1977: 11
17. Salzer 1987: 463
18. Vastokas and Vastokas 1973: 24
19. Reid and Rajnovich 1991: Figure 14
20. William A. Ross, personal communication
21. Cleland and Peske 1968: 56
22. For instance, Hickerson 1970 and Dewdney 1975.
23. For instance, Johnston 1982; Hoffman 1891 and Warren1970.
24. Johnston 1982: 98
25. Thwaites 1896 Vol. 23: 222
26. Dewdney 1975: 92
27. Thwaites 1896 Vol. 23: 223
28. Callender 1979: 257
29. Hoffman 1891: Plate 3
30. Radisson 1967: 149-150
31. Johnston 1982: 107-108
32. Kidd 1981: 41
33. Densmore n.d.(a): 1
34. La Potherie, in Blair 1911: 88

CHAPTER 3

1. Kohl 1985: 142; Mallery 1881: 380; Tomkins 1969: 74.
2. Mallery 1881: 380-381
3. Mallery 1881: 318 and 327
4. Densmore 1913: 155
5. Coleman 1947: 2-7
6. Coleman 1947: 7
7. Coleman 1947: 12
8. Coleman 1947: 70-71
9. Densmore 1979: 82

10. Lahontan 1932: 269-270
11. James 1956: 165
12. Kohl 1985: 384
13. Dewdney 1975: 72
14. Kohl 1985: 376-377
15. Densmore n.d. (b)
16. Densmore tapes on file at the Library of Congress, Archive of Folk Culture. Awunakumigikan AFS 10,540: A3 to 10,541: A1.
17. Densmore 1905
18. Densmore 1950
19. Hoffman 1888: 155-156

CHAPTER 4

1. Papworth 1958: 42-44
2. Densmore 1926: 21-22
3. Densmore 1910: 32
4. Seymour, personal communication
5. Dewdney and Kidd 1973: 14
6. Jones 1981: 72
7. Brown and Brightman 1988: 55-58
8. Hoffman 1891: 233
9. Dewdney 1971: 3
10. Brown and Brightman 1988: 197
11. Dewdney and Kidd 1973: 14
12. Dewdney and Kidd 1973: 14
13. Dewdney 1971: 3
14. Jones 1861: 159
15. Hallowell 1981: 42
16. Red Sky, personal communication
17. Hallowell 1981: 59
18. Densmore 1910: 90
19. Brown and Brightman 1988: 37
20. Brown and Brightman 1988: 38
21. Kohl 1985: 415
22. Hoffman 1891: 172-177; Johnston 1982: 96
23. Hoffman 1891: 185
24. Kohl 1985: 60
25. James 1956: 184-185 and 355
26. Thwaites 1896 Vol. 54: 201
27. Michelson 1917: 433
28. Henry 1921: 203
29. La Potherie, in 1911: 286-287; Hoffman 1896: 117
30. Hoffman 1896: 199

31. Densmore 1928: 385
32. James 1956: 351
33. Speck 1915: 83
34. Tassé 1977: 59
35. Jones 1861: 255
36. Jones 1861: 43
37. Hoffman 1896: 205-206
38. For instance, Kohl 1985: 387-390
39. Michelson 1917: 501
40. Hoffman 1891: 194-195
41. Hoffman 1891: 195
42. Hoffman 1891: 194
43. Hoffman 1891: 194
44. Hoffman 1891: 211
45. Hoffman 1891: 230
46. Hoffman 1891: 195
47. James 1956: 379
48. Hoffman 1891: 196
49. James 1956: 360
50. Scrolls on file in the Dewdney Collection, Royal Ontario Museum.
51. Mallery 1880
52. Hoffman 1891: 202
53. Hoffman 1891: 209
54. Hoffman 1891: 272
55. James 1956: 348
56. Hoffman 1891: 283
57. Densmore 1979: 173
58. Mallery 1894: 711
59. Seymour, personal communication
60. Densmore 1979: 173; Coleman 1947: 12
61. Kohl 1985: 141
62. Mallery 1880
63. Coleman 1947: 12
64. Hall 1983: 94-95
65. James 1956: 369
66. Densmore 1932
67. Williams 1988: 79
68. Densmore 1910: 74
69. Densmore 1910: 72
70. Hoffman 1891: 254
71. Hoffman 1891: 202
72. Hoffman 1891: 282
73. Hoffman 1891: 167; Kohl 1985: 387
74. Densmore 1979: 175
75. Coleman 1947: 12
76. Copway 1850: 134

77. Lahontan 1932: 224
78. Hoffman 1891: 168
79. Johnston 1982: 108
80. Densmore 1910: 66
81. Peter Engelbert, personal communication
82. Holmes 1883: 185-310
83. Kelly 1990: 92
84. Seymour, personal communication
85. Kohl 1985: 292
86. James 1956: 353
87. Mallery 1894: 254
88. Hoffman 1891: 209
89. Hoffman 1891: 259
90. Hoffman 1891: 194
91. Scrolls on file in the Dewdney Collection, Royal Ontario Museum
92. Densmore 1910: 67
93. Densmore 1910: 68
94. Densmore 1910: 59
95. Densmore 1910: 73
96. Mallery 1880
97. Seymour, personal communication
98. Hoffman 1891: 209
99. Hoffman 1891: 211
100. Hoffman 1891: 230
101. Hoffman 1891: 208
102. Hoffman 1891: 267
103. Barnouw 1977; Johnston 1976
104. Red Sky, personal communication
105. James 1956: 163
106. Densmore 1913: 60
107. Thwaites 1896 Vol. 6: 211
108. Thwaites 1896 Vol. 5: 179
109. Thwaites 1896 Vol. 71: 289
110. Seymour, personal communication
111. Dewdney 1975: 96
112. Coleman 1947: 49
113. Perrot, in Blair 1911: 59-60
114. Hoffman 1896: 168
115. James 1956: 376-377
116. Stoltman 1973: 24
117. Dewdney 1975
118. Thwaites 1896 Vol. 54: 155
119. Thwaites 1896 Vol. 71: 265
120. Radin 1923: 288
121. Barnouw 1977: 132-133
122. Henry 1921: 197

123. Kohl 1985: 62
124. Thwaites 1896 Vol. 6: 175
125. James 1956: 367
126. James 1956: 359
127. James 1956: 345-346
128. Thwaites 1896 Vol. 9: 119
129. Thwaites 1896 Vol. 12: 27
130. James 1956: 376
131. James 1956: 354
132. James 1956: 354
133. Conway 1989: 10
134. Henry 1921: 169
135. Henry 1921: 220
136. Griffin 1946: 73
137. Thwaites 1896 Vol. 5: 223
138. Coleman 1947: 68
139. Densmore 1913: 86
140. Thwaites 1896 Vol. 12: 26-27
141. Hoffman 1891: 176 and 157
142. Kohl 1985: 400
143. Densmore 1913: 77
144. Stoltman 1973: 24
145. Densmore 1910: 77
146. Hoffman 1896: 177
147. Hoffman 1896: 89
148. Hoffman 1891: 173
149. Densmore 1910: 38
150. Hoffman 1891: 264
151. Densmore 1910: 66
152. Densmore 1910: 63
153. Collections of the Ontario Ministry of Culture and Communications
154. Charles E.Cleland, personal communication.
155. Dewdney and Kidd 1973: 116
156. Thwaites 1896 Vol. 12: 10-11
157. Hoffman 1891: 222
158. James 1956: 164
159. James 1956: 164
160. Seymour, personal communication
161. Densmore 1979: 176
162. Thwaites 1896 Vol. 9: 117
163. Perrot, in Blair 1911: 127
164. Hoffman 1891
165. Densmore 1910 and 1913
166. James 1956: 369
167. Densmore 1910: 112
168. Hoffman 1891: 292

169. Coleman 1947: 82
170. Densmore 1913: 60
171. Radisson 1967: 219
172. Perrot, in Blair 1911: 184-185
173. Catlin 1989: 27
174. Densmore 1910: 80
175. James 1956: 356
176. James 1956: 356
177. Kohl 1985: 287
178. Hoffman 1891: 268
179. Keating 1959: 235
180. Thwaites 1896 Vol. 5: 131
181. Hoffman 1896: 105
182. Thwaites 1896 Vol. 33:37
183. Thwaites 1896 Vol. 6: 203
184. Thwaites 1896 Vol. 6: 173
185. Kohl 1985: 33-34
186. Thwaites 1896 Vol. 9: 277
187. Vastokas and Vastokas 1973: 126-129
188. Densmore 1910: 29
189. Kohl 1985: 403-404
190. Copway 1850: 135-136
191. Mallery 1894: 245
192. Mallery 1894: 241
193. Densmore 1913: 248
194. Kohl 1985: 383
195. Schoolcraft 1851: 101
196. James 1956: 19 and 23
197. James 1956: 346
198. Densmore 1910: 67
199. Kohl 1985: 150
200. Densmore 1910: 68
201. Tomkins 1969: 26; Mallery 1881: 381
202. Marston 1911: 173
203. Barnouw 1977: 251
204. Kohl 1985: 292
205. Kohl 1985: 287
206. Hoffman 1891: 250
207. Hoffman 1891: 155
208. James 1956: 371
209. Hoffman 1891: 255
210. Kohl 1985: 292
211. Hoffman 1891: 294
212. Kohl 1985: 292
213. Hoffman 1891: 294
214. Kohl 1985

215. Copway 1850: 132
216. Kohl 1985: 402
217. Laidlaw 1922
218. Hoffman 1891: 177
219. Densmore 1979: 174

CHAPTER 5

1. Behm 1987
2. William A. Ross, David Arthurs, William A. Fox, personal communication
3. Halverson 1988: 11 and 15
4. Swauger 1984: 126
5. Radin 1923: 65
6. Arthurs, personal communication
7. Catlin 1989: 26 and 429
8. Catlin 1989: 429
9. Catlin 1989: 431
10. Catlin 1989: 430
11. Letter from W. H. Holmes to Garrick Mallery, June 2, 1892. Smithsonian Institution, National Anthropological Archives, 2372, Box 9
12. Rubbings by W. H. Holmes. Smithsonian Institution, National Anthropological Archives, 2372, Box 9
13. Densmore 1913: 98
14. James 1956: 366
15. Densmore 1910: 76
16. Hoffman 1896: 87-88
17. Vastokas and Vastokas 1973: 116
18. Michelson 1917: 373-389
19. Keating 1959: 164
20. Michelson 1917: 403
21. Hoffman 1896: 88
22. Dewdney and Kidd 1973: 116

CHAPTER 6

1. Hodder 1987: 6, Hall 1977: 500
2. Hodder 1987: 6
3. James 1956: 369
4. Schoolcraft 1851: 662
5. Densmore 1910 and 1913
6. Copway 1850: 30-33
7. Thwaites 1896 Vol. 6: 207
8. Schoolcraft 1853 Vol. III: 85

LIST OF FIGURES

43. Ojibway clothing designs
44. Birchbark song records depicting the Mide and the mountain
45. Blindfold Lake
46. Knee Lake
47. Northern Twin Lake
48. Birchbark song records about maymaygwayshi and Nanabojou
49. Birchbark song scroll depicting the origins of the Midewiwin
50. La Roche à l'Oiseau, Ottawa River
51. Matagamasi Lake
52. Little Missinaibi Lake
53. Cache Bay, Quetico Provincial Park
54. Picture Rock Island, Lake of the Woods
55. Birchbark song records depicting arms up
56. Fairy Point, Missinaibi Lake
57. Blindfold Lake
58. Birchbark song records depicting arms up and down
59. Obabika Lake
60. Picture Rock Island, Lake of the Woods
61. Deer Lake
62. Birchbark song records depicting a painter and megis
63. Pictured Lake
64. Agawa Rock, Lake Superior
65. Birchbark song records depicting medicine as a circle
66. Worthington Bay, Lake Superior
67. Worthington Bay, Lake Superior
68. Upper Molson River
69. Ferris Lake
70. Deer Lake
71. Cuttle Lake
72. Birchbark song records depicting circles and spiral
73. Cuttle Lake
74. Birchbark song records depicting the "circle of heaven"
75. Scotia Lake
76. Birchbark song records depicting power lines
77. Burditt Lake
78. Worthington Bay, Lake Superior
79. Painted Rock Island, Lake of the Woods
80. Nipigon Bay, Lake Superior
81. Burnt Bluff, Lake Michigan
82. Agawa Rock, Lake Superior
83. Deer Lake
84. Crooked Lake
85. Wizard Lake
86. Birchbark song records depicting spirit lines
87. Obabikon Narrows, Lake of the Woods
88. Birchbark song record depicting a song from Sault Ste. Marie

89. Barbara Lake
90. Birchbark song records depicting Mishipizheu
91. Hickson-Maribelli, Saskatchewan
92. Lenallen Lake
93. Wasawakasik Lake
94. High Rock, Nelson River area
95. Birchbark song records depicting snakes
96. Fairy Point, Little Missinaibi Lake
97. Pictured Lake
98. Birchbark song records depicting birds
99. Birchbark song records depicting bears
100. Birchbark song records depicting beavers
101. Frances Lake
102. Birchbark song records depicting hunters' medicine
103. John Tanner's dream during a medicine hunt
104. Bigshell Lake
105. Agawa Rock, Lake Superior
106. Upper Molson River
107. A hunting scene recorded on birchbark
108. Ojibway musical instruments
109. Birchbark song records depicting the medicine drum
110. Namakan Narrows, Namakan Lake
111. Medicine man preparing medicine
112. Lac La Croix
113. Bloodvein River
114. Bloodvein River
115. Birchbark song records depicting medicine bags and other items
116. Lac Wapizagonke
117. Ojibway birchbark canoe
118. Dakota Indian's dream
119. Deer Lake
120. Agawa Rock, Lake Superior
121. Dryberry Lake
122. Whitefish Bay, Lake of the Woods
123. Crooked Lake
124. Birchbark song records depicting powerful medicine
125. Medicine pole in Wisconsin
126. Fairy Point, Missinaibi Lake
127. Sassaginnigak Lake area
128. Birchbark song records depicting crosses
129. Birchbark song records depicting crooked lines
130. Deer Lake
131. Picture Rock Island, Lake of the Woods
132. Birchbark song records depicting lines of communication
133. Birchbark song records depicting footprints
134. Deer Lake

Location	Figure Number	Text Citation
Agawa Rock, Lake Superior	2, 6, 12, 64, 82, 105, 120	9, 14, 23, 36, 86, 98, 103, 118, 120, 131, 162
Annie Island, L. of the Woods	7	14, 57, 92, 137, 140
Barbara Lake, N.C. Ontario	89	104
Bigshell Lake, Manitoba	104	117
Blindfold Lake, N.W. Ontario	45, 57	68, 75
Bloodvein River, N.W. Ontario	3, 4, 113, 114	9, 11, 15, 123
Burditt Lake, N.W. Ontario	77	94
Burnt Bluff, Michigan	39, 81	50-1, 53, 86, 95, 147, 163
Burntside Lake, Minnesota	42	54-55, 101
Cache Bay, Quetico Park	53	75
Cow Narrows, Saskatchewan	15	26, 100, 140
Crooked Lake, Minnesota	84, 123	98, 131
Crowrock Inlet, N.W. Ontario	31	42, 66
Cuttle Lake, N. W. Ontario	71, 73, 142	88, 117, 120, 157
Darky Lake, Quetico Park	29	36, 44
Deer Lake, N.W. Ontario	10, 61, 70, 83, 119 130, 134, 135	23, 81, 88, 98, 115-116, 131,137, 140, 142
Dryberry Lake, N.W. Ontario	121	131
Fairy Point, Missinaibi Lake	56, 96, 126	75, 109, 134
Ferris Lake, N. E. Ontario	69	88
Frances Lake, N.W. Ontario	101	115, 145, 157
Gottschall, Wisconsin	37	47-48, 157, 163
Hegman Lake, Minnesota	141	157
Hickson-Maribelli L., Sask.	91	105
High Rock, Manitoba	94	70, 107
Keso Point, French River	24	32
Knee Lake, Manitoba	26, 46	32, 68
Lac La Croix, Quetico Park	112	122
Lenallen Lake, Manitoba	92	105
Little Missinaibi, N.E. Ontario	52	75, 120
Mameigwess Lake, N.W. Ont.	27	32
Matagamasi Lake, N.E. Ontario	51, 140	75 156
Mazinaw Lake, E. Ontario	143	161
Namakan Narrows, N.W. Ont.	110	120
Nipigon Bay, L. Superior	28, 80	35, 94, 148
Northern Twin Lake, N. W. Ont.	47	68
Obabika Lake, N. E. Ontario	59	76

BIBLIOGRAPHY AND SUGGESTED READING

Arthurs, David
 1986 Archaeological Investigations at the Long Sault Site (Manitou Mounds).
 Ontario Ministry of Citizenship and Culture, Conservation Archaeology Reports,
 Northwestern Region Report 7.

Barnouw, Victor
 1977 *Wisconsin Chippewa Myths and Tales and their Relation to Chippewa Life.*
 University of Wisconsin Press, Madison.

Behm, Jeffrey
 1987 Rock Art at the Silver Mound Quarries and Workshops. *Wisconsin*
 Archaeologist 68(4): 376-387.

Blair, E. H., editor
 1911 *The Indian Tribes of the Upper Mississippi Valley and Regions of the Great Lakes.*
 Arthur H. Clark, Cleveland.

Blessing, Fred K.
 1963 Birchbark Mide Scrolls from Minnesota. *Minnesota Archaeologist* 25(3): 88-
 142.

 1977 *The Ojibway Indians Observed.* Minnesota Archaeological Society, St. Paul.

Brown, Jennifer S. H. and Robert Brightman
 1988 *"Orders of the Dreamed": George Nelson on Cree and Northern Ojibwa Religion*
 and Myth, 1823. University of Manitoba Press, Winnipeg.

Callender, Charles
 1979 Hopewell Archaeology and American Ethnology. In *Hopewell Archaeology:*
 The Chillicothe Conference, edited by David S. Brose and N'omi Greber,
 pp. 254-257. Kent State University Press, Kent.

Catlin, George
 1989 *North American Indians.* Peter Mathiessen, editor. Reprinted by Penguin
 Books, Markham.

Cleland, Charles E.
 1992 *Rites of Conquest: The History and Culture of Michigan's Native Americans,*
 University of Michigan Press, Ann Arbor.

Cleland, Charles E., Richard D. Clute and Robert E. Haltinger
 1984 Naub-cow-zo-win Discs from Northern Michigan. *Midcontinental Journal of*
 Archaeology 9(2): 235-249.

Cleland, Charles E. and G. Richard Peske
 1968 The Spider Cave Site. In: The Prehistory of the Burnt Bluff Area, assembled
 by James E. Fitting, pp.20-60. *University of Michigan, Museum of
 Anthropology, Archaeological Papers* 34.

Coleman, Sister Bernard
 1947 *Decorative Designs of the Ojibwa of Northern Minnesota.* The Catholic
 University of America Press, Washington.

Conway, Thor
 n.d. The Providence Bay Site. Ms. on file, Ontario Ministry of Culture, Tourism
 and Recreation.

 1989 Scotia Lake Pictograph Site: Shamanic Art in Northeastern Ontario. *Man in
 the Northeast* 37:1-23.

Copway, George (or Kahgegagahbowh)
 1850 *The Traditional History and Characteristic Sketches of the Ojibway Nation.*
 Charles Gilpin, London.

Dawson, K. C. A.
 1976 Algonkians of Lake Nipigon: An Archaeological Survey. *National Museum of
 Man Mercury Series, Archaeological Survey of Canada* 48.

Denny, Peter
 1992 *The Entry of Algonkian Language into the Boreal Forest.* Paper presented at the
 annual meeting of the Canadian Archaeological Association, London.

Densmore, Frances
 1905 First Field Trip Among the Chippewa. Ms. on file, Smithsonian Institution,
 National Anthropological Archives.

 1910 Chippewa Music. *Bureau of American Ethnology Bulletin 45.* Smithsonian
 Institution.

 1913 Chippewa Music II. *Bureau of American Ethnology Bulletin 53.* Smithsonian
 Institution.

 1926 *American Indians and their Music.* The Woman's Press, New York.

 1928 Uses of Plants by the Chippewa Indians. *Bureau of American Ethnology
 Bulletin* 44, pp. 275-397.

 1932 Untitled Manuscript 3942. Manuscript on file, Smithsonian Institution,
 National Anthropological Archives.

1935 Lecture on Indian Music, at Minot, North Dakota. Ms. on file, Smithsonian Institution, National Anthropological Archives.

1942 The Study of Indian Music. Ms. on file, Smithsonian Institution, National Anthropological Archives.

1950 Music in Relation to the Life of the American Indian. Lecture notes on file, Smithsonian Institution, National Anthropological Archives.

1979 *Chippewa Customs.* Reprinted by Minnesota Historical Society Press, St. Paul.

n.d.(a) Turtles Go to War. Ms. on file, Smithsonian Institution, National Anthropological Archives.

n.d.(b) Autobiography. Ms. on file, Smithsonian Institution, National Anthropological Archives.

Dewdney, Selwyn
 1971 Insights on Vision Sites: A Matter of Relevance. *Royal Ontario Museum, Archaeological Newsletter* 69.

 1974 Verbal Vignettes from the Pictograph Corner. *Royal Ontario Museum, Archaeological Newsletter* 105.

 1975 *The Sacred Scrolls of the Southern Ojibway.* University of Toronto Press, Toronto.

 1977 Search for Forgotten Dreams. In: Relèves et Travaux Recents sur L'Art Rupeste Amerindien, by Gilles Tassé and Selwyn Dewdney. *Université de Québec à Montréal, Collection Paleo-Québec* 8: 36-69.

Dewdney, Selwyn and Kenneth E. Kidd
 1973 *Indian Rock Paintings of the Great Lakes.* University of Toronto Press, Toronto.

Dragoo, Don W.
 1963 *Mounds for the Dead: an Analysis of the Adena Culture.* Carnegie Museum, Pittsburgh.

Griffin, James B.
 1946 Cultural Change and Continuity in Eastern United States. *Man in Northeastern North America: Papers of the Robert S. Peabody Foundation for Archaeology* III: 37-95.

Gjessing, Gutorm
 1978 Rock-Pictures in Northern Fenno-Scandia and their Eastern Affinities. In *Acts*

of the International Symposium of Rock Art, edited by Sverre Marstrander, pp. 14-30. Universitetsforlaget, Oslo.

Hall, Robert L.
1977 An Anthropocentric Perspective for Eastern United States Prehistory. *American Antiquity* 42(4): 499-518.

1983 A Pan-Continental Perspective on Red Ochre and Glacial Kame Ceremonialism. In: Lulu Linear Punctated: Essays in Honor of George Irving Quimby; R. C. Dunnell and D. K. Grayson, eds., pp. 74-107. *University of Michigan, Museum of Anthropology, Anthropological Paper* 72.

Hallowell, A. Irving
1936 The Passing of the Midewiwin in the Lake Winnipeg Region. *American Anthopologist* 38: 32-51.

1942 *The Role of Conjuring in Saulteaux Society.* Publications of the Philadelphia Anthropological Society 2. Philadelphia.

1981 *Ojibway Ontology, Behaviour and World View. Reprinted in Culture in History: Essays in Honor of Paul Radin*, edited by Stanley Diamond, pp. 20-43. Octagon Books, New York.

Halverson, Colleen
1988 *An Archaeological Survey of Stephen, Cameron, Flint and Kakagi Lakes in Northwestern Ontario.* Ontario Ministry of Culture and Communications, Conservation Archaeology Reports, Northwestern Region Report 12.

Henry, Alexander
1921 *Alexander Henry's Travels and Adventures in the Years 1760-1776.* Reprinted by The Lakeside Press, Chicago.

Hickerson, Harold
1970 *The Chippewa and their Neighbours: A Study in Ethnohistory.* Holt, Rinehart and Winston, Toronto.

Hlady, Walter M.
1970 *Manitoba - the Northern Woodlands. In Ten Thousand Years - Archaeology in Manitoba*, edited by Walter M. Hlady, pp. 93-121. Manitoba Archaeological Society, Altona.

Hodder, Ian
1987 *The Contextual Analysis of Symbolic Meanings. In The Archaeology of Contextual Meanings,* edited by Ian Hodder, pp. 1-10. Cambridge University Press, Cambridge.

Hoffman, W. J.

 1888 *Pictographs and Shamanistic Rites of the Ojibway.* The American Anthropologist 1: 209-229.

 1891 *The Midewiwin or "Grand Medicine Society" of the Ojibwa.* Smithsonian Institution, Bureau of Ethnology, Seventh Annual Report 1885-86.

 1896 *The Menomini Indians.* Smithsonian Institution, Bureau of Ethnology, Fourteenth Annual Report 1892-93.

Holman, Margaret B.

 1984 *Pine River Ware: Evidence for In Situ Development of the Late Woodland in the Straits of Mackinac Region.* Wisconsin Archeologist 65 (1): 32-48.

Holmes, W. H.

 1883 *Art in Shell of the Ancient Americans.* Smithsonian Institution, Bureau of Ethnology, 2nd Annual Report, 1880-81, pp. 185-310.

Honigman, John J.

 1981 *Expressive Aspects of Subarctic Indian Culture.* In Handbook of North American Indians 6, edited by June Helm, pp. 718-738. Smithsonian Institution, Washington.

James, Edwin

 1956 *A Narrative and Adventures of John Tanner, During 30 Years Residence Among the Indians.* Reprinted by Ross and Haines, Minneapolis.

Johnston, Basil

 1976 *Ojibway Heritage.* McClelland and Stewart, Toronto.

 1982 *Ojibway Ceremonies.* McClelland and Stewart, Toronto.

Jones, Rev. Peter

 1861 *History of the Ojibway Indians.* A. W. Bennett, London.

Jones, Tim E. H.

 1981 *The Aboriginal Rock Paintings of the Churchill River.* Saskatchewan Department of Culture and Youth, Anthropological Series 4.

Keating, William H.

 1959 *Narrative of the Expedition to the Source of the St. Peter's River, Lake Winnepeek, Lake of the Woods etc.* Ross and Haines, Minneapolis.

Keesing, Felix M.

 1971 *The Menomini Indians of Wisconsin.* Johnson Reprint Corporation, New York.

Kelly, John E.
1990 Range Site Community Patterns and the Mississippian Emergence. In *The Mississippian Emergence*, edited by Bruce D. Smith, pp. 67-112. Smithsonian Institution Press, Washington.

Kenyon, Walter A.
1986 Mounds of Sacred Earth: Burial Mounds of Ontario. *Royal Ontario Museum Archaeology Monograph* 9.

Kidd, Kenneth
1981 A Radiocarbon Date on a Midewiwin Scroll from Burntside Lake, Ontario. *Ontario Archaeology* 35: 41-43.

Koezur, Polly and James V. Wright
1976 The Potato Island Site, District of Kenora, Ontario. *National Museum of Man Mercury Series, Archaeological Survey of Canada* 51.

Kohl, Johann Georg
1985 *Kitchi-Gami: Life Among the Lake Superior Ojibway.* Reprinted by Minnesota Historical Society Press, St. Paul.

Lahontan, Baron de (Louis Armand de Lom d'Arc)
1932 *Lahontan's Voyages.* Graphic Publications, Ottawa. (Republished from 1703 original).

Laidlaw, Col. G. E.
1922 Ojibwa Myths and Tales. *Legislative Assembly of Ontario, Thirty-third Annual Archaeological Report.*

Lambert, Peter
1983 The Northwestern Ontario Rock Art Project: the 1982 Results. *Ontario Ministry of Citizenship and Culture, Conservation Archaeology Reports, Northwestern Region Report* 2.

1985 *The Northwestern Ontario Rock Art Project: the 1984 Results.* Ontario Ministry of Citizenship and Culture, Conservation Archaeology Reports, Northwestern Region Report 8.

La Potherie, Claude Charles Le Roy, Bacqueville De
1969 History of the Savage People Who Are Allies of New France. Reprinted in *The Indian Tribes of the Upper Mississippi Valley and Regions of the Great Lakes,* edited by E.H. Blair. Arthur H. Clark, Cleveland.

Lathrap, Donald W. and Rudolph C. Troike
1988 Relationships Between Linguistic and Archaeological Data in the New World. *Journal of the Steward Anthropological Society* 15(1-2): 4-22.

Layton, Robert
 1992 *Australian Rock Art: A New Synthesis.* Cambridge University Press, Cambridge.

Lewis-Williams, J. D.
 1986 Cognitive and Optical Illusions in San Rock Art Research. *Current Anthropology* 27 (2): 171-179.

Lugenbeal, Edward M.
 1977 The Archaeology of the Smith Site: A Study of the Ceramics and Culture History of Minnesota Laurel and Blackduck. PhD dissertation, University of Wisconsin, Madison.

Mallery, Garrick
 1880 Gesture Signs and Signals of the North American Indians. *Smithsonian Institution, National Anthropological Archives, Box 8: 2372, Folder 1.*

 1881 A Collection of Gesture-Signs and Signals of the North American Indians with Some Comparisons. *Smithsonian Institution, Bureau of American Ethnology, First Annual Report for 1879-80.*

 1894 Picture Writing of the American Indians. *Smithsonian Institution, Bureau of Ethnology, 10th Annual Report for 1893.*

Marston, Major Morell
 1911 Memoirs Relating to the Sauk and Foxes. In *The Indian Tribes of the Upper Mississippi Valley and Regions of the Great Lakes*, edited by E. H. Blair. Arthur H. Clark, Cleveland.

Martynov, Anatoly I.
 1991 *The Ancient Art of Northern Asia.* University of Illinois Press, Urbana.

Mason, Ronald J.
 1981 *Great Lakes Archaeology.* Academic Press, Toronto.

McPherron, Alan
 1967 The Juntunen Site and the Late Woodland Prehistory of the Upper Great Lakes Area. *University of Michigan, Museum of Anthropology, Anthropological Papers* 30.

Meyer, David and Dale Russell
 1987 The Selkirk Composite of Central Canada: A Reconsideration. *Arctic Anthropology* 24 (2): 1-31.

Meyer, David and S. J. Smailes
 1975 Archaeology. In *Saskatchewan Department of the Environment, Churchill River Study, Final Report* 19.

Michelson, Truman, ed.
1917 *Ojibway Texts II - Part 1, Collected by William Jones.* E. J. Brill, Leyden.

Papworth, Mark
1958 An Archaeological Survey of the Petroglyph Site. In: the Sanilac Petroglyphs. *Cranbrook Institute of Science, Bulletin* 36: 39-47.

Pelshea, Victor
1980 The West Patricia Rock Art Project: First Year. In: Studies in West Patricia Archaeology No. 1: 1978-1979, edited by C. S. Paddy Reid, pp. 49-69. *Ontario Ministry of Culture and Recreation, Archaeological Research Report* 15.

n.d. Pictographs at Whitefish Bay on Lake of the Woods, Ontario. Reproductions on file in the Kenora Field Office of the Ontario Ministry of Culture and Communications.

Powell, J. W.
1881 On Limitations to the Use of Some Anthropologic Data. In *First Annual Report of the Bureau of Ethology, Smithsonian Institution, 1879-80,* pp. 73-86.

Radin, Paul
1923 The Winnebago Tribe. *Thirty-seventh Annual Report of the Bureau of Ethnology, Smithsonian Institution.*

Radisson, Paul Esprit
1967 *The Exploration of Pierre Esprit Radisson.* Reprinted by Publications of the Prince Society, Boston.

Rajnovich, Grace
1980 The Rainy Lake Archaeological Survey: 1978-1979. *Ontario Ministry of Culture, Tourism and Recreation, Archaeological Research Reports on File.*

1981 The Deer Lake Pictographs. In: Studies in West Patricia Archaeology No. 2: 1979-1980, edited by C. S. Paddy Reid and W. A. Ross, pp. 280-307. *Ontario Ministry of Culture and Recreation, Archaeological Research Report* 16.

1983 The Spruce Point Site: A Comparative Study of Selkirk Components in the Boreal Forest. *Ontario Ministry of Citizenship and Culture, Conservation Archaeology Reports, Northwestern Region Report* 1.

1989 Visions in the Quest for Medicine: An Interpretation of the Indian Pictographs of the Canadian Shield. *Midcontinental Journal of Archaeology* 14(2): 179-225.

1991 Reading Rock Art. Paper presented at the annual Midwest Archaeological Conference, La Crosse.

Reid, C. S. Paddy and Grace Rajnovich
 1991 Laurel: A Re-evaluation of Spatial, Social and Temporal Paradigms. *Canadian Journal of Archaeology* 15: 193-234.

Salzer, Robert J.
 1987 Preliminary Report on the Gottschall Site (471a80). *Wisconsin Archaeologist* 68(4): 419-472.

Sanger, Kay Kenady and Clement Meighan
 1990 *Discovering Prehistoric Rock Art: A Recording Manual.* Wormwood Press, Calabasas.

Schoolcraft, Henry R.
 1851 *Personal Memoirs of a Residence of Thirty Years with the Indian Tribes on the American Frontiers.* Lippencott, Grambo and Co., Philadelphia.

 1853 *Information Respecting the History, Condition and Prospects of the Indian Tribes of the United States.* Lippincott, Grambo & Co., Philadelphia.

Speck, F. G.
 1915 Family and Hunting Territories and Social Life of Various Algonkian Bands of the Ottawa Valley. *Canada Department of Mines, Geological Survey, Memoir* 70.

Stoltman, James B.
 1973 *The Laurel Culture in Minnesota.* Minnesota Historical Society, St. Paul.

Swauger, James L.
 1984 *Petroglyphs of Ohio.* Ohio University Press, Athens.

Tassé, Gilles
 1977 Premierès Reconnaissances. In Relèves et Travaux Recents sur L'Art Rupeste Amerindien, by Gilles Tassé and Selwyn Dewdney. *Université de Québec à Montréal, Collection Paleo-Québec* 8: 36-69.

Thwaites, Reuben, ed.
 1896 *The Jesuit Relations and Allied Documents.* Burrows Brothers, Cleveland.

Tomkins, William
 1969 *Indian Sign Language.* Reprinted by Dover Publications, New York.

Tyyska, Allen Edwin and James A. Burns
 1973 Archaeology from North Bay to Mattawa. *Ontario Ministry of Natural Resources Research Report* 12: pp. 32-43.

Vastokas, Joan and Romas Vastokas
 1973 *Sacred Art of the Algonkians: A Study of the Peterborough Petroglyphs.* Mansard Press, Peterborough.

Warren, William W.
 1970 *History of the Ojibway Nation.* Reprinted by Ross and Haines, Minneapolis.

Wheeler, C. J.
 n.d. The Oxford House Pictograph. *Canadian Rock Art Research Associates, Manitoba Chapter Newsletter* 1(4): 2-9.

Williams, Winston
 1988 *Florida's Fabulous Seashells and Other Seashore Life.* Worldwide Publications, Tampa.

Wright, James V.
 1972 The Shield Archaic. *National Museums of Canada, Publications in Archaeology* 3.

ABOUT THE AUTHOR

Grace Rajnovich (pronounced rye-no-vich), born in Sault Ste. Marie, Ontario, was a field archaeologist for 14 years with the Ontario government, stationed in Kenora. She holds a BA from York University, an MA in English from the University of Toronto and an MA in anthropology from the University of Manitoba. She is currently studying for a PhD in anthropology at Michigan State University. She has written more than 25 research works including "Visions in the Quest for Medicine: An Interpretation of the Indian Rock Paintings of the Canadian Shield", for the Midcontinental Journal of Archaeology , on which this book is based. She is a founding member of the Ontario Rock Art Conservation Association.

ABOUT THE ILLUSTRATORS

Wayne Yerxa, who provided the ink illustrations of the rock paintings for this book, was born on the Couchiching Indian Reserve near Fort Frances, Ontario. He has been an artist for 20 years, specializing in Ojibway themes using combined acryllics and ink. He illustrated three books and his work appeared in two magazines, Harrowsmith and The Ontario Indian. He has sold hundreds of his works internationally to private collectors.

The watercolour reproductions were done by the late Selwyn Dewdney, Canada's foremost rock art researcher and author of Indian Rock Paintings of the Great Lakes. The original watercolours are part of the Dewdney Collection of the Royal Ontario Museum, Department of New World Archaeology.